Arthur Dove

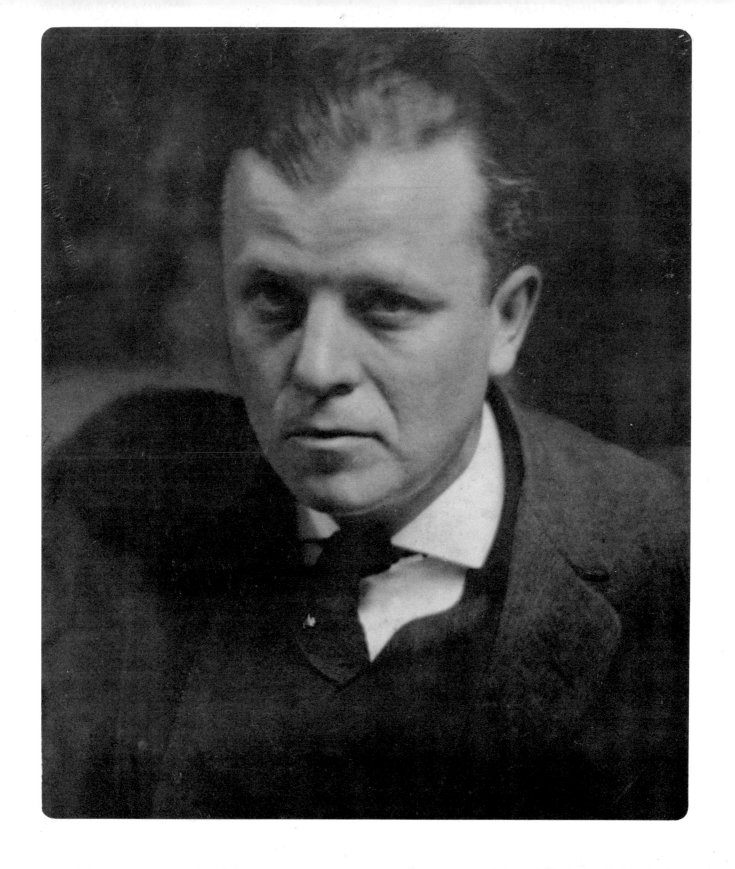

Barbara Haskell

San Francisco
Museum of Art

Arthur Dove

This project is supported
by a grant from the
National Endowment for the Arts in
Washington, D.C., a Federal Agency.

Distributed by
New York Graphic Society, Boston

Exhibition Dates

San Francisco Museum of Art
San Francisco, California
November 21, 1974 - January 5, 1975

Albright-Knox Art Gallery
Buffalo, New York
January 27 - March 2, 1975

The St. Louis Art Museum
St. Louis, Missouri
April 3 - May 25, 1975

The Art Institute of Chicago
Chicago, Illinois
July 12 - August 31, 1975

Des Moines Art Center
Des Moines, Iowa
September 22 - November 2, 1975

Whitney Museum of American Art
New York, New York
November 24, 1975 - January 18, 1976

Designed by John Coy
Produced in Los Angeles by Tom Kellaway,
American Art Review Press

New York Graphic Society, Ltd.
11 Beacon Street
Boston, Mass. 02108

International Standard Book No. 0-8212-0651-6
Library of Congress Catalog Card No. 74-24700
©1974 San Francisco Museum of Art

Frontispiece:
Dove. Photograph by Alfred Stieglitz.

Cover:
That Red One. 1944.

Table of Contents

Acknowledgments

From the inception of this project I have had the fullest measure of assistance and cooperation from many people and have been deeply touched by the level of commitment to Arthur Dove shown by the individuals who graciously shared their experiences about Dove with me or who spent time allowing me to view their Dove works. That lenders were willing to part with important and fragile works for such a long period attests not only to their generosity and sense of responsibility toward the general community, but also to their deep feelings for the art of Arthur Dove. Without their more than ordinary level of support, this exhibition would not have been possible. I am particularly grateful to Georgia O'Keeffe and Doris Bry, whose assistance in securing loans was significant and to the William H. Lane Foundation and the Phillips Collection for graciously agreeing to lend so many important works from their collections.

The exhibition was originally scheduled to open at the Pasadena Museum of Modern Art, but due to changes in the orientation of the Pasadena Museum, the sponsorship of the exhibition was transferred to the San Francisco Museum of Art. I am immensely grateful to everyone at the San Francisco Museum for enthusiastically and diligently assuming the various coordinational responsibilities that were suddenly transferred to them. Henry Hopkins has been particularly supportive and helpful as have been Sue King, registrar and Karen Tsujimoto, assistant curator. The National Endowment for the Arts generously allowed the San Francisco Museum to become the recipient of the grant which had made the exhibition possible in the first place.

I also deeply appreciate the support that was given by the staff and community of the Pasadena Museum during the preparation of the exhibition and after the sponsorship had been transferred. William Agee, former director of the Pasadena Museum of Modern Art, offered helpful advice and encouragement during the initial stages of the exhibition. Sara Giesen, who assisted in the preparation of the catalogue and John Coy and Barbara Smith, who designed the catalogue, contributed enormously to the smoothness and good cheer surrounding the project. Special thanks are due Gordon Hampton, whose generous grant to the catalogue helped to make possible the reproduction of numerous works in color.

I appreciate the warm cooperation that was shown by the Terry Dintenfass Gallery and especially want to thank Bill and Aline Dove, Arthur Dove's son and daughter-in-law, for their generous hospitality, delicious meals and long hours spent talking with me about Arthur Dove.

Finally, I want to thank Diane Tucker, my secretary and assistant, who has helped in every phase of the exhibition and catalogue. I am immeasurably indebted to her.

B.H.

Arthur Dove

In all his paintings Arthur Dove attempted to extract from an object or situation its essential "spirit." American painters in the first part of the century spoke a great deal about painting "ideas." An "idea" was a theme or motif that was not tied to the representation of objects. At the time of his 1912 exhibition in Chicago Dove was quoted as saying, "Yes, I could paint a cyclone ... I would show the repetition and convolutions of the rage of the tempest. I would paint the wind, not a landscape chastized by the cyclone."[1] Ideas, then, could express a quality apart from an object, as when Dove spoke of painting the idea of "ruggedness."

By means of color, form and line, Dove expressed the idea that lay behind the veil of appearances. Color was the dominant element in his compositions. As it had been for the Fauves and Die Brücke artists, color for Dove was liberated from the world of appearance. He believed that all things had a color condition or a "condition of light." It was through this "condition of light" rather than through surface details that one could represent the essence or inner character of an object.[2] Dove once said, "you can describe a person in a color" and "...the most important thing is the statement of color ...so that an artist could know exactly in color how a person felt." This attitude was similar to the concept of aura, the envelopment of the body by surrounding colors which mystics use to reveal the character or state of health of the individual. For Dove, the condition of light pervaded the object. To demonstrate this to his son, he once pulled up a geranium and tore it to pieces, showing how color ran throughout the flower. Dove first described this "condition of light" in a letter to Samuel Kootz which was reprinted in *Modern American Painters*:

...There was a long period of searching for something in color which I then called 'condition of light.' It applied to all objects in nature, flowers, trees, people, apples, cows. These all have their certain condition of light, which establishes them to the eye, to each other, and to the understanding.

To understand that clearly, go to nature, or to the Museum of Natural History and see the butterflies. Each has its own orange, blue, black; white, yellow, brown, green and black, all carefully chosen to fit the character of the life going on in that individual entity.[3]

Dove believed that the same principle which had been true for color applied to forms. That is, each object had a certain configuration that captured its spirit or inner structure but that did not necessarily conform to its objectively perceived shape. Referring to this condition of form, Dove wrote, "The second step was to apply this same principle to form, the actual dependence upon the object (representation) disappearing, and the means of expression becoming purely subjective. After working for some time in this way, I no longer observed in the old way, and, not only began to think subjectively but also to remember certain sensations purely through their form and color ..."[4] Dove came to describe this identifying form through "force lines" or "growth lines." Force lines did not refer to the physical outlines of an object but to the forces or tensions alive within it. "The force lines of a tree," Dove wrote, "seem to me to be more important than its monumental bulk. When mariners say 'the wind has weight,' a line seems to express that better than bulk."[5]

The reduction of objects to a few simple color and form motifs was the basis of Dove's work throughout his life. As he explained to the writer and collector Arthur Jerome Eddy, "...having come to the conclusion that there were a few principles existent in all good art from the earliest examples we have, through the masters to the present, I set about it to analyze these principles as they occurred in works of art and in nature. One of these principles which seemed the most evident was the choice of a simple motif. This same law held in nature, a few forms and a few colors sufficed for the creation of an object. Consequently I gave up my more disorderly methods (Impressionism). In other words I gave up trying to express an idea by stating innumerable little facts, the statement of facts having no more to do with the art of painting than statistics with literature..."[6]

For Dove, the work of art consisted of two elements—the inner and the outer. The outer was the material world that the artist experienced, the inner was the emotion or idea in the mind of the artist. In a work of art, the subjective and the objective were necessarily brought into relation with one another. That the inner element was the determining and vital one is illustrated in Dove's writings: "We certainly seem to set down a self-portrait of our own inner feelings with everything we do." "...It is the form that the idea takes in the imagination rather than the form as it exists outside."

Dove communicated his feeling of oneness with nature in all his works. He perceived nature, not as an observer would perceive it from without, but as if he were an inseparable part of it. His childhood and adult experiences on farms and the sea taught him to live within nature so that he was not a separate entity. It was not that he felt the world within himself, but that he felt himself present in the world.

As a continuous reference point, nature was not only Dove's source of forms, but also provided the spiritual laws and compositional principles upon which all his work was based. It was simply by observing nature that he devised the principles of force lines, color condition and simplification, as well as the principles of unity and continuity that support his work.

Dove felt that each individual must understand his innermost spirit and find a means of expression that is in harmony with that spirit, not allowing the imposition of external standards or styles. "...We certainly seem to set down a self-portrait of our own inner feelings with everything we do," he wrote, "and how much finer to have the means of expression in harmony with those feelings. We have seen veritable truck drivers stuttering along with a handful of tiny brushes making little dots of so-called pure color. Of course it depends on the way it is done and the man, but we know at the time, that if they were free and had found their own truth, they would not be doing quite that. This denial of self in order to corroborate with the past leads to a rather unhealthy unhappiness."[7] This individualism relates philosophically to Ralph Waldo Emerson who wrote, "Nothing is more sacred than the laws of our own nature and we must thoroughly look within ourselves and not permit outside standards to be imposed upon us."

Dove's commitment to the inner spirit enabled him to remain true to his private visions throughout his life. His continual search for the next truth and his resolve to paint these truths in the face of a hostile public and little financial support were the source of his moral strength as an artist. "There is a certain grim satisfaction," he wrote, "in grinding out your own truths and knowing that you have to accept them."[8]

Below: Dove family residence on North Main Street, Geneva.

Bottom: Dove family residence at 512 South Main Street, Geneva. Due to an increase in their economic status, the Dove family moved into the more fashionable district of Geneva when Dove was 16. Dove preferred the earlier, less pretentious house and never liked the new house.

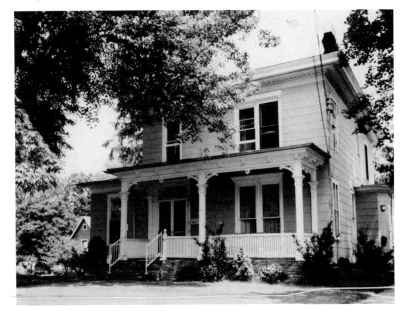

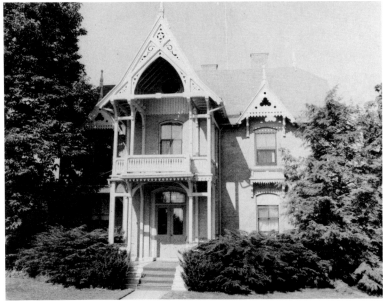

Early Years

Arthur Garfield Dove was born on August 2, 1880, in Canandaigua, New York, the first child of Anna Elizabeth and William George Dove. He was named after the soon-to-be elected presidential and vice-presidential candidates of that year, James Garfield and Chester Arthur. Dove's father, a prosperous and well-respected brickmaker and later contractor in Geneva, had been elected County Clerk prior to Dove's birth and had moved the family to nearby Canandaigua during his two-term appointment. At the end of his term, the family returned to Geneva, New York, where Dove had an apparently conventional upbringing.

In later years Dove repeatedly wrote that his most formative boyhood influence was Newton Weatherly, a naturalist who lived across the street from the Dove family. Weatherly was a truck farmer who supported himself by farming vegetables and raising plants in a backyard greenhouse. Although in his fifties, Weatherly became a companion to Dove, taking him along as he went about his activities, teaching him hunting and fishing in the woods and lakes of upstate New York. It was Weatherly who sharpened Dove's love and responsiveness to nature and taught him to feel himself a part of it. As

Dove was later to say, "I can claim no background except perhaps the woods, running streams, hunting, fishing, camping, the sky.

As a role model Weatherly was important in first introducing the idea of painting to Dove. He was an amateur musician and painter and would stretch up his canvas scraps for Dove who, at the age of nine, would try to paint along with him. Aside from these experiences with Weatherly and some private painting lessons from a neighborhood schoolteacher, there is nothing in Dove's background that would indicate the career he was to devote himself to.

What was suggested in his early life was the self-reliance and independence of spirit that characterized him both as an artist and as a person. That Dove was an only child for the first part of his life accounts for this in part. He had a sister, Mary Marguerite, who was born in 1883 and died two years later; his brother Paul was not born until he was twelve. His independent spirit and strong convictions were demonstrated at the age of twelve when he resigned from the Presbyterian church due apparently to the clergy's refusal to allow an atheist the right to his opinions.

Dove attended Hobart College in Geneva for two years and then transferred to Cornell University where he originally enrolled as a pre-law student to placate his father. He soon lost interest in law and found himself increasingly committed to art. At Cornell, Dove's art instructor, an illustrator named Charles Wellington Furlong, encouraged Dove to become an illustrator. Apparently having already found the humorous style that was to make his later illustrations popular, Dove was asked to illustrate the Cornell yearbook.

After graduation in 1903 Dove went to New York and after a few months in advertising, turned to free lance illustrat-

ing. His humorous, anecdotal sketches were soon in demand, and commissions to illustrate fiction began coming in from *Harper's, Scribners, Collier's, Life* and *The Saturday Evening Post*. A year later he married Florence Dorsey, a Geneva woman six years his senior. With an annual income of around $12,000 he and his new bride lived quite comfortably, but Dove had been painting on the side and began to realize that

Photograph of Dove taken in Europe.

he wanted to devote himself to fine art rather than to commercial illustrating. In the fall of 1907, with $4,000 in savings and some financing from the family, the Doves left for an eighteen-month sojourn in France.

Paris 1907-1909

Paris at that time was the cultural capital of the world. Life there was one of pompous display, frivolity, relaxed morals, and cultivated taste. More styles and "isms" rose and fell during this period than would ever again be produced in so short a time: Impressionism had fallen into the public domain after its last group show in 1886; the heroic age of French Fauvism was at its height; the Cézanne memorial exhibition had just been held and Picasso had recently completed *Les Demoiselles d'Avignon*. Although none of Dove's abstract paintings were executed until after he had returned to the United States, this revolutionary input stimulated the development of his own abstract style.

Almost every American artist during this period who was interested in advanced painting felt it was important to go to Paris. Of the Americans living there, Alfred Maurer became Dove's closest friend and remained so until his suicide in 1932. It was probably through Maurer, who had already lived in Paris for ten years and was actively involved in the social life, that Dove was introduced to the Parisian art scene and met the other American artists, Max Weber, Patrick Henry Bruce, Arthur Carles and Jo Davidson. Dove was sufficiently known in this community to have exhibited in the 1908 and 1909 Salon d'Automne.[9]

The five paintings from this period that Dove brought back to the United States continued the Impressionist style in which he had been working earlier in New York, but their color was brighter. The liberation of Dove's palette relates these paintings to those of the Fauves, whose work he undoubtedly saw in Paris. This development was probably furthered through the companionship of Maurer who had been studying with Matisse and was then working in a Fauvist style. Dove and Maurer spent considerable time together in France and Dove later said that he and Maurer had together undertaken to "simplify Impressionism," much as Matisse was doing at the time, by reducing compositions to larger areas of pure color.

It is possible too that the physical brightness of the landscape of Southern France was a factor in lightening Dove's color, for he spent relatively little time painting in the city, preferring the countryside of Southern France around Cagnes. One is reminded of the change in van Gogh's palette from the dark, heavy tones of the paintings produced in Belgium to the high-keyed colors of his Provence period.

The Lobster, which Dove sent to the 1909 Salon d'Automne and which was to later represent him in Stieglitz's "Younger American Painters" exhibition, has a simplicity and rhythmic sinuousness that recall Matisse and a compositional and structural quality reminiscent of Cézanne. The simplification of color areas and the curvilinear quality of *The Lobster* suggest the stylized organic forms that would later characterize his 1912 abstract pastels. The manner in which colors appear altered by the recession of planes and by the reflection of adjacent objects, and the manner in which forms are distorted in order to indicate the existence of multiple planes shifting in depth relate *The Lobster* to the still life compositions of Cézanne.

Dove returned from Europe in the spring of 1909. He spent that summer camped in the woods near Geneva studying and thinking through the implications of his experiences in France. He returned to New York City, took a three-week newspaper job, then began illustrating again to support himself. Sometime in late 1909 or early 1910, with an introduction arranged through Maurer, who was still in Paris, he took some of his work into Stieglitz's gallery "291."

In 1910 a large independents' show was organized by the Ashcan Group in which none of the artists associated with Stieglitz were asked to participate. As a challenge to the Realists' claim that they represented the most advanced tendencies, Stieglitz mounted a show in March of that year entitled "Younger American Painters." The exhibition included Brinkley, Fellows, Marin, Maurer, Hartley, Steichen, Weber, Carles and Dove, who was represented by *The Lobster*. This was the beginning of a deep personal and artistic relationship between Dove and Stieglitz that was to last throughout their lives.

Stieglitz and His Circle

Stieglitz's role in Dove's life was far more than that of a dealer. He provided the support and encouragement for Dove that was so lacking elsewhere in America. Stieglitz and Dove maintained a correspondence throughout the years that served as Dove's artistic lifeline. When asked what Stieglitz meant to him as an artist, Dove replied, "Everything... Because I value his opinion as one who has always known. I do not

think I could have existed as a painter without that super-encouragement and the battle he has fought day by day for twenty-five years. He is without a doubt the one who has done the most for art in America."[10]

Stieglitz's contribution to American art of the first quarter of the century cannot be overestimated. It was a time when American society was relatively indifferent to the existence of artists. As Dore Ashton has pointed out, the European vanguard artist could regard himself as part of the intelligentsia, as the enemy of the bourgeois and the upholder of intellectual criticism. American artists, on the other hand, were isolated both from their society and from each other. American artists, as de Kooning said, could never find a comfortable chair.[11]

Modern art was frequently dismissed as immoral, technically incompetent, unintelligible, a hoax, insane and a foreign conspiracy by the public and the art critics. Except for the conspiracy element, which was a peculiarly American phenomenon, these were the usual charges levied against modern art wherever it appeared.[12]

In addition to the problem of imposing a high art style on a democratic, pluralistic society, the American heritage itself hindered the acceptance of modern art. Still lingering was the Puritan suspicion of the sensuous side of existence and the feeling that making art was not useful work, either because it had traditionally been the province of women or because it was unremunerative and therefore of low status in a success-oriented culture. In an age that was oriented toward the material, toward "order" and toward "reason," the artists voiced a minority view in being dedicated to the intuitive and the spiritual. When Stieglitz suspended publication of *Camera Work* in 1917 there were only thirty-six subscribers.

In the face of an unresponsive public, Stieglitz's gallery was

the only center where artists could find the support and stimulation they so desperately needed. Playing a sheltering, patriarchal role, Stieglitz gave the artists a sense of belonging to a community. As Sherwood Anderson wrote in the dedication to *A Story Teller's Story*: "To Alfred Stieglitz, who has been more than father to so many puzzled, wistful children of the arts in the big, noisy, growing and groping America." It was at "291" that the artists first came into contact with the newest developments in Europe. It was here that the expatriates returning from France were encouraged to continue the experiments they had begun abroad.

"291," and all Stieglitz's subsequent galleries, were never galleries in the commercial sense. His objective was not to make money but to support artists and provide them with an opportunity to exhibit their work. No attempt was made to please the public or to explain the meaning of what was hung. Stieglitz never took a salary and indeed much of his own money went into the upkeep of the gallery. For payment he would take a painting from each show. If an artist was having a good year, part of what was received from sales would go toward the gallery. Dove, whose sales were low, often spoke of wishing he could do more for the gallery. His trust and love for Stieglitz were absolute; in April of 1916 he wrote "Treat them [the paintings] as though they were your own as you know you are welcome to any of them at any time to do with as you think best."

The Armory Show of 1913 provided little encouragement. It was more a *succès de scandale* than an occasion for artistic acclaim and acceptance. Although the show produced several converts like Duncan Phillips and Katherine Dreier and stimulated the opening of new galleries showing contemporary art, it did not win wide patronage for American art. The sentiments of the era were articulated in a statement made by the director of the Metropolitan Museum, Sir Purdon Clark: "There is a state of unrest all over the world in art as in all other things. It is the same in literature, as in music, in painting and in sculpture. And I dislike unrest."[13]

Although Stieglitz continued to exhibit European modernism after the Armory Show, he came to feel that his attention should concentrate on those artists that he respected in the United States. He said that he would do everything he could to protect them "not in the name of chauvinism, but because one's own children must come first."[14]

The enthusiasm that had existed at "291" gradually dissipated due to the war and in 1917 Stieglitz closed the gallery. In 1925 he opened The Intimate Gallery which was devoted to showing Seven Americans (Marin, Dove, Hartley, O'Keeffe, Stieglitz, Demuth, Strand) plus X, the unknown, "whoever that might be." Four years later it was necessary for Stieglitz to vacate this gallery because of rumors that the Anderson Galleries building in which The Intimate Gallery was located would soon be torn down. After the closing of the Gallery, Dorothy Norman organized a group of Stieglitz's friends and raised funds for a new gallery. This gallery, called An American Place, was opened in 1930 and ran until Stieglitz's death in 1946. It too acted as a center for those artists who had formed the nucleus of The Intimate Gallery.

The three artists that Stieglitz most fervently and consistently supported and to whom he felt the most responsibility were John Marin, Georgia O'Keeffe and Arthur Dove.

A close personal friendship and professional respect existed between O'Keeffe and Dove. O'Keeffe hung many of Dove's shows and bought his paintings. As she said, "I discovered Dove and picked him out before I was picked out and dis-

covered. Where did I see him? A reproduction in a book. The Eddy book I guess, a picture of fall leaves. Then I trekked the streets looking for others. In the Forum Exhibition there were two or three — then later there were more." Dove shared a similar personal commitment to O'Keeffe. The one work that was hung in Dove's houseboat, the *Mona,* was an early drawing by O'Keeffe.

Although Dove spoke highly of Marin's work in his letters to Stieglitz, the two were not close friends. It is possible that Stieglitz felt emotionally closer to Marin than to Dove. Stieglitz and Marin shared a flamboyance and an interest in the cult of personality which both O'Keeffe and Dove avoided. Although Stieglitz was committed to Dove as an artist and as a person, the serenity and sensuous feelings toward nature that were communicated in Dove's paintings were more foreign to Stieglitz than the frenetic activity suggested by Marin's brush-strokes. As Herbert Seligmann said, "For Stieglitz, Marin, as he grew, became more and more a symbol. In himself, Marin was the true, free, joyous and simple human being, whom it became a necessity to enable to live, as a flower is cared for, in a tree bearing fruit."[15]

Westport 1910-1920

Dove's son William was born on July 4, 1910 and the family went directly from the hospital to a farm in Westport, Connecticut. Here, Dove hoped to support his family and his painting by farming. Westport, a colony of artists, writers and illustrators, was populated, as one of its inhabitants, Van Wyck Brooks suggested, with "displaced New Yorkers... who lived beyond the suburbs but who remained urbanites at heart."[16] In addition to the local population like Brooks and Paul Rosenfeld, a variety of artists and writers from New York regularly made their way to Westport.

In 1912 Dove moved to a different farm, Beldon Pond, near Westport where he hoped to raise chickens and vegetables. Having chosen art above material comforts, money was a struggle that plagued him the rest of his life. However, as Dove was to write later, "really loving anything means the incapacity of doing anything else."

These years were difficult for Dove. A small farm, like any small business, runs on a low profit margin and the chance of disaster is always present. With the high price of eggs caused by a wartime economy, Dove managed to keep things going by working from 4 a.m. until midnight every day. He was even given an award by the Farm Board of the State of Connecticut for an efficiently run farm. The physical hardships and daily problems didn't leave much time for painting, however.

In hopes of alleviating this situation, Dove asked his father to help him with $100 a month. His father was evidently not only incapable of understanding Dove's need to paint, but his Victorian morality held that Dove's responsibility as a husband and father was to provide a comfortable life for his family. He was totally aghast when he saw Dove's first one-man exhibition. "No," he told Stieglitz, "I won't encourage this madness."[17]

In spite of these difficulties Dove produced a body of work in the first eighteen to twenty months in Westport that was not only a radical leap from his Impressionist style but which placed him in the forefront of American modernism.

Abstractions 1910

I am beginning more and more to see behind or, to put it better, through things, to see behind them something which they conceal, for the most part cunningly, with their outward appearance, by hoodwinking man with a facade which is different, which is quite different from what it actually covers.
Franz Marc, diary entry, 1914.

The advent of non-objective painting cannot be considered in isolation from the sum of ideas that evolved in the first part of the twentieth century. Art renders in visual terms the thoughts and feelings by which individuals conceive of themselves and their world. Non-objective painting was the expression of a radically different relationship between man and the visual world that became manifest in the early twentieth century. Recent scientific discoveries — the disintegration of the atom, Einstein's theory of relativity, Freud's theory of the unconscious, quantum physics — had shaken faith in the reality of the concrete, visible world. It had invalidated the concept that our sense perceptions of the external world yield up a true vision of "reality." Things themselves and their visual substances were no longer self-evident and unquestioned. Modern artists began shifting their attention from static objects to the dynamic forces behind them. They began seeking to transcend the veil of the visible world and penetrate to the more fundamental reality and universal constants behind surface appearances. It was in relationship to this new consciousness that artists like Dove began making non-representational art.

Sometime after the 1910 "Younger American Painters" exhibition Dove painted six small oil paintings which he called *Abstraction Numbers 1 through 6*. The six abstractions themselves are small in scale, with loose compositions and freely painted surfaces alternating between short brushstrokes and palette knife application. They were never shown during Dove's lifetime and it is possible that he considered them as studies for later work or as explorations of his then-evolving non-representational imagery. That the composition of *Abstraction No. 1*, for example, is almost directly translated into the later pastel *Connecticut River* reinforces this interpretation. Although they vary in the extent to which they eliminate direct references to the visual world, they all seem to ultimately derive their imagery from the landscape. They represent Dove's first attempt at abstracting from outside forms, and, as such, are more representational than his next group of paintings.

With the exception of *Abstraction No. 2*, the colors in these works are somber, close-harmonied, earth tones. In their emphasis on structuring through color, their tendency toward geometric abstraction and their overlapping planes, they are still related to the work of Cézanne. Simplification of shape and overlapping of planes in a shallow three-dimensional space characterized Dove's approach to composition for several decades.

In these paintings Dove began to abandon representational forms and to become absorbed in extracting the underlying essence of things, in rendering the invisible visible. To Stieglitz he said that feeling the spirit of the thing was not to be confused with merely setting down one's emotions about it: "Anybody should be able to feel a certain state and express it in

terms of paint or music. I do not mean feeling a certain way about something. That is taking an object or subject and liking certain things about it and setting down those things."[18]

Dove was concerned that these abstractions be concrete and independent experiences and not refer back to any other object for their meaning. He wanted the significance of the work of art to be inherent in the work itself. This involved eliminating the illustrative painting and replacing it with color-form relationships that were autonomous and complete within their own limits.

Then there was a search for a means of expression which did not depend upon representation. It should have order, size, intensity, spirit....If I could paint the part that goes to make the spirit of the painting and leave out all that just makes tons and tons of art.

I have always felt it is much better to...paint things that exist in themselves and do not carry the mind back to some object upon which they depend for their existence. We lean too heavily on nature. I would rather look at nature than to try to imitate it. In the same way I enjoy looking at a Greco, a Cézanne, or an African sculpture, but have no desire to do one and if we find at any time that we are depending too much on any one thing, we will also find that it is just that much that we have missed finding our own inner selves.

I would like to make something that is real in itself, that does not remind anyone of any other thing, and that does not have to be explained — like the letter A for instance.[19]

In his own writings Dove used the word "abstraction" to refer to what is usually defined as non-objective — that is, forms that do not relate to the objective or external world. He used the word "extraction" to refer to the process of distilling spirit or essence from the visual world. "There is no such thing as abstraction," he wrote. "It is extraction, gravitation toward a certain direction and minding your own business. . . ."[20]

To make a painting that did not depend on representation in 1910 was a radical step. On the continent, Kandinsky was beginning to formulate his theory of non-objective art although his actual paintings lagged behind his theoretical posture, and, at this point, still retained a definite landscape sense.[21]

Any formal resemblance between Dove's early abstractions and Kandinsky's work from this period may stem from their similar practice of abstracting from forms in nature and thus their mutual use of organic shapes that recall landscape forms. The first Kandinsky painting that Dove was likely to have seen was the one purchased by Stieglitz from the 1913 Armory Show and, by that time, Dove's abstract style had evolved into something quite different from Kandinsky's.

Although Kandinsky and Dove originally occupied similar positions, their concepts of non-representational art were to go in different directions. All of Dove's compositions, however abstract, were derived from the external world. He never sought out objects or forms that were equivalent to purely subjective states. The outer world always provided his most vital source of forms. Kandinsky, on the other hand, believed that painting *should* objectify inner states through form and color relationships.

It is revealing to note the different orientation in color theory in Dove and Kandinsky. From Kandinsky's point of view, color evoked psychic reactions in the observer and had

Abstraction Nos. 1, 4, 2, 5. 1910.
Oil on composition board, each 8⅜″ x 10½″
Mr. and Mrs. George Perutz, Dallas, Texas

17

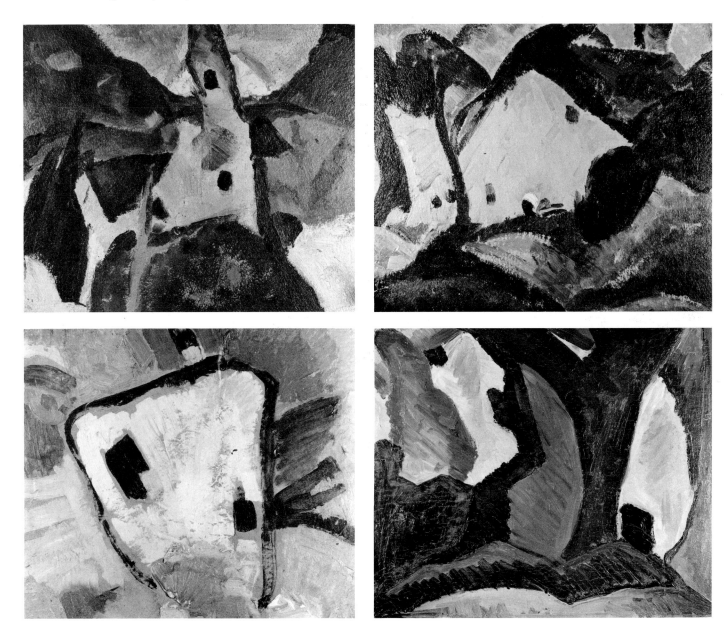

The Lobster. 1908.
Oil on canvas, 26″ x 32″
Mr. and Mrs. Hubbard H. Cobb

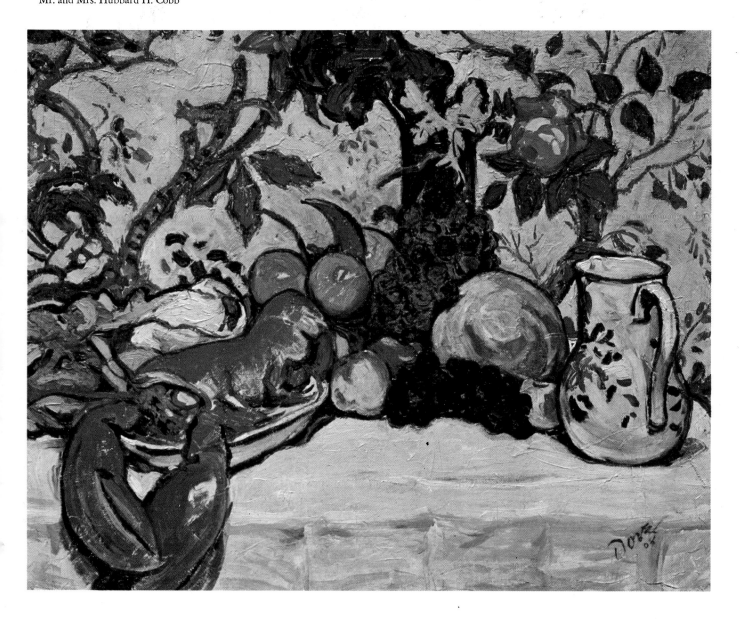

Abstraction No. 3. 1910.
Oil on composition board, 8⅜″ x 10½″
Private collection

19

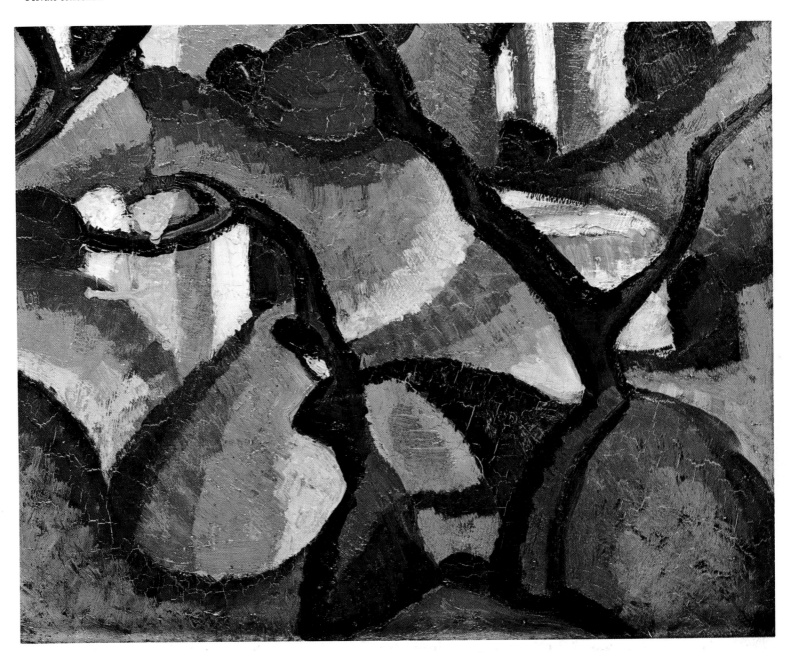

the emotional power to directly influence the human soul. Kandinsky ascribed symbolic meanings to colors much as had been done in Medieval heraldry. Pure green, for example, was "the most restful color, lacking any undertone of joy, grief, or passion"; red had an "unbound warmth"; brown was "unemotional, disinclined to movement."[22] Just as in music, however, where major and minor modes are not endowed with characteristics that call forth identical reactions in different listeners, no direct parallels have been established between Kandinsky's color associations and the observer's emotional reaction. What is interesting, in relation to Dove, is that Kandinsky was concerned with the psychic effect of color, whereas Dove used color as a means of capturing what he called "truths" or essences.

Kandinsky's orientation appears similar to other European thinking, especially to T. S. Eliot's theory of the "objective-correlative" — an object or set of objects which is equivalent or correlates to the artist's emotional state and which will evoke a similar state in the viewer. Stieglitz, born here but educated in Europe, made photographs of "Equivalents" later in the century which reflected a similar philosophical viewpoint. "What is of greatest importance," he said, "is to hold a moment, to record something so completely that those who see it will relive an equivalent of what has been expressed.... Shapes, as such, do not interest me unless they happen to be outer equivalents of something already taking form within me." Similar to this is the statement by Picabia, active at "291" by 1913, that the new expression in art tended toward subjectivity but needed objects to communicate what he called "the objectivity of a subjectivity." He felt that he did not want to reproduce objects in nature but to "render external an internal state of mind or feeling."

Dove's orientation directly from experience to the abstract places him within a tradition that has been so continuous as to almost constitute *the* American tradition. The identification of moral and ethical truth with the bare facts of experience that was implicit in Pragmatism, the only philosophic system developed exclusively by Americans, has been, in a sense, the defining character of the American mind. Like the writers James, Poe, Melville and Stein, Dove believed that general conclusions are realized in their particular manifestations. Hutchins Hapgood, writing in *The Globe and Commercial Advertiser*, related a crisis that had apparently hit Dove early in his career. In 1913 Dove announced to Stieglitz that his line had gone dead and attributed this to his having tried to work with pure form. He felt that only by going back to nature and rooting his art in experience could he keep it alive.[23]

Pastels 1911-1920

In 1912 Dove had his first one-man exhibition at "291" which constituted his first major public exposure. He included ten pastels to which he gave the generic title *The Ten Commandments* along with some paintings in his older Impressionist style. Stieglitz's statement, "So the pictures went up, and,

of course they were over the heads of the people.... They were beautiful, they were not reminiscent of any one else," was to be true of Dove throughout his career.[24] As the only American artist to have developed his own non-representational style before the Armory Show, Dove became a symbol of deranged modernism in the eyes of the American public. When the exhibition moved to the Thurber Galleries in Chicago, it created even more notoriety. Dove was decried as "John the Baptist" and students at the Art Institute made effigy dolls of him which they ritualistically stuck with pins.

Which ten paintings actually constituted this group is by now conjecture. Known collectively as *The Ten Commandments*, the pastels were shown without individual titles and no precise records of the exhibition were kept. Several of the paintings were later shown in Stieglitz's 1916 Forum Exhibition under the generic title *Nature Symbolized* and others acquired specific titles or were referred to at different times by various designations.

Titles were never terribly important to Dove. As he was reported to have said in Chicago during his Thurber Gallery exhibition, "I don't like titles for these pictures, because they should tell their own story."[25] Although some paintings were titled after the locale or object which they were drawn from, Dove would often title his paintings by the color motifs that were used in their execution. Sometimes the title had nothing to do with the subject matter of the painting: "That's no feather pillow," for example, was an exclamation that a friend uttered upon seeing what was henceforth called *No Feather Pillow,* and *Alfie's Delight* was a painting that Alfy Maurer especially liked. Stieglitz often changed titles after a painting had arrived at the gallery, as he had done in the case of *The Ten Commandments* and *Nature Symbolized.* All of this makes tracking the history of specific paintings difficult, and especially frustrating in the case of *The Ten Commandments.*

Dove turned to pastels in his more realized group of works because the texture of pastels gave the paintings a deeper, more velvety quality than would have been possible with oils. Their chalky quality and soft edges conveyed a sense of atmospheric depth, which directed the viewer's attention into the pictorial space.

As compositions, *The Ten Commandments* were tighter and more stylized than Dove's preceding abstractions. They were ordered on a principle of repetition of similar shapes. This repetition of radiating, circular motifs centered the spectator's attention. Like the Futurists who claimed in their "Technical Manifesto" that their goal in organizing a painting was "to put the spectator into the center of the picture,"[26] Dove was seeking, through formal means, an involvement of the viewer with the work.

Shapes were either saw-toothed or swelling and organic. The stylized, curvilinear quality of the paintings prefigured what would be called Art Deco in the twenties and thirties. Like the earlier abstractions, the forms existed as flat planes which overlapped in a fairly shallow three-dimensional space. The swelling, rounded curves that would be typical of Dove's ensuing work projected a condition of nurturance between man and the world.

Forms coincided with color areas and were clearly defined by the use of dark perimeter lines which recalled the accentuated outlines of Matisse and Gauguin. In his letter to Arthur Jerome Eddy, Dove called these lines the "character lines" of an object and spoke of their being determined by the meeting or intersection of planes of color. They, in effect, followed the outer edges of planes and gave a sense of dimension to

Team of Horses. 1911.
Pastel on linen, 18½″ x 21½″
Mary B. Holt, M.D., Bay Shore, New York

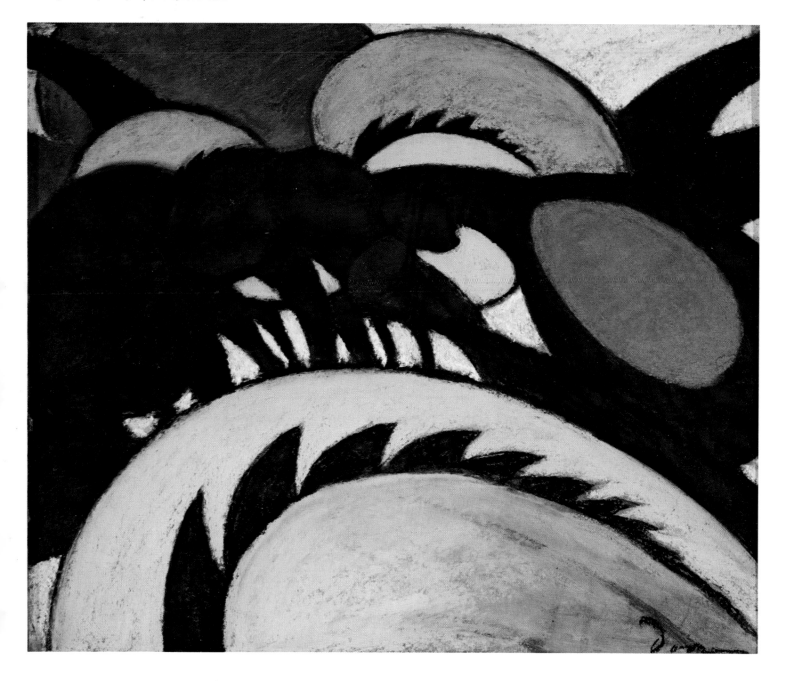

Nature Symbolized No. 2. 1914.
Pastel on linen, 18″ x 21⅝″
The Art Institute of Chicago, Alfred Stieglitz Collection

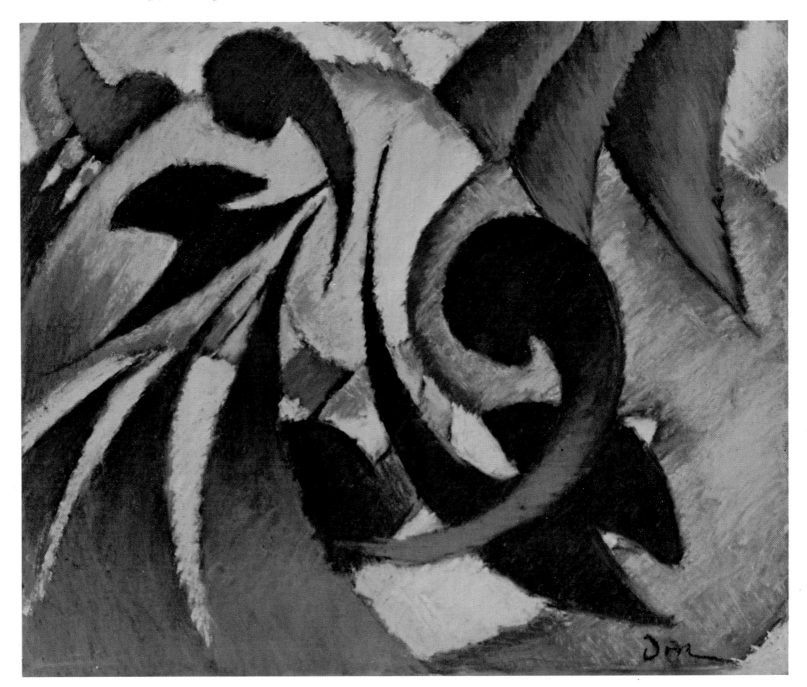

the forms. Although initially the identifying form of the object was expressed by flat planes and character lines, it was later defined by what Dove called "force lines" or "growth lines." Unlike character lines, force lines referred to the energy or inner structure of objects.

During this period many of Dove's painting theories were shared by the Futurists. As a term, "force lines," comes originally from the Futurists' vocabulary and suggests dynamic energy and movement which suited the rapid industrialization of this country. Dove was not the only American artist of this period to reflect the Futurist influence. Max Weber, Joseph Stella, Lyonel Feininger, John Covert, John Marin, and Charles Demuth all incorporate the angular force lines of the Futurists in their work. Perhaps the Futurists' enthusiastic proclamations of a new civilization corresponded to the idealistic spirit of the early American modernists and the energy of reform and change that shaped the Progressive era. In any case, the impact of Futurism was much stronger in America than that of Cubism which was perhaps too rational to appeal to the American sensitivity at that time. In contrast to other American artists who drew only compositional principles from the Futurists, Dove responded to their empathetic identification with a world of objects and their denial of stasis.

Dove felt that no object can be seen in isolation but absorbs its surroundings just as it contributes to them. He depicted this interplay between the object and its environment by dissolving isolated objects in a holistic totality. Figure and ground are completely interlocked through a system of interpenetrating forms, repeated shapes and overall color and textural similarities. A similar fusion between the object and its environment had been depicted by the Impressionists with their complex, broken color. It was extended by the Futurists to the very forms of objects. The Futurists looked upon objects as embodying a kind of motion that moves outward in space mingling its rhythms with those of other objects and eventually merging with space itself. As their Manifesto stated: "Our bodies enter into the divans on which we sit, the divans enter into us; just as the train going by enters the houses, and they in turn hurl themselves upon the train and merge with it."[27]

Of the philosophers who have questioned the reality of the concrete object, Dove felt the most affinity to Henri Bergson who believed that there are no such things as definite, isolated objects. Instead, there are only intimations of objects within the continuous flux of color and form that we perceive. Bergson felt that movement was the essential constituent of reality. "There are movements," he wrote, "but there is no inert or invariable object which moves: movement does not imply a mobile...What we call immobility is a certain state of things analogous to that produced when two trains move at the same speed, in the same direction, on parallel tracks: each of the two trains is then immovable to the travelers seated in the other."[28] Our eyes have developed the habit of separating figures in the visual field which we perceive as changing place but not changing form. In fact, the continuous movements of life changes the shapes of "objects" quite as much as light does.

Dove saw the character of the world in the movement of life rather than in the stasis of things. "When a stream of water is running," he said, "there is no regular rhythm but the stream is doing the same thing all the time."[29] Contemporary scientific discoveries in the field of quantum physics reinforced the notion that objects, perceived as solid forms, are not static but are constantly in motion at the atomic level. This new physics described all mass as interpenetrating without discrete boundaries.

Cow. 1911.
Pastel on linen, 17¾" x 21½"
The Metropolitan Museum of Art, Alfred Stieglitz Collection

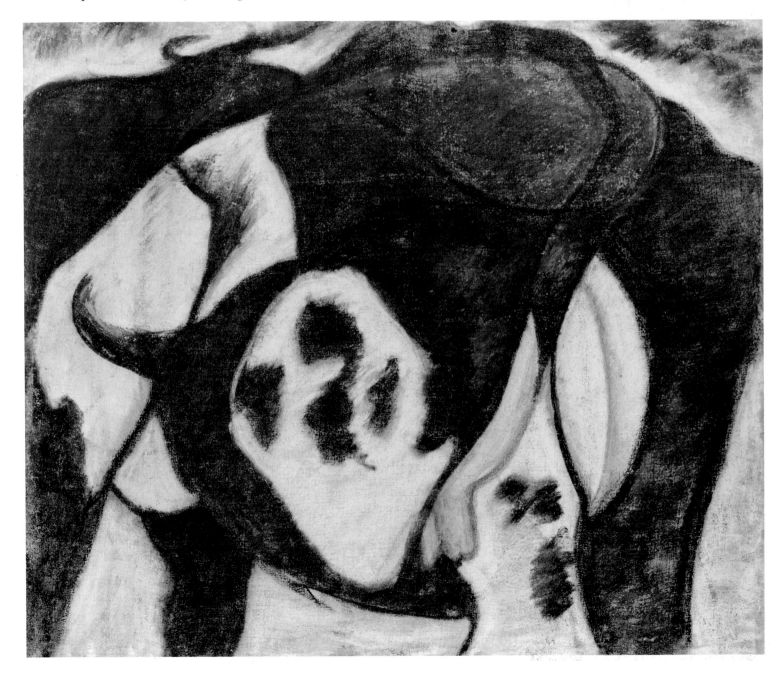

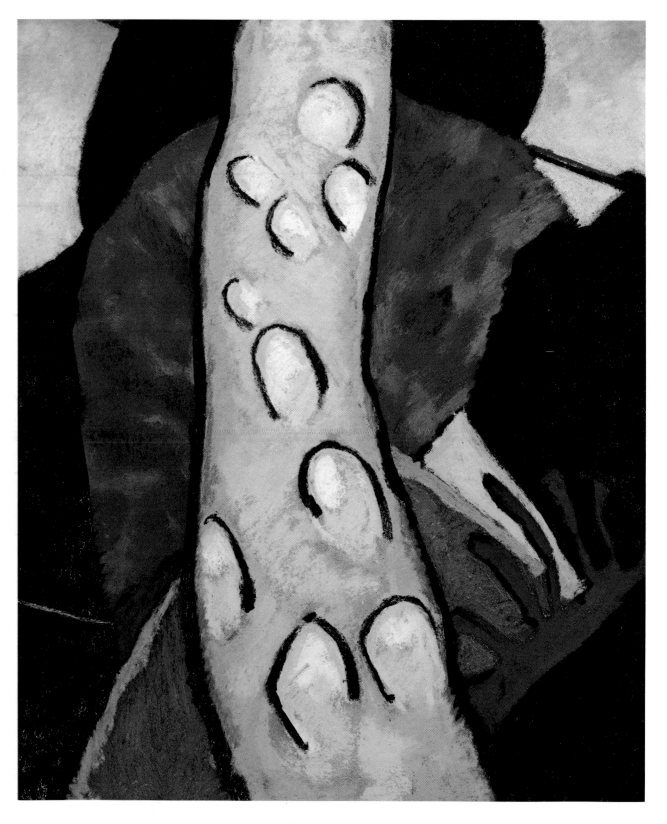

A Walk Poplars. 1920.
Pastel on linen, 20¾" x 17½"
William Zierler Gallery, New York

Connecticut River. 1911–1912.
Pastel on linen, 17¾″ x 21¼″
William Zierler Gallery, New York

27

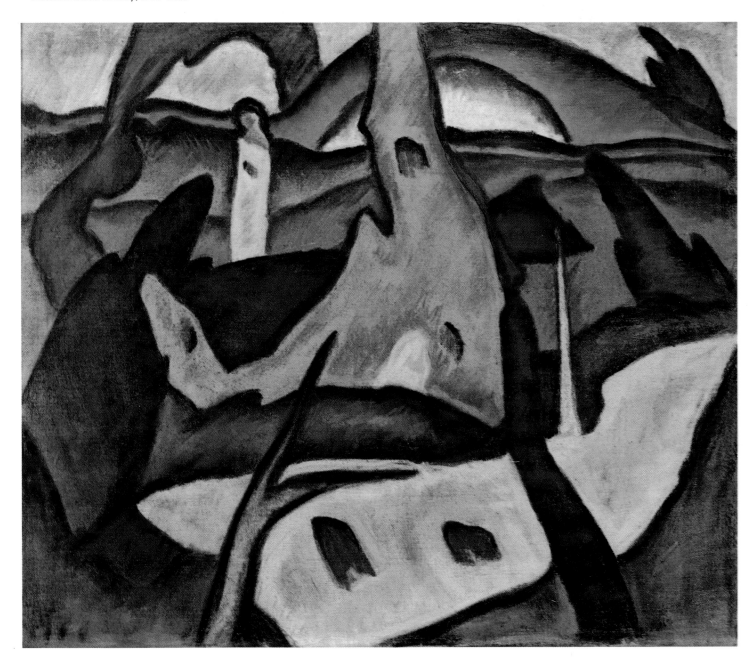

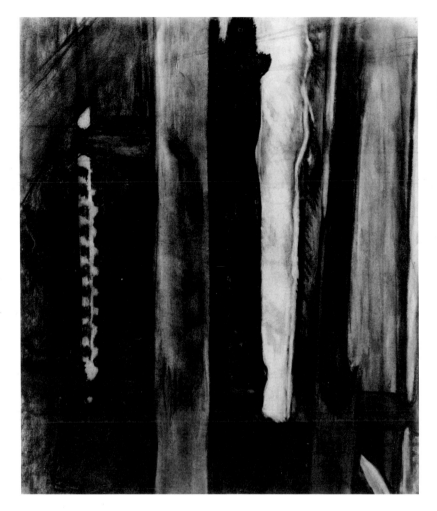

Barn Interior No. 2. c. 1917.
Charcoal on paper, 20½″ x 17½″
Private Collection

Dove captured this philosophy of dynamism in his pastels through overlapping and interpenetrating planes, and by modeling his forms from dark to light so that they seemed to pulsate with a luminous energy. Since the Renaissance, time has been represented in paintings as frozen, as if it were standing still. Through repetitions of the same form in one picture, Dove depicted the object as it moved through space and thus through time. He captured the simultaneous rather than the sequential aspect of time by telescoping time in one picture rather than representing it in separate pictures.

Dove said, "You see that forms repeat themselves in various phases of light, and that convolutions of form are the result of reflections in nature." This idea was similar to the Impres-

sionist premise that forms change under various light conditions. In an attempt to capture fleeting moments of life, Claude Monet painted the Rouen Cathedral over and over again under different light conditions. Rather than separating out these passing moments, Dove depicted them simultaneously in one painting, thus visually representing Bergson's concept of time as a continuous duration that cannot be divided up into "before" and "afters."

It was also in this period that Dove first experimented with synaesthesia, the process by which one type of stimulus produces a secondary, subjective sensation, as when, for example, a specific color evokes a sense of smell. The theory of synaesthesia was promoted by the Symbolist poets who experi-

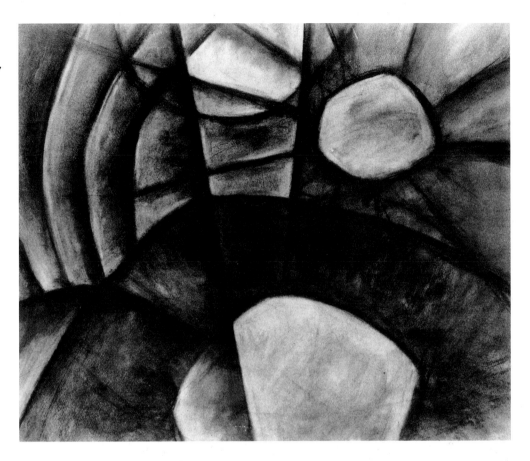

Sun on Water. 1917-1920.
Charcoal on paper, 17″ x 20½″
Michael Scharf, New York

mented with verbal metaphor as a means of layering or intensifying all of the senses. Dove's interest in synaesthesia generated several paintings which were visual equivalents of sound. *Music* (1913), *Sentimental Music* (1917) and *Chinese Music* (1923) are musical compositions that have been translated into visual terms through color and line. This endeavor continued beyond the pastel period in such works as *George Gershwin's "Rhapsody in Blue" Part I* (1927) which Dove painted while listening to that music. *Fog Horns* (1927) depicts the sound of horns blurred by the fog rather than the horns themselves.

Throughout the decade, Dove continued to work in the style that had characterized *The Ten Commandments* of 1912.

The black and white charcoal drawings from this period are compositionally and philosophically related to these pastels as well as to certain black and white paintings by the Futurist Giacomo Balla. Dove's *Nature Symbolized* series, which was shown in the 1916 Forum Exhibition, was so stylistically similar to *The Ten Commandments* that several paintings from this earlier group were included in the 1916 Forum Exhibition. Dove did not exhibit another major group of new works until his 1926 exhibition at Stieglitz's Intimate Gallery. Given the demands of the farm, the paucity of his production in these years is not surprising. In 1917 he wrote to Stieglitz: "I hope to be painting again by the first of June, if things are no worse, but the future for anything doesn't look bright."[30]

Plant Forms. 1915.
Pastel on linen, 17¼″ x 23⅞″
Whitney Museum of American Art, New York
Gift of Mr. and Mrs. Roy R. Neuberger

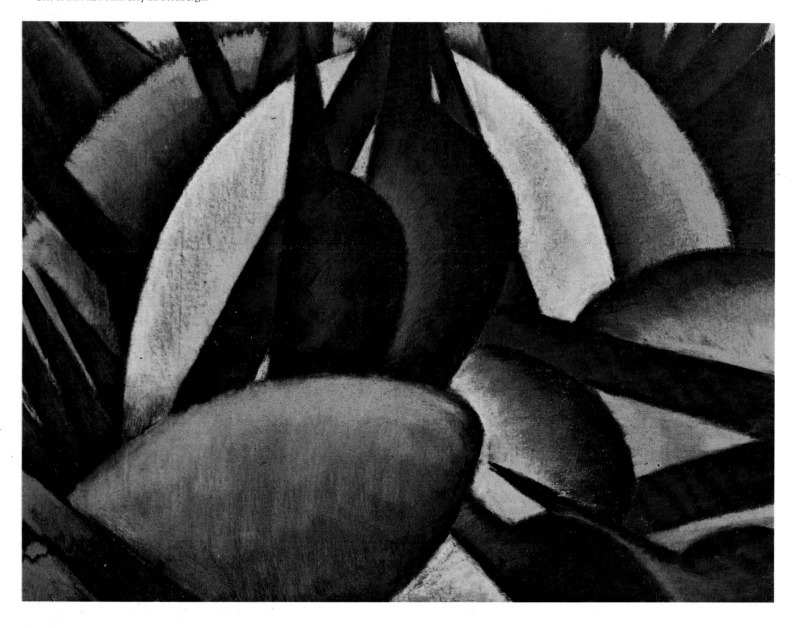

Spirit of the Second Decade

The intellectual community during the second decade of the century partook of a common consciousness to which Dove subscribed. The central goal of intellectuals during this period was the creation of a new civilization, a new culture. A militant idealism and enthusiasm for change and reform characterized the era. It was a time when everything seemed possible to the human spirit.

These utopian attitudes were not limited to the United States: Kandinsky spoke of painting as an assertion of inner values that would help to overcome materialism; Die Brücke and the Futurist manifestoes sounded the call for revolutionaries and creative people to join them in establishing a spiritually more meaningful future.

In the American political arena, the progressive enthusiasm of the decade was identified with the rise of organized labor, the establishment of the International Workers of the World, and the passage of the women's suffrage amendment.

It was an era oriented toward the individual rather than society, with newly founded idealism and faith in the potential of the individual rather than the collective. Progressivism focused on the moral reformation of the individual and viewed politics simply as a vehicle with which to improve the tone and quality of people's private lives. Slowly the old belief that group life could be equitable enough to nurture individual creativity was replaced by the hope that the liberated individual would reform the group.

The art community shared a general messianic preoccupation with reinstating feeling and instinct in the human experience. Intellectuals realized the importance of feeling in the development of the integrated person. They also recognized that Victorian morality, dependent on the triumph of the mind over the body, was responsible for a complex system of standards that fragmented the individual. True integration and fulfillment of the individual would come about through the cultivation of the senses and emotional responses that had hitherto been suppressed. The intellectuals felt that modern man had grown "out of touch" with himself by relying too heavily on rational logic, and that the learned and the traditional had come between him and his own experience.

D. H. Lawrence, one of the writers most admired by the artists gathered at "291," was one of the strongest voices crusading for the liberation of the instinctual life. Critics such as Benjamin de Casseres and Marius de Zayas, whose writings appeared often in *Camera Work*, waged a revolt against the suffocating limitations of logical thought by proclaiming the value of disorder and unreason. The emotional, impressionistic writing style that characterized this period can partially be explained by the orientation of its best and brightest minds toward feeling and against reason. The most pervasive art jargon was apparently the word "felt," with value and status attributed to those things and individuals that were the most "felt."

The championing of intuition was neither a wholly modern idea nor was it limited to the United States. It was inherent in

Westport. 1920.
Pastel, 8½″ x 10½″
Private Collection

the romanticism of the nineteenth century and the cult of individuals outside "rational" society — the uncivilized or primitive, the child, the insane. It was particularly manifested in the early twentieth century by Futurism and German Expressionism and later by Surrealism and Dadaism. An exhibition of paintings by children at "291" in 1912 was an aspect of this embrace of the uncorrupted and liberated individual.

What the intellectuals sought in effect was a recognition that there were different ways of perceiving the world from the ones generally accepted. As Gertrude Stein noted, "People really do not change from one generation to another ... indeed nothing changes from one generation to another except the things seen and the things seen make that generation, that is to say nothing changes in people from one generation to another except the way of seeing and being seen...." What the intellectuals of the 1910s were seeking was a change in consciousness, a change in "the way of seeing and being seen."

Dove's personal philosophy of the value of the intuition found a parallel in the thinking of Henri Bergson. Bergson felt that there were two ways of apprehending the world — intellectually and intuitively.[31] The intellectual mode dealt with external, spatial objects but missed the more fundamental core of life. Intuition, on the other hand, had the potential of a direct perception of the inner being of the thing itself. Through intuition the mind could reach beyond rational contemplation to an empathetic identification with the spirit of the object. It was through intuition and not analysis that one could transcend the facts of outward appearance.

"... An absolute," Bergson wrote, "can only be given in an *intuition*, while all the rest [of our knowledge] has to do with *analysis*. We call intuition here the *sympathy* by which one is transported into the interior of an object in order to coincide with what there is unique and consequently inexpressible in it. Analysis, on the contrary, is the operation which reduces the object to elements already known, that is, common to that object and to others. Analyzing them consists of expressing a thing in terms of what is not it."[32] Knowing about a thing was not what was important; what was important was moving oneself into the thing in order to reach its spirit.

This relates directly to the theory of empathy that was developed at the turn of the century by the German philosopher Theodor Lipps. Empathy was the metaphyical concept of the subject existing in the object: "The first principle of empathy is this, that when I observe a form I am within it. And, if empathy is complete, I am *completely* in the form I observe. In empathy then, I am not the real self, but am inwardly separated from it, i.e., I am separated from everything that is tangential to my observation of the form...."[33] As with Bergson, the proponents of empathy believed that esthetic experience resulted from a fusing of subject and object rather than from analysis.

In Europe, a number of painters with varying viewpoints expressed a similar desire to reject objective analysis and to identify emotionally with the external world. About the Futurists, Boccioni wrote, "we do not want to observe, dissect and translate into images — we identify ourselves with the thing which is profoundly different."[34] "We Futurists," said Carrà, "strive with the force of intuition to insert ourselves into the midst of things in such a fashion that our 'self' forms a single complex with their identities."[35] A similar sentiment is echoed again and again in the writings of the German Expressionists, particularly Franz Marc who said, "I try to heighten my feeling for the organic rhythm of all things, try to feel myself pantheistically into the trembling and flow of the blood of nature."[36]

Dove believed that thinking or reason sets up a duality — a division between the "I" that is looking and the subject that is being observed. Only in a non-analytic state where one is transported beyond a sense of ego, beyond the context of one's personal needs and desires and beyond analytical categorizing, can one truly "see" the object. As Stieglitz said, "When I am no longer thinking but merely am, then I may be said to be truly living, to be truly affirming life. Not to know, but to let exist what is, that alone, perhaps, is truly to know."[37]

Abstract art was difficult for the early 20th century audience to accept because materialism and its way of seeing had dominated American life for so long. Individuals had placed so much emphasis on the exterior world that they had stopped experiencing. Intellectually, they labelled and categorized situations or objects they encountered without ever really experiencing them. A representational work of art was acceptable because the objects in it could be recognized and labelled. Abstract art, however, since it was not composed of recognizable objects, had to be simply experienced. As John Marin said, "abstraction is *seeing*, realism is cerebral."

In art, things could be understood by direct apprehension before they were "named" and thus became separate entities. Dove felt that direct communication took place on a primarily visual or preverbal level. In noting that one could understand all the facts about an object and miss its essence he wrote, "truth does not get so important as the whole." Art was a way of communicating those things that could not be adequately expressed in words. The intellect, Bergson said, was man's tool for rationalization but art "has no other object than to brush aside the utilitarian systems, the conventional and socially accepted generalities, in short, everything that veils reality from us, in order to bring us face to face with reality itself." "It is

our instincts that have form," Dove wrote, "not our thoughts." Abstract art, which conveyed "feeling" as opposed to subject matter, was thought of as a vehicle by which people could get back in touch with their intuitive side. Since it appealed to the non-rational faculties, abstract art came to be viewed as a symbol of liberation from the limitations of reason.

Since art represented a reality that had to be experienced, its significance could not be described in words. It would be like asking someone to explain the experience of a sunset or love, or to describe why one liked the taste of clams, as Stieglitz once did of a viewer. Stieglitz's absolute unwillingness to explain an artist's work to an often bewildered public was notorious. He felt that the moment one tried to fit a work into a theory or to derive a theory from it, one betrayed it. "You will find," he said, "as you go through life that if you ask what a thing means, a picture, or music, or whatever, you may learn something about the people you ask, but as for learning *about* the thing you seek to *know*, you will have to sense it in the end through your own experience, so that you had better save your energy and not go through the world asking what cannot be communicated in words. If the artist could describe in words what he does then he would never have created it."[38] As Dove wrote in the 1916 Forum Exhibition catalogue, "Theories have been outgrown, the means is disappearing, the reality of the sensation alone remains. It is *that* in its essence which I wish to set down. It should be a delightful adventure. My wish is to work so unassailably that one could let one's worst instincts go unanalyzed." Stieglitz reiterated this by saying, "we insist on remaining relaxed and not theorizing."

Although Stieglitz and the group of artists and writers that met with him for Saturday night dinner professed not to be involved with theory, these evenings were filled with a great

deal of rhetoric. Due to Dove's physical distance from the city and his very real conviction that, as he observed, "too many thoughts spoil an idea," he did not participate in the art talk around the gallery. On one occasion after he and Alfy Maurer had been discussing modern art, Dove wrote, "Will tell Stieglitz if I have a chance. If it is discussed in the gallery too much by the intellectuals it will be called a 'theory' or a 'system'."

A corollary to the emphasis on direct experience was the emphasis on the present moment. The past and the future were only intellectual remembrances or anticipations that drew one's energy and focus from the present. Stieglitz was quoted as saying, "I am the moment. I am the moment with all of me and anyone is free to be the moment with me. I want nothing from anyone. I have no theory about what the moment should bring. I am not attempting to be in more than one place at a time. I am merely the moment with all of me."[39] It was as if nothing could be known or was, in a sense, real, but the experience of the now.

Dove, too, wrote over and over again of the importance of the concrete moment. "... to choose between here and there," he said, "I should say here. The recent philosophy and fiction also tend to strengthen that idea.... It seems to me to be the healthiest idea that has come from modern painting, or life, if you could define 'health' or 'modern'."[40] This concern with the directness of concrete experience, one of the main tenets of American Pragmatism, was a generally accepted attitude and was frequently mentioned during this period. In *A Story Teller's Story* Sherwood Anderson wrote, "I have come to think that the true history of life is but a history of moments. It is only at rare moments that we live."

The American attitude toward time had been expressed as the "continuous present" in the writings of Gertrude Stein. Stein was interested in the integrity and uniqueness of the "thing seen at the moment it is seen." She felt that the spirit and rhythm of the present had to be continuously sustained in literature against the intrusions of the past. "Being is not remembering," she wrote in *What Are Masterpieces*, disclaiming the importance of the past. Stein found this ability to respond with immediacy to the moment to be rooted in the geography of America. In *Lectures in America* she observed that if one has space, one is less likely to rely on precedent, tradition, intellect, and the contrivances of "daily living" and is more inclined to take experience for what it is.

Long Island 1920-1933

Dove was sensitive to the emotional effect that places or people have on the psyche. He felt that places and people either harmonized or "neutralized" one's inner nature and that individuals should be aware of which situations increase or sap the power of their inner spirit. "Some people, some places, some things" he wrote, "have a color condition which runs all through them — put them in certain lights and their spirit becomes neutralized — that is evident when individuals come together — they either harmonize or do not. If only the man who has the audacity to harness people together for life could see what some gifted individuals see."

The difficulty of accepting the disharmony with someone you care for is great. In 1920 Dove acknowledged the failure

of his marriage and he and his wife Florence separated. Florence, having come from a conservative, upper middle class background, had not been prepared for the harshness and financial difficulties of living on a farm. She found it difficult to understand Dove's need to paint and to be close to nature. After the separation, Florence stayed in Westport with their son William. Here, with another Westport resident, she opened a hotel-restaurant called the Manor House. It was apparently a successful venture, as Dove mentioned in a letter to Stieglitz that one month they had taken in $1,000. Relations between Dove and Florence were strained after the separation and Florence never granted Dove a divorce.

While in Westport Dove had met a painter, Helen Torr (Weed) who had moved to Westport around 1919 with her husband Clive. The affinity between Helen Torr, or Reds as she was called, and Dove, both as artists and as people, was unquestionable. They had met in Westport and had fallen very much in love. In 1920 they began living together on a houseboat on the Harlem River. Their life together was one of mutual support and understanding; they were inseparable and deeply committed to each other. "This unity of interest," Dove wrote, "is marvelous, so we are very happy."[41]

In 1923 they were able to buy a forty-two-foot auxiliary yawl named "Mona" which was their home for the next seven years. As Reds explained, "We bought the yawl for two reasons: first, we had very little money to waste because paint, canvas and other equipment were so expensive. Then, we liked boats. Arthur was crazy about the water."

They cruised Long Island Sound and its various harbors, mooring in the winter at Halesite, near Huntington Harbor. Living quarters on the boat were cramped. The Mona was five feet-ten inches at its highest point, so neither of them could stand erect when painting. The tiny cabin held a shipmate stove (which served as both stove and heater) and very little else. Georgia O'Keeffe recalls visiting them and having the choice of sitting on the pot-bellied stove or on their one chair.

Life on the boat was strenuous. Winters were cold and the boat needed Dove's constant attention. In a letter to Stieglitz, Dove wrote that it was so cold "one has to work fast to get time to work between stoking [the fire]." In another letter he described a storm aboard the Mona:

> It is now 3:45 AM in the midst of a terrific gale and we are anchored in the middle of Manhasset Bay held by a ¾ inch line run through a shackle to a mooring. We have been fairly pounding the bottom out of the boat for 24 hours and just hoping that line will have the decency not to cut through. Sheets of rain drive across the cabin roof and we are taking turns at watch and nursing a light fire in our stove until morning on a small pail of charcoal. Life has seemed this way for the last month. So full of contrasts that even they become somewhat monotonous. We think we would like a little rest for a few days — by that I mean a chance to paint.
>
> We left Thursday at 7 AM and by the time we were well out in the Hudson that storm which you may have read of overtook us and we could not make headway against it and the tide so went with it until we made in behind the lighthouse at Ft. Washington 172 St. Pounded there all day and night and rewired the engine to be sure there was no leakage. Needed full power to get around the Battery the next day. Well, we made it, but felt a trifle as though we were

creeping through 42 St. on a kiddie car. This boat is no speed demon. The ferrys, tugboats, etc., were very considerate — hardly noticed our efforts to keep out of their way.

They make about 15 miles an hour so suppose our four didn't seem so important to them as it did to us.

The engine held until we were in the East River at Brooklyn Bridge. After two hours of being hurled against a canal boat in a slip where we tied, found the trouble in a water valve that had stuck and heated up the cylinders. Also climbed the mast, fixed loose rigging and a bob stay under the boat that had broken — we made time in Hellgate as the current runs at about 5 miles and things fairly flew by. We made the Sound and this bay just as things started up again ...

Have been trying to memorize this storm all day so that I can paint it. Storm green and storm grey. It has been too dark and nerve-strained to paint so did three illustrations this morning just to keep from cutting the rope through by thinking so hard about it.

Was afraid Reds might not be able to stand the rough seas. She has been a wonder. Really has done the work of a sailor. This unity of interest is marvelous, so we are very happy ...

Will probably stay here ... until the weather is fit to go back ...

The storm seems to be letting up a little. I hope it will stay that way ... [42]

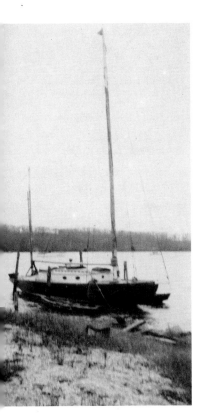

Mona, the 42-foot yawl on which Dove and Reds lived for 7 years

Financial pressures constantly plagued them. Dove took up illustrating again but developed an increasing antipathy for it.

He would work as an illustrator for enough months to make a living and then produce his serious paintings in a feverish spurt before his yearly exhibition.

Dove's only financial support during these years came from Duncan Phillips, whose purchase of *Waterfall* from Dove's 1926 one-man exhibition at the Intimate Gallery began a life-long commitment to Dove. By 1930 Phillips was sending Dove a guaranteed annual payment of $1,000 in exchange for his choice of paintings from Dove's yearly exhibitions. This steady though meager income was crucial to Dove's survival, especially during the Depression years. Although Dove had been receiving a warm response from the reviewers, there were few sales other than those to Phillips. As the most consistently abstract of Stieglitz's artists, Dove remained, as Stieglitz had commented when *The Ten Commandments* were hung, "over the heads of the people." At a time when John Marin's watercolors were selling for $4,000–$6,000, Dove's paintings were priced at $700 and $900.

Despite the difficulties, Dove's letters to Stieglitz during this period were full of hope. In 1921 Dove wrote, "So many things nice and otherwise have happened that I have been trying to put them all into action. Consequently have not written and have five or six drawings or paintings that are almost self-portraits, in spite of their having been done from outside things. They seem (to me) more real than anything yet. It is great to be at it again, feel more like a person than I have in years. Trying to develop an ego — purple or red. I don't know which yet. Think that is what has been lacking. You will understand. At any rate it must be done in spite of everything." [43]

In the winter of 1928-1929 Dove and Reds accepted an offer by Mr. Pratt, a friend of Duncan Phillips, to live in one

Dove, Ketewomoke Yacht Club, Halesite

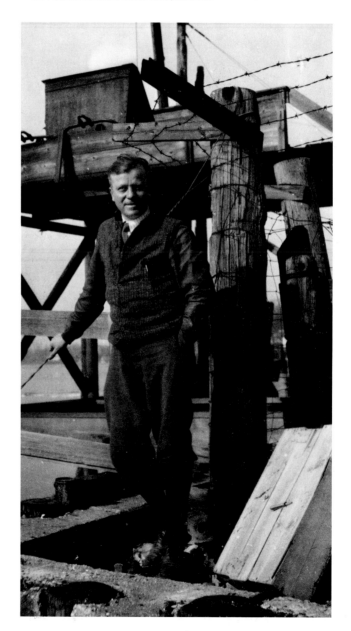

of his houses in exchange for being winter caretakers. The house was one of several located across the sound on Pratt's Islands near Noroton, Connecticut.

The following spring they moved into the second floor of the Ketewomoke Yacht Club in Halesite where they remained until 1933. Rent was free in exchange for taking care of the boats moored there and giving a party for yacht club members once a year. As Dove explained to Stieglitz, "Well, we are back here. It is much bigger country here on the whole and we are feeling more at home if that is possible. I wrote the secretary of this little yacht club here and offered them $5 a month for the top floor which is practically unused except for occasional dances. They called a meeting and gave us the top floor and use of the rest rent free just to have someone there. The room is full of light about 30' x 40'. A bedroom off toilet lavoratory, etc., gas and electricity and a wonderful view of the whole harbor. So our wish for a house on a dock where we could tie (up our) boat has come true. And we think it will work out for winter, too. Have been enclosing stairway doing floors, etc."[44]

In 1929 Florence, Dove's first wife, died and he and Reds, who had divorced Clive Weed in the meantime, were finally able to marry. Their wedding day was evidently fairly un-eventful — they took the train into New York and had the ceremony performed by a city justice of the peace. On the way home they stopped in Huntington and opened a joint checking account. "We liked that," as Reds wrote in her diary.

The stock market crashed in 1929. Illustrating jobs became fewer and fewer. Commissions were so non-existent that by 1930 Dove had ceased even making the rounds of magazine offices in New York to look for jobs. His letters from this period conveyed their sense of financial desperation:

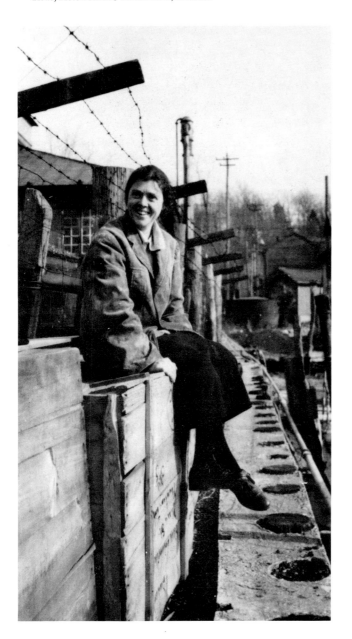

Reds, Ketewomoke Yacht Club, Halesite

39

"Can stick it out for another week and then if neither Phillips nor Paul can do anything the food stops. Suppose a grown up person of fifty is a damn fool to like such chances but that seems to be the kind of one I am. Have done it so long that it does not interfere with work quite as much as it used to. Reds is a grand help at that."[45]

"Mother speaks of sending Reds some jewels to keep as family treasures instead of any money for Christmas. A bag of wheat would be far more interesting than jewels on Christmas."[46]

"If anything comes up would be glad to take anything edible for paintings at any value."[47]

Dove's paintings during the 1920-1929 period were stylistically more diversified than at any other time in his life and referred back to issues that he had dealt with in the pastels, or anticipated the swelling, circular motifs that he would develop in the thirties. The line motif, with which Dove expressed the inner structure of an object, was noticeably present in work from this period. In *Waterfall* and *George Gershwin*, for example, Dove described having reduced the idea's "condition of shape" to the line, because "the line was fast enough to get the spirit of it." In contrast to this, several paintings from this period such as *Sand Barge, Silver Tanks and Moon* and *Lantern*, recalled the simple architectural forms and subject matter of contemporaries like Georgia O'Keeffe, Charles Sheeler and Charles Demuth. By abstracting from geometrical structures, Dove simplified the forms in these paintings to straight lines and rectangles. Although Dove explored various stylistic approaches during this period, much of his artistic energy was focused on his assemblages.

Spirit of the Twenties

The American people fought World War I almost as a religious crusade to make the world safe for democracy. With the disenchantment that followed the close of the war, a deep cynicism developed in America about participation in European affairs. A conservative atmosphere reasserted itself and a wave of nationalism swept the country.

It was an era of disillusionment, of the lost generation. The idealistic dreams for a social-spiritual reform had been shattered by the war. As Alfred Kazin wrote, "Nothing was so dead in 1920 as the crusading spirit of 1910."[48] The war, which appeared as an imperialist struggle for power, was taken as final evidence of the bankruptcy of a civilization. Intellectuals saw the world as a wasteland devoid of human values. Men had died, wrote Ezra Pound, "for an old bitch gone in the teeth — for a botched civilization."

The twenties were a period of enormous changes. Not only had the country's faith in progress and idealism been destroyed, but the old authority and systems had broken down. In a relatively short period of time, the United States had to come

to terms with a strong state, urban dominance, the breakdown of religious faith, loss of family authority and the advent of mass culture. As Willa Cather said, "The world broke in two in 1922 or thereabouts."

The old order had been torn apart and no new ideology had arisen that provided the security and sense of truth that existed before the war. Walter Lippmann wrote in *A Preface to Morals* that, ". . . in the modern age, at first imperceptibly with the rise of towns, and then catastrophically since the mechanical revolution, there have gone into dissolution not only the current orthodoxy, but the social order and the ways of living which support it. This rebellion and emancipation have come to mean something far more drastic than they have ever meant before. The earlier rebels summoned men from one allegiance to another, but the feeling for certainty in religion and for decorum in society persisted. *In the modern world it is this very feeling of certainty itself which is dissolving.* It is dissolving not merely for an educated minority but for everyone who comes within the orbit of modernity."

The American people were reluctant to accept the implications of the enormous changes that were occurring around them. In a desperate attempt to find something solid to hold onto, Americans reached back toward their roots. An immense nostalgia developed for the quality of life that had existed before the war. In attempting to re-stabilize the foundations of their lives, the identification of what was American and what constituted the American experience was critical. It was as if by focusing on this underlying experience, all diverse and chaotic elements could be unified.

The desire to define the American experience had always been characteristic of Americans. Perhaps being a country with so short a history had compelled people to try and understand

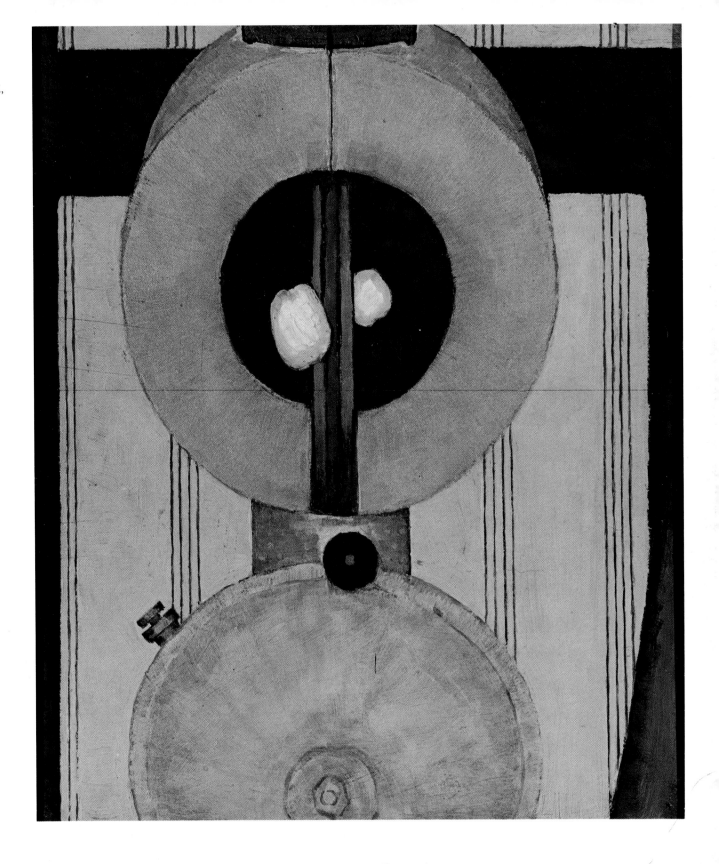

Lantern. 1921.
Oil and silver paint on wood panel,
21⅜″ x 19″
The Art Institute of Chicago,
Alfred Stieglitz Collection

41

Sea Gull Motif. 1926.
Oil on panel, 20½″ x 26″
Andrew Crispo Gallery, New York

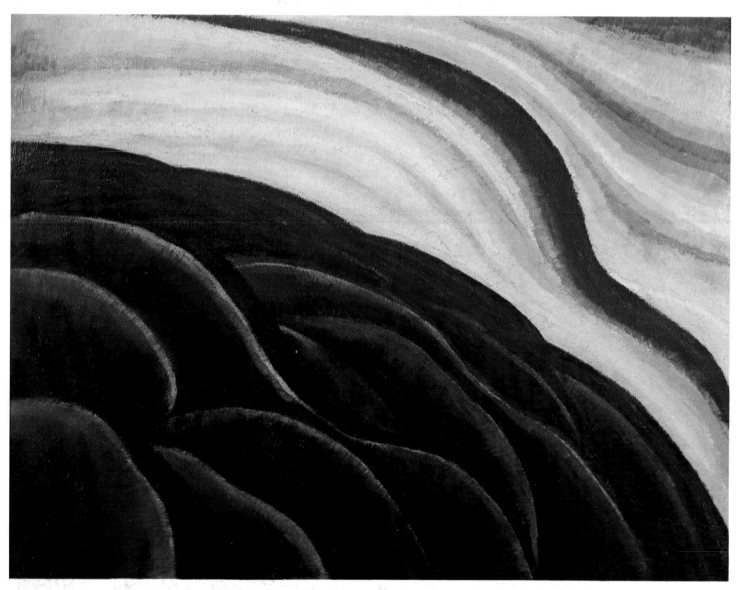

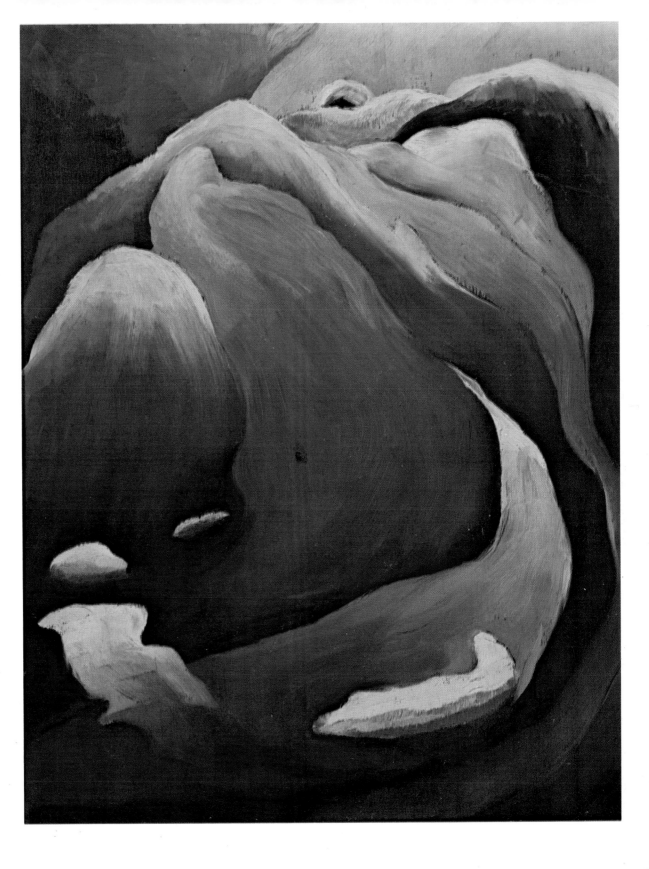

Waterfall. 1925.
Oil on composition panel, 10″ x 8″
The Phillips Collection, Washington, D.C.

43

themselves. Even an expatriate like Gertrude Stein felt a need to define the American experience. She began *The Making of Americans* by noting: "It has always seemed to me a rare privilege, this, of being an American, a real American, one whose tradition it has taken scarcely sixty years to create. We need only realize our parents, remember our grandparents, and know ourselves and our history is complete." In writing in 1923 about the psychic spirit of America, D. H. Lawrence noted that "every continent has its own great spirit of place. Every people is polarized in some particular locality, which is home, the homeland. Different places on the face of the earth have different vital effluence, different vibration, different chemical exhalation, different polarity with different stars: call it what you like. But the spirit of place is a great reality. The Nile valley produced not only the corn, but the terrific religions of Egypt. China produces the Chinese, and will go on doing so. The Chinese in San Francisco will in time cease to be Chinese, for America is a great melting pot."[49]

The uncertainty of the twenties, and the search for cultural identity erupted in a wave of nationalistic fervor that was manifested by the Red Scare, the execution of Sacco and Vanzetti, the passage of the immigration restriction laws, the rejection of United States membership in the League of Nations, the rise of the Ku Klux Klan and the Scopes trial.

Dove fought against the nationalistic pressures to depict American subjects. As he had done earlier in the century, he preferred to paint the spirit of a place, not its external forms. "When a man paints the El," he said in a conversation with Alfy Maurer, "a 1740 house or a miner's shack, he is likely to be called by his critics, American. These things may be in America, but it's what is in the artist that counts. What do we call 'America' outside of painting? Inventiveness, restlessness,

speed, change. Well, then, a painter may put all these qualities in a still life or an abstraction, and be going more native than another who sits quietly copying a skyscraper."

"I cannot," Dove said, "go on making paintings out of what I already know. I prefer growth to effort and both take time. Reds has been working and letting go of the past which is so hard for us all to do. The future seems to be gone through by a spiral spring from the past. The tension of that spring is the important thing."[50] In a 1931 poem he wrote:

> *For those who try to weave the idea of comfort, by that I mean not endlessly trying to go beyond the last thing they have done for something further on;*
> *For those who have no further wish than the expression of the thing at the roadside;*
> *For those who feel they must go back to the classic to realize themselves;*
> *For those that have no hope of anything beyond;*
> *For those there is no hope.*
> *It must be your own sieve through which you sift all these things and the residue is what is left of you.*[51]

In such a state of unrest, the reality of the recognizable object was preferred to that of the abstract. People wanted to return to a reality that was concrete and literal. In *Concerning the Spiritual in Art,* Kandinsky equates purely representational art with materialism in life. In an age when spiritual values are at a low ebb, he said, men seek a substitute in material acquisitions. Everything is uncertain and as men have no faith, they cling to their material possessions as a drowning man clings to a straw.

Cars in Sleet Storm. 1925.
Oil on canvas, 15″ x 21″
Memorial Art Gallery of the University of Rochester, New York
Marion Stratton Gould Fund

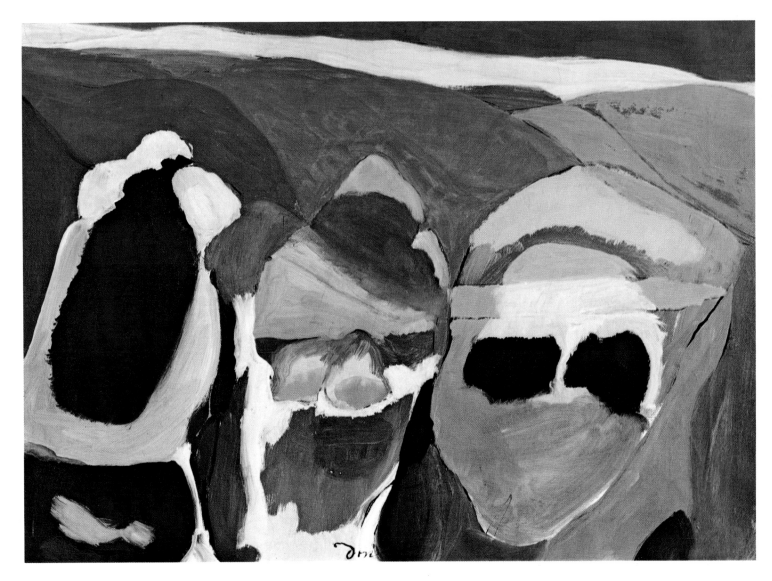

River Bottom (Silver, Ochre, Carmine, Green). 1923.
Oil on canvas, 24″ x 18″
Andrew Crispo Gallery, New York

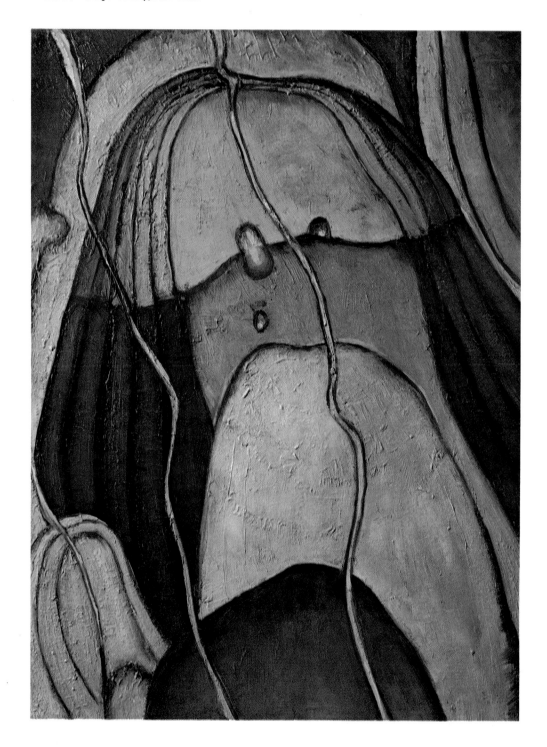

Writers employed a starker craftsmanship than their impressionist predecessors. Hemingway, for example, avoided adjectives which he felt were betraying and instead pushed as far as he could with nouns and verbs. In general, novelists of the period were realists who dealt with the commonplace American scene. Their literature was a literature of anger and self-deprecation. They wrote about a failed America that was a cultural and spiritual vacuum. Their novels were peopled with characters who were unable to impose themselves on their world and at the same time were incapable of initiating other circumstances. Strangely enough, the twenties produced a literature of tremendous importance: Sherwood Anderson, Sinclair Lewis, Van Wyck Brooks, William Faulkner, Ring Lardner, Hart Crane, e. e. cummings, Marianne Moore, Wallace Stevens, Willa Cather, Frank Norris, Ernest Hemingway and F. Scott Fitzgerald.

American scene realism and the rejection of internationalism dominated the decade in the visual arts as it had in literature. Of the early American abstract artists, only Dove remained committed to abstraction. Modernism seemed to have died. The twenties saw the rise of painters such as Edward Hopper and Charles Burchfield who explored the spiritual isolation and romantic nostalgia of America, and the Precisionists who coldly depicted the industrial landscape.

Sam Hunter has pointed out that perhaps one reason modernism suffered such a drastic decline in America was that it had been supported by the same utopian hopes that were lost in the disillusionment of the postwar years.[52] European disillusionment was manifested in the outwardly directed rebellion of the Dadaists against modern society and in the retrenching of modernists like Matisse and Derain who re-turned to more conservative modes. It was minor, however, in comparison to the despair that characterized American painters.[53]

The discouragement that American painters felt was internal and for that reason more tragic. By the end of the thirties Alfred Maurer, Oscar Bluemner, Morton Schamberg and Patrick Henry Bruce had all committed suicide and John Covert had given up art altogether and gone into business. In talking of his postwar work, Charles Burchfield reflected the immobilizing malaise that American painters felt: "There followed a period of degeneracy in my art that I have never been able to explain . . . I later destroyed all the paintings of this period. . . ."[54]

Golden Storm. 1926.
Metallic paint on wood panel, 18½″ x 20½″
The Phillips Collection, Washington, D.C.

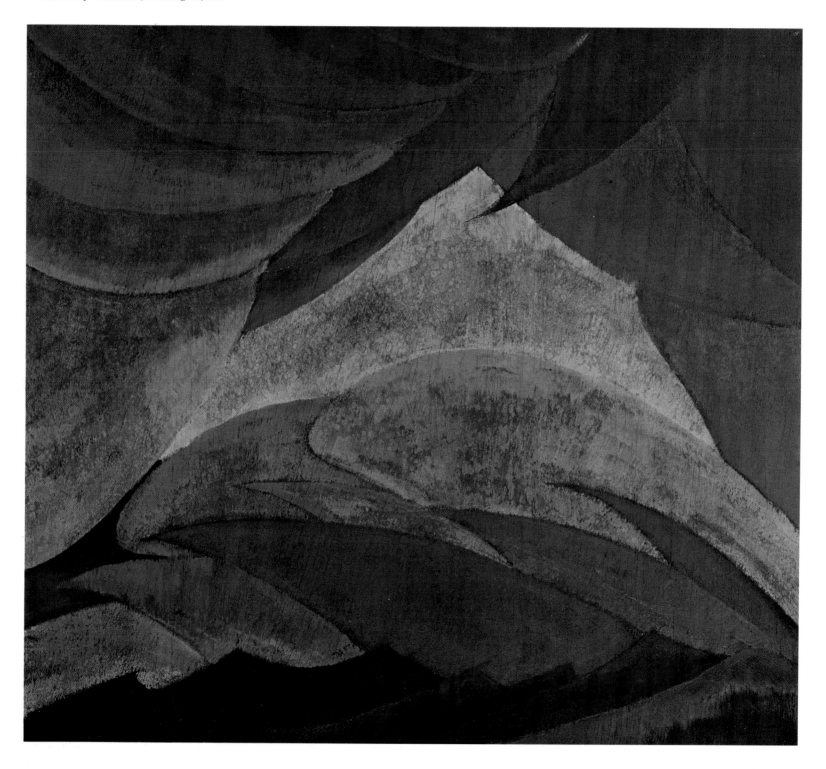

49

Assemblages

> *. . . many diverse images, borrowed from very different orders of things may, by the convergence of their action, direct the consciousness to the precise point where there is a certain intuition to be seized. By choosing images as dissimilar as possible, we shall prevent any of them from usurping the place of the intuition it is intended to call up.*
>
> Henri Bergson, *Introduction to Metaphysics*

Between 1924 and 1930, Dove produced a group of about twenty-five assemblages or "things" as he called them. Although some of these might properly be called collages, the majority are composed with three-dimensional objects that project from a flat background. They differ in so many respects from his previous work that the question of why he began making them immediately arises. One factor was undoubtedly the cramped working quarters on the *Mona*. It is true that he did execute oil paintings during this period but their limited number underscores the difficulty of painting

on the boat. Added to this is Georgia O'Keeffe's explanation that ". . . he worked with collage because it was cheaper than painting and also it amused him — once he was started on it, one thing after another came to him very easily with any material he found at hand."[55]

Expanding on O'Keeffe's comment, it is true that Dove did experiment with a variety of materials during this period. Even in works that are not assemblage pieces, he used glass and metal as painting surfaces. Texture was always of primary importance to Dove and it was this interest that led him to experiment with pastel, metallic paint and wax emulsion. Given this inclination, it is quite probable that the tactile variety of non-art materials was a great attraction.

Artists of varying disciplines have stressed the economical aspect of assemblages in legitimizing substitutes for art supplies, especially during crises of war and depression. Even a formalist painter like Josef Albers, for example, urged his students at the Bauhaus to make use of rubbish because he found it too expensive to provide fresh materials for their class exercises. The American legacy of pragmatism, which allowed anything to be used providing it was available and served the purpose, reinforced Dove's inclinations to appropriate materials that had not been utilized before to make fine art.

It also could be that Dove was reacting unconsciously to the national mania for the literal. Since collage incorporates actual pieces of everyday reality, it is the ultimate in literalness or "super-realism."

Dove was, of course, cognizant of the use of collage among contemporary European artists. Although there is a great stylistic variation among his assemblages and some of them appear to relate superficially to certain art movements, as a

Sea II. 1925.
Chiffon on metal, 12½″ x 20½″
Barney A. Ebsworth, St. Louis

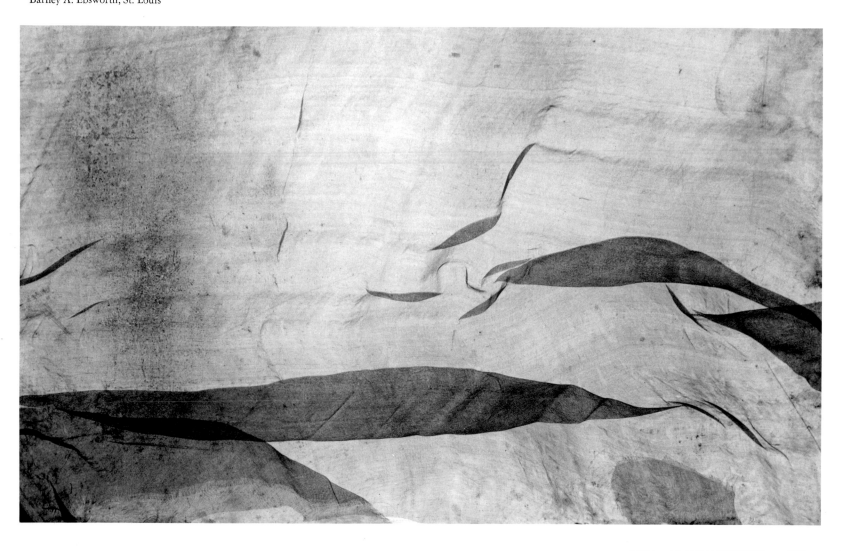

Hand Sewing Machine. 1927.
Cloth and paint on metal, 14⅞″ x 19¾″
The Metropolitan Museum of Art, New York
Alfred Stieglitz Collection

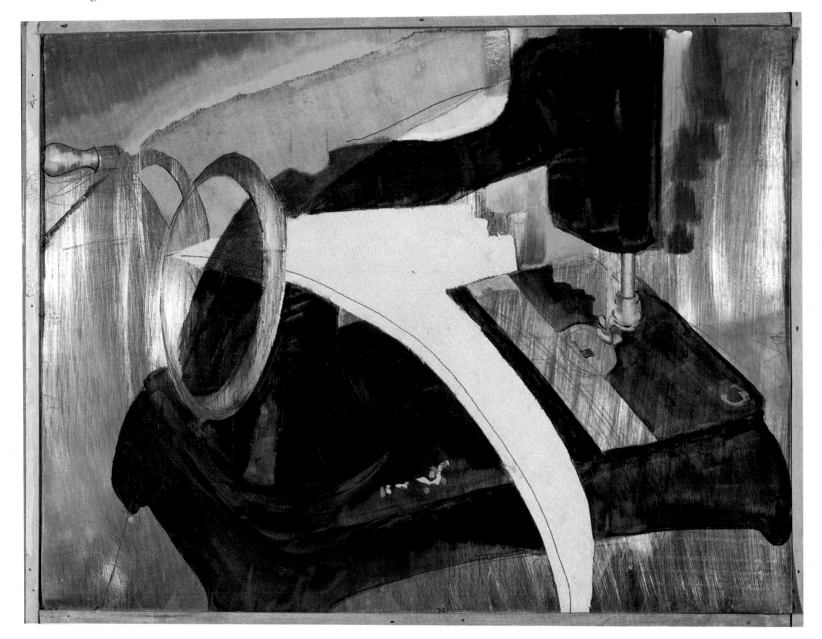

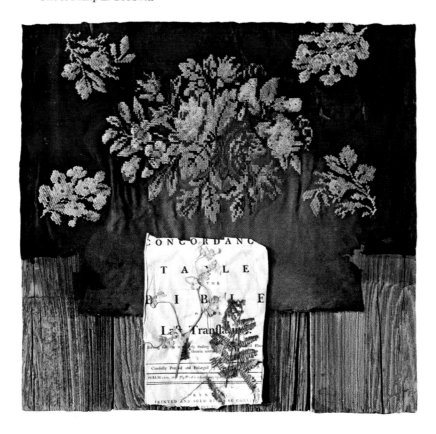

whole, they are highly idiosyncratic. As he had done with his paintings, Dove assimilated his artistic ambiance into an extremely personal vision.

The materials in Dove's assemblages operate on three different levels of meaning: literal, in which materials convey their original purpose or "actuality"; formal, dealing with purely visual, abstract qualities of color, texture and composition; metaphoric, in which physical and psychic characteristics of the subject are symbolized. In each assemblage, the objects' original function, their metaphoric connotations and their formal properties combine to produce an entity that both includes and transcends its parts.

Dove's utilization of objects for their referential quality as well as for their formal properties separates his work from the Cubist-derived compositions of artists like Kurt Schwitters, Joseph Stella and John Covert, although in pieces like *Untitled* he did approach the formalist tradition. The expressive power of Dove's assemblages is heightened precisely because the materials retain their identity as "real" objects and are not completely transmuted into "art." This approach to the image value of found objects relates Dove more to an artist like Robert Rauschenberg than to any of his contemporaries.

Ten Cent Store. 1924.
Cloth, flowers and paper, 18″ x 16¼″
University of Nebraska, Lincoln
Nebraska Art Association, Nelle Cochrane Woods Collection

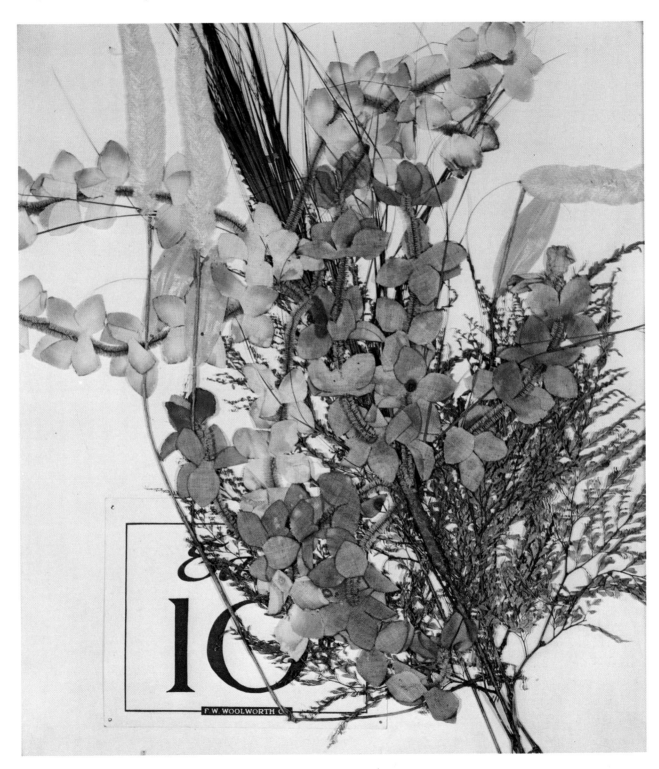

Whether Dove's assemblages deal with people, places or ideas, all the elements in them relate thematically. Like his paintings, his assemblages vary in the degree to which they diverge from visual likeness of the external world. Some, like *Huntington Harbor*, are almost representational pictures.

A number of Dove's assemblages fall within the category of object portrait, or non-representational portrait, which uses objects symbolically to illustrate a psychic or physical characteristic of the subject. The object-portrait had several practitioners in the first part of the century. In 1915, Francis Picabia made drawings of isolated technological objects in his machinist style, inscribing legends that identified them as particular personalities. The most famous of these was a portrait of Stieglitz represented as a folding camera. Prior to this, Marius de Zayas produced caricatures of public personalities from typographic elements. Charles Demuth made seven portrait paintings in which he selected and arranged objects that he associated with the personalities of his friends. One of these portraits was of Dove, although more famous was Demuth's portrait of William Carlos Williams, *I Saw the Figure Five in Gold*. All three of these individuals (Picabia, de Zayas and Demuth) were members of Stieglitz's group and Dove would have had occasion to discuss work and ideas with them.

Another person admired very much by Dove was Gertrude Stein, who was also repudiating the portrait "likeness." In her abstract portraits, words were like objects which she used symbolically, relying on their associations to transmit information about the subject. These language portraits were well known by the artists experimenting with object-portraits. Marsden Hartley, in fact, credited Stein with influencing the portraits he was doing in Germany during the 1910s that used numbers and German military insignia. Even Picabia began his own

object-portraits after he had met Stein in Paris.

Neither Dada, Surrealism nor folk art provide a complete context in which to view Dove's assemblages. Dada has often been proposed as a metaphysical umbrella for Dove's collages. Sociologically, Dada was the angry and bitter response of intellectuals who saw bourgeois rationalism and culture as responsible for World War I. By 1924, when Dove started making collages, the anti-social and anti-rationalist energy behind Dada had been largely assimilated into Surrealism or, as was especially true in the United States, dissolved into a demoralized retreat from modernism. None of Dove's work stems philosophically from Dadaist nihilism or its desire to subvert middle class culture, hypocrisy and rationalism. The humor and playfulness that seem closest to Dada in Dove's assemblages originated more from his innate sense of humor than from a belief in the efficacy of irrationality. He did believe in the importance of intuition over rational thought, but never felt that the intuitive side of existence could be emphasized through irrationality or unreasoned order.

Surrealism does not accurately define Dove's intentions either. Dove never employed unrelated juxtaposition, epitomized in Isidore Ducasse's now-famous image of the "chance encounter of a sewing machine and an umbrella on a dissecting table," which the Dadaists and Surrealists enlisted to liberate hidden meanings and unlock expressive possibilities. The elements in his assemblages, with the exception of works like the enigmatic *Monkey Fur,* are all thematically related to the "idea" of the piece.

Roger Shattuck has pointed out that the twentieth century addressed itself to arts of juxtaposition, the "setting of one thing beside the other without connective," as opposed to the earlier arts of transition.[56] The thematic unity of Dove's

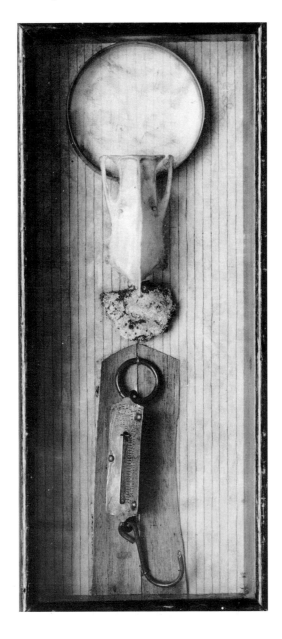

The Intellectual. 1925.
Magnifying glass, fish bone, moss, fish scale and bark
on scored wood panel, 17″ x 7⅛″
The Museum of Modern Art, New York
Philip L. Goodwin Collection

55

compositions, unlike Dadaist or Surrealist work, softens the discontinuity that results from bringing together otherwise disparate materials. This unity, which Dove achieved in all his work, undoubtedly reflected a sense of continuity that he felt underlay the apparent plurality and chaos in the world and which sharply contrasted with the discontinuity and alienation typifying much of twentieth-century thought.

Some historians have attempted to relate Dove's assemblages to the mixed media constructions of American folk artists. The assemblages that most closely resembled these compositions were his representational pieces like *Huntington Harbor*. Although Dove did use objects that, on one level, retained their history and association, his assemblages differed fundamentally in purpose from those of the folk artists who were primarily concerned with visual likeness. Dove, on the other hand, retained a formal concern for the abstract qualities of texture and composition and simultaneously allowed the objects to function as literary or symbolic equivalents.

The fact that there was a pronounced increased interest in folk art after the war does not, in itself, indicate that Dove either saw or was influenced by it. No mention was ever made of it in Dove's letters or in Reds' diaries, while other art experiences were frequently noted. The increasing emphasis on Americanism was precisely what Dove was fighting against and would have been anathema to Stieglitz's elitist point of view.

Edith Halpert, the dynamic owner of The Downtown Gallery who became Dove's dealer after Stieglitz died, was profoundly interested in American folk art. Her excitement at seeing a similarity between Dove's work and that of native artists was instrumental in the widespread viewing of Dove's assemblages in this context.

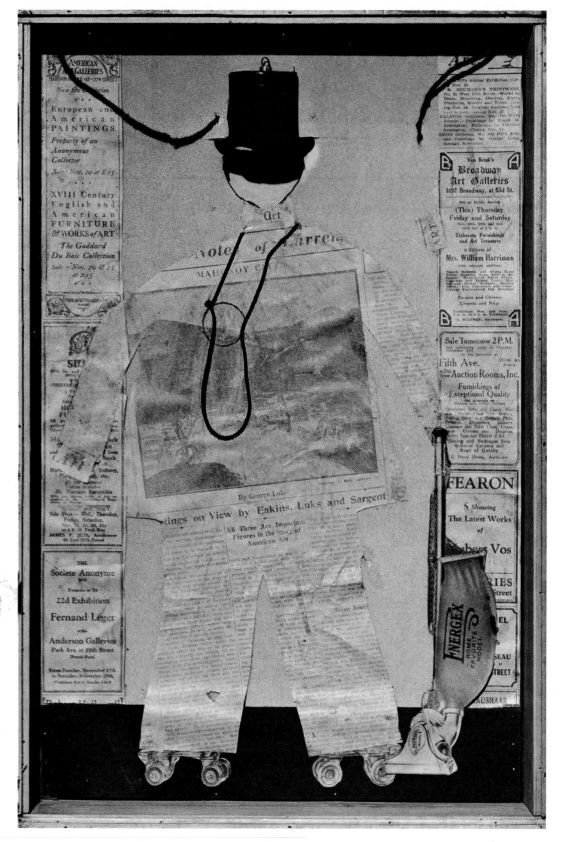

The Critic. 1925.
Cardboard with newspaper,
magazine ads, cord and velvet, 19½″ x 12½″
Estate of the artist, courtesy
Terry Dintenfass Inc., New York

57

Huntington Harbor. 1929.
Painted wood panel with shells, corduroy, sticks,
paper appliqué and rope frame, 12″ x 18″
Estate of the artist, courtesy Terry Dintenfass Inc., New York

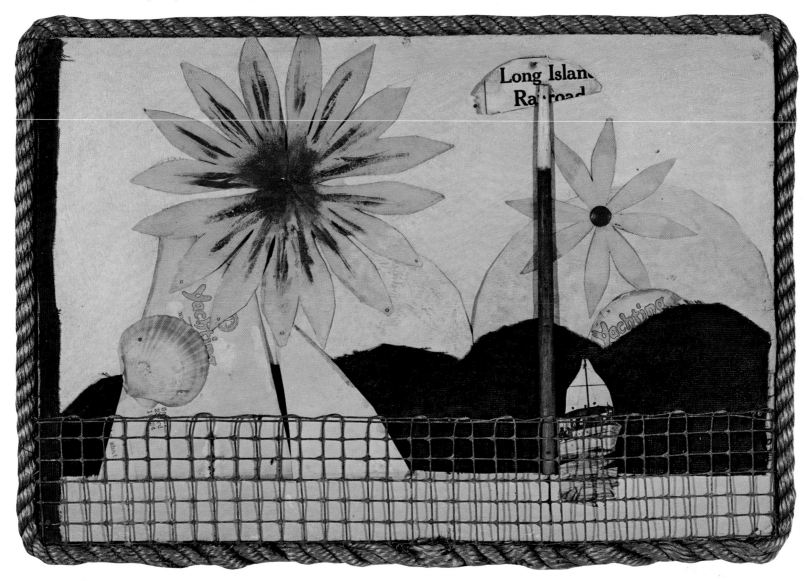

Untitled. c. 1924-30.
Metal rods, spring, wood, nails, wire, staple, and disk on wood, 4¾″ x 5⅛″
Philadelphia Museum of Art, gift of Paul and Hazel Strand

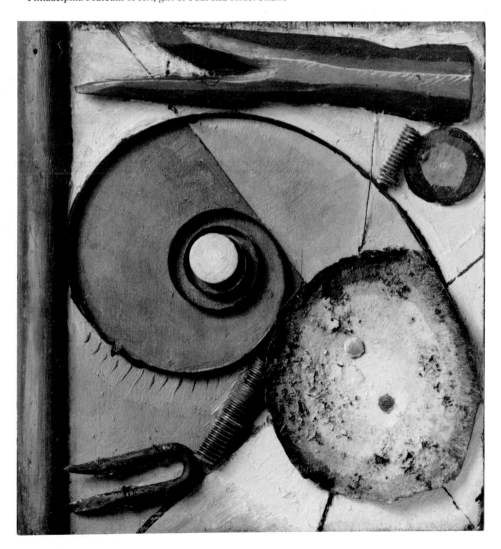

Goin' Fishin'. 1926.
Denim, bamboo and bark on composition board, 19½″ x 24″
The Phillips Collection, Washington, D.C.

59

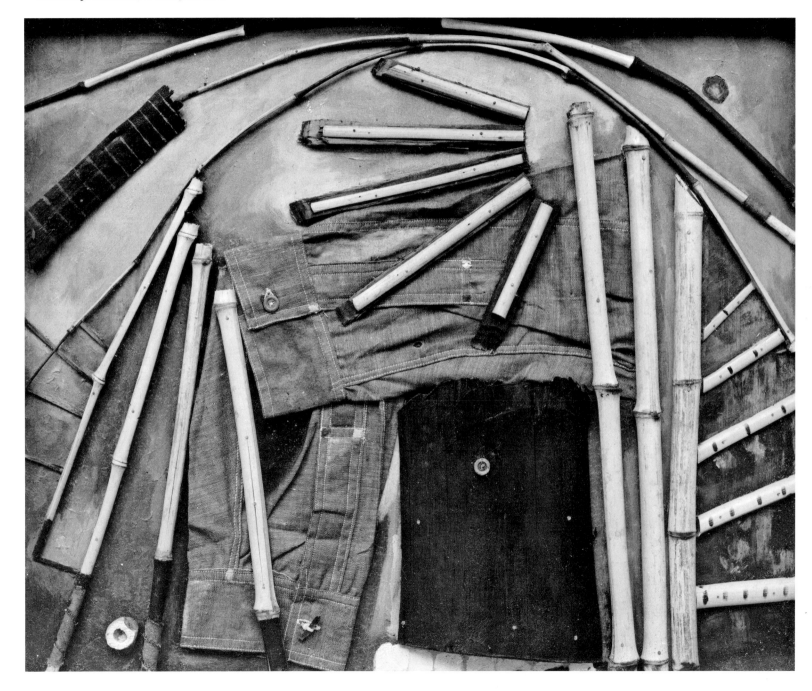

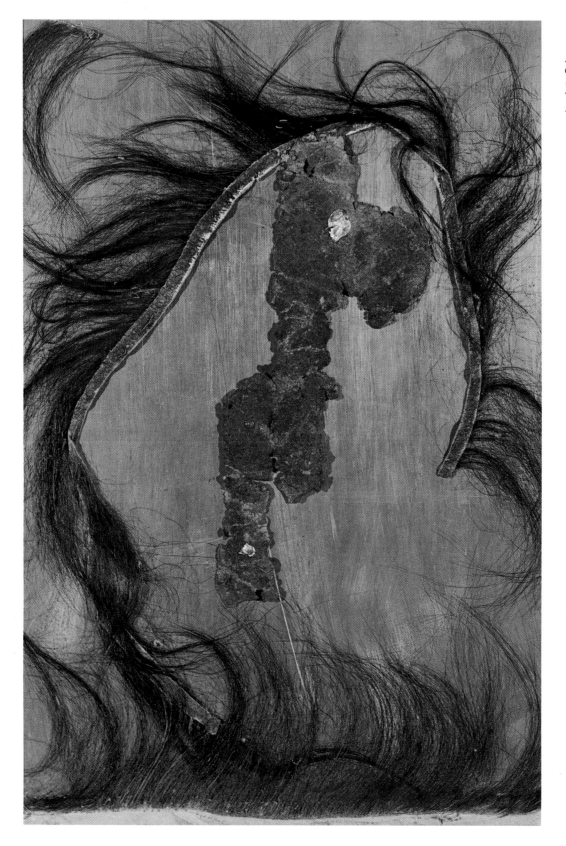

Monkey Fur. 1928.
Corroded metal, monkey fur,
tin foil and cloth on metal, 17″ x 12″
The Art Institute of Chicago,
Alfred Stieglitz Collection

Clouds. 1927.
Oil and sandpaper on sheet metal, 16″ x 21″
William H. Lane Foundation

61

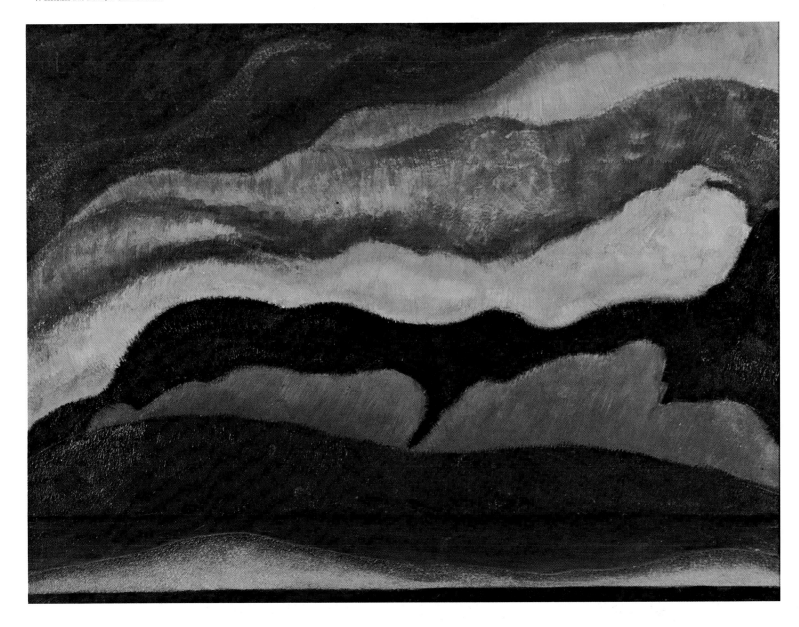

Rain. 1924.
Twigs and rubber cement on metal and glass,
19½″ x 15⅝″
Georgia O'Keeffe, Abiquiu, New Mexico

Untitled. c. 1924.
Plaster, mesh wire, cork, blue cloth and paint,
21½″ x 13⅜″
Amon Carter Museum of Western Art,
Fort Worth, Texas
Gift of Georgia O'Keeffe

63

Huntington Harbor, 1926.
Oil, sand, cloth and wood on panel,
12″ x 9½″
The Phillips Collection,
Washington, D.C.

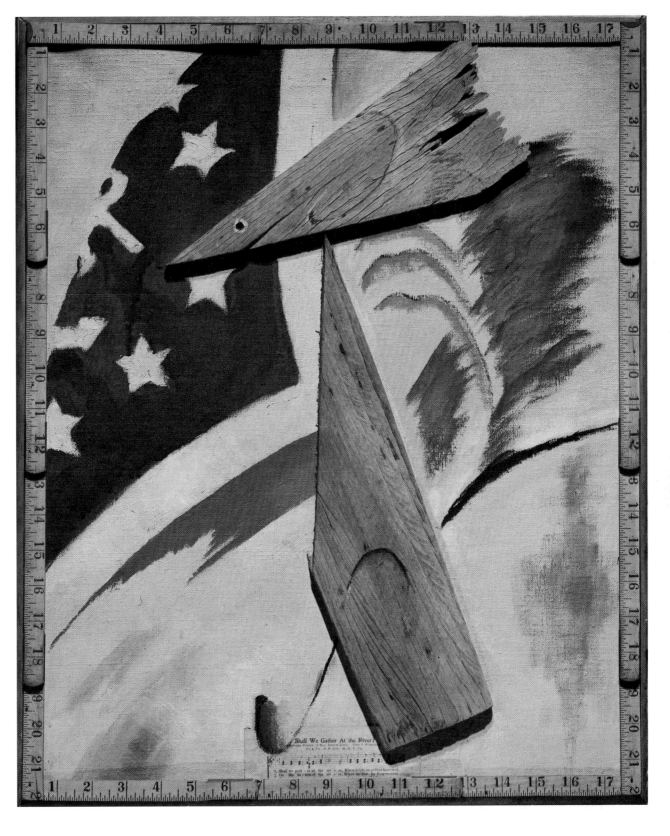

Portrait of Ralph Dusenberry. 1924.
Oil on canvas with applied ruler,
wood and paper, 22″ x 18″
The Metropolitan Museum
of Art, New York
Alfred Stieglitz Collection

65

George Gershwin, Rhapsody in Blue Part I. 1927.
Oil and metallic paint on aluminum with clock spring, 11¾″ x 9¾″
William Young, Wellesley Hills, Massachusetts

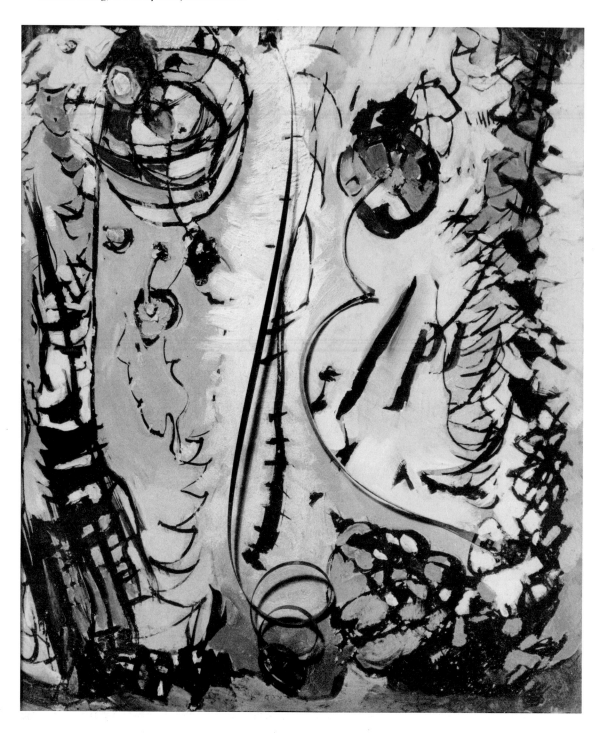

Portrait of Alfred Stieglitz. 1926.
Mirror on cardboard with lens,
steel wool and clock spring,
16⅜″ x 12⅜″
The Museum of Modern Art, New York
Edward M. M. Warburg Fund

67

Starry Heavens. 1924.
Oil on glass, 18″ x 16″
Estate of the artist, courtesy Terry Dintenfass Inc., New York

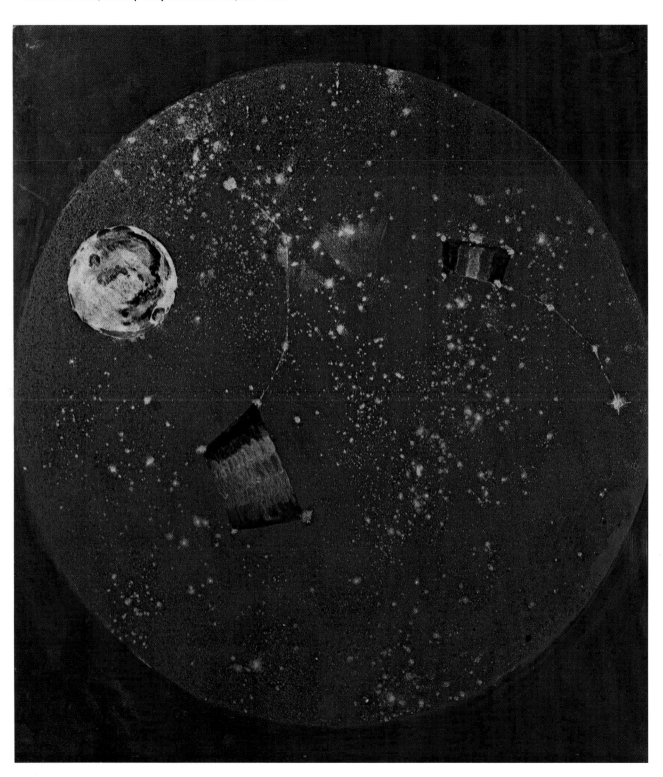

Spirit of the Thirties

The realism that existed in the twenties reached unprecedented heights in the thirties. The stock market crash in 1929 pitched America into a general despair. As a result of the political and economic crises of the Depression, artists increasingly turned their attention to the service of social issues. Art as an expression of social conscience, either as commentary or as protest, dominated the Depression years. As Dore Ashton noted, "No artist, however committed he was to art for its own sake, could have escaped entirely from the haunted eyes of his urban contemporaries."[57]

The turmoil and violence that accompanied the breakdown of America's economic system caused Americans to search more than ever for the verities of their lives and for their cultural identity. William Scott pointed out in *Documentary Expression and Thirties America* that the culture of the thirties was dominated by the documentary motif; the camera was the basic symbol of the age. This motif found expression in descriptive journalism, new documentary books like James Agee's and Walker Evans' *Let Us Now Praise Famous Men*, the federal arts projects, a renewed interest in American history and folk art and in Social Realist and American Scene paintings.

Artists like Thomas Hart Benton and critics like Thomas Craven called for a pictorial art based on regional themes suitably expressing a nationalistic message. Other artists like Philip Evergood, Ben Shahn and William Gropper expressed their concern over the political and economic crises caused by the Depression through an art that conveyed specifically political messages.

In 1935 the New Deal inaugurated the Federal Art Project (within the Works Progress Administration) as part of the public works program to employ those out of work due to the Depression. Through this project, painters, sculptors, and graphic artists were employed by the government at a monthly stipend. Although these programs produced little work of consequence that has survived, they radically altered the relationship between the artist and society. For the first time, American artists were able to view themselves as necessary functionaries in society. By affording them a chance to work full time, the W.P.A. gave artists a sense of pride and professionalism previously unavailable outside the academic context. It also provided them with a sense of an artistic milieu for the first time. In contrast to the younger art community in New York, the artists associated with Stieglitz retained their belief in the efficacy of individual enrichment over communal action and declined to participate in the W.P.A. projects. This isolated them from the younger artists and limited their direct influence on the generation that was fighting to forge a new phase of modernism. That participation in the W.P.A. project was of crucial importance is evidenced by Barnett Newman's statement, "I paid a severe price for not being on the project with the other guys; in their eyes I wasn't a painter; I didn't have the label."[58]

Geneva 1933-1938

Dove's father had died in 1921 and his mother died in 1933 after a protracted illness, leaving Dove and his brother Paul with the family holdings. Dove went to Geneva and found a near-bankrupt and what he felt was a mismanaged estate. The once successful tile and brick plant had all but shut down because bricks could be produced more cheaply and in larger quantities in the Midwest and shipped to Geneva. Mortgages had been taken out on the family properties in order to pay nursing costs during his mother's illness and taxes had not been paid for some time.

Neither Dove nor Reds wanted to move but Dove felt there was "no other choice but to come here [Geneva] for this year anyway." They sold the *Mona* and in July moved into a small farmhouse on the family property.

Dove struggled to salvage what he could of the family fortune, but money was scarce and the estate was debt-ridden. He attempted to make ends meet by farming and renting whatever he could of the land, the farmhouses and space in the Dove Block, a commercial building in the center of town that his father had built. In hopes of a little income, Dove borrowed money from the bank to remodel the family home into four apartments.

Farming proved unprofitable: "This working your head off at haying poor oats and badly planted barley at a loss is just nonsense."[59] "By working ½ a day you can get about $8 back of the 25 the hay cost."[60] Unable to get a loan on the 180 acres of farmland and faced with pressures to pay back taxes, Dove tried to sell pieces of the property, but at the height of the Depression, there were few buyers and prices were low.

By this time the W.P.A. easel painting project had been established, but Dove declined to participate even though Phillips' $50 a month was less than the $95 a month received by W.P.A. artists. On January 12, 1934, he wrote to Stieglitz:

> *Government payroll at $34 per week. If I could substitute old work in storage, keep the present and use money for materials it would help a lot but I could not think of giving them all present work, that would hardly buy paint and canvas and the committee 'would have to be satisfied.' How nice! And all your years of building to go for nothing at a government auction. If they hang these paintings in place of historical prints or what they have now in school, etc., what becomes of George Washington. Do they know how much it costs to paint a 30-hour week for materials alone. They pay the man who lives in an old shanty here on the farm*

Dove Block, Geneva.

Interior view of top floor of Dove Block.

50¢ an hour for road work and most of them sit in the bank and smoke so he says.

I cannot see how they are going to pay for creative work by the hour. This morning for instance a slat in the bed broke. We had to get up and get the carpenter tools and fix it so from two o'clock on I lay awake and painted mentally and learned a lot. Would I get credited with that time and how could I explain it to a committee. He said I could do anything I wanted — portraits or anything and work at home. Couldn't imagine them hanging some of the things in the general high school and if they did who is going to answer questions? The only way I can see is to trade them some of the past instead of the present.

In May of 1934 Dove and Reds moved into a larger house at the other end of the farm. As with their previous dwellings, they transformed these surroundings into a pleasant home. Dove wrote to Stieglitz that their new decor was "...aluminum paint, white ceilings, a white door, black surbase and what will be mars violet floors."[61] Earlier that winter Dove had written that "it is so cold in here this morning I can hardly write. Wonder how we have lived through it, let alone getting any work done."[62] During the summer they were almost able to live off the garden, mushrooms and fruit. New and old friends continued to visit regularly: "About 25 people," Dove wrote in May of 1936, "have invited themselves to spend the summer. What does one do. Start a hotel or move out?"

In 1937 the second farmhouse was sold for taxes. Dove and Reds moved into the top floor of the Dove Block which had originally been used as an armory, then as an auditorium and finally as a skating rink. Although similar to what would now be regarded as a typical artist's loft, the hall was an improbable dwelling for those times. The space was 60' x 70', with 15' ceilings and 10' windows on three sides of the room. Dove and Reds painted the one unbroken wall white and hung a number of paintings on it. Pieces of furniture were placed in clusters around the room in order to divide up the space into different areas. A black strip painted in a circle on the hardwood floors remained from the time when the hall had been a skating rink. The Block was located in the main square of the city: "We see and hear everything," wrote Dove, "even the Salvation Army band concerts every evening. Have listened all winter and are not saved yet."[63]

The strain during these years was psychological as well as physical and financial. "This going out to paint," he wrote to Phillips in 1933, "then rushing back and slamming the door quickly to keep the wolf out is not soothing to the nerves. It has meant several discussions each day with my brother, creditors, lawyers, farm inspectors, realtors, etc., all of which is not especially in harmony with the thoughts an artist would like to keep on his mind." Dove detested the narrowness and materialism of the society in which he found himself. His frustration was augmented by disagreements with Paul over the management and disposal of the properties. In January of 1934 he wrote, "The thing is Geneva but it is also the rest of America... just finished sixty watercolors in spite of the stupid circus that surrounds us."[64]

Below the Flood Gates. 1930.
Oil on canvas, 24″ x 28″
Private Collection

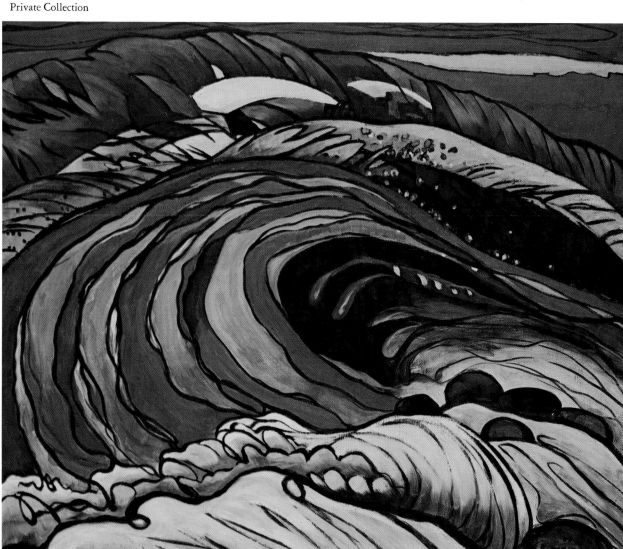

Paintings 1929-1938

The poet in utter solitude remembering his spontaneous thoughts and recording them, is found to have recorded that which men in crowded cities find true for them also. The deeper he dives into his privatest, secretist presentiment, to his wonder he finds this is the most acceptable, most public, and universally true. The people delight in it; the better part of every man feels: this is my music, this is myself.

Ralph Waldo Emerson *The American Scholar*

An image describes in the best possible way the dimly discerned nature of the spirit. A sign does not define or explain, it points beyond itself to a meaning that is darkly defined yet still beyond our grasp, and cannot be adequately expressed in the familiar words of our language.

Carl Jung *Man and His Symbols*

The character of Dove's paintings in the late twenties and thirties is dominated by nature imagery. The irregular, circular shapes swelling outward with halos of modulated color that Dove favors in this period, suggest growth and explosive energy. The straight lines and sharp angles that were present in the pastels are generally absent from the wax emulsion works of this period.

Carl Jung, in speaking of archetypal or primordial images, has pointed out that there are certain visual images that connect with a universal or collective unconscious and possess emotional connotations that go beyond the obvious meaning or recognized form of the image. The circle is one of the most powerful of these images. As explained in *Man and His Symbols*, a circle is a symbol for wholeness — the wholeness of the psyche and the integration of man and the entirety of nature. It is this imagery of unity and wholeness that Dove employs in his paintings from this period.

The feeling of wholeness that attends Dove's circular forms is related to the Gestalt principle of closure, the tendency to see an "unclosed" figure as "closed," or to see an incomplete form as complete. Perceptually, the uncompleted ends of a curved line have a tendency to continue their arc and unite. In a complete circle, when these lines actually touch, the tension between what the eye sees and what the brain wants to see ceases. A greater internal harmony exists when our inner and outer perceptions are resolved.

Dove expressed his concern for continuity and wholeness by relating single images to other analogous shapes in the composition, in a manner similar to Cubist "rhyming." As with his earlier work, it was through this correspondence of similar

Snow and Water. 1928.
Oil on aluminum, 20″ x 27½″
The Currier Gallery, Manchester, New Hampshire
Extended loan of Paul and Hazel Strand

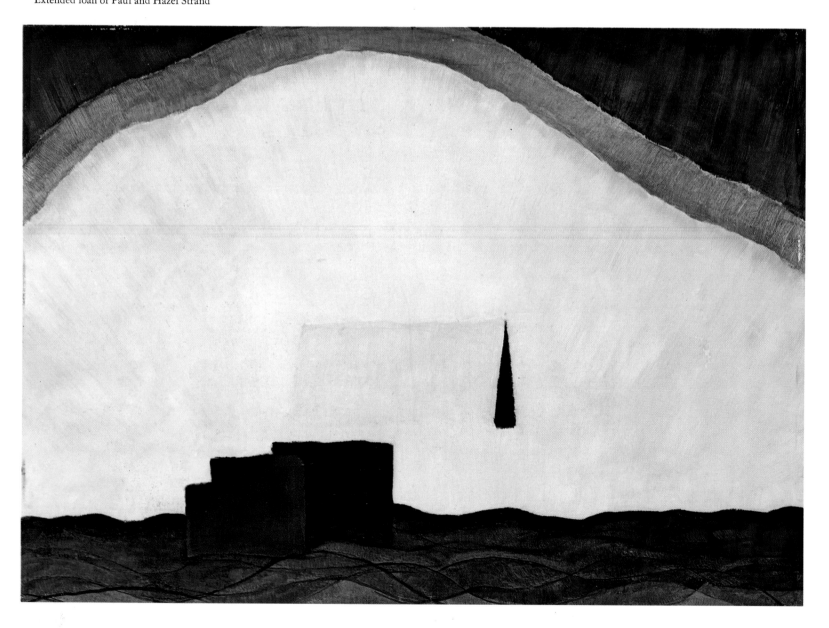

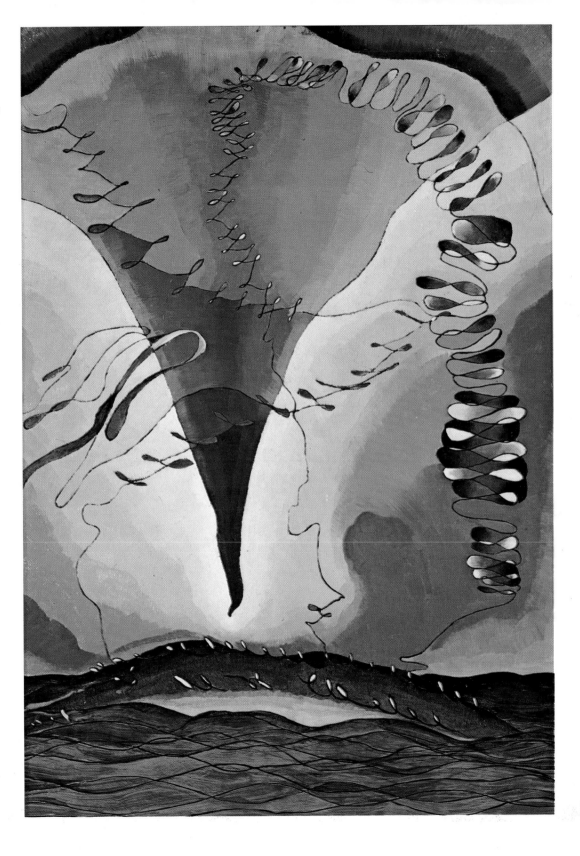

Violet and Green. 1931.
Oil on metal, 28″ x 20″
Dr. and Mrs. Harold Rifkin, New York

75

The Clay Wagon. 1935.
Oil on canvas, 20" x 28"
Charles H. MacNider Museum, Mason City, Iowa
Gift of Francisca S. Winston Trust

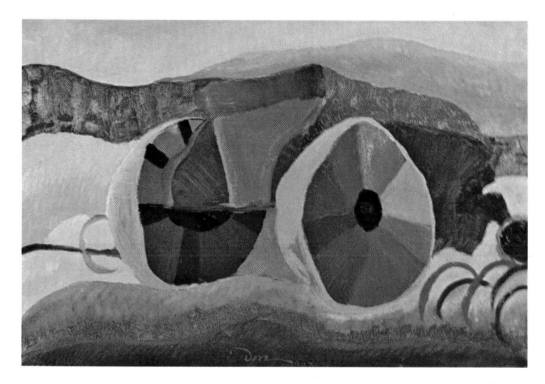

forms that Dove evoked a feeling of overall unity. He further eliminated the separateness of forms through the use of hazy, indistinct contours that merged into each other and into the atmospheric environment.

As he had in his earlier pastels, Dove continued to seek pictorial equivalents of the universal rhythm or life force that he felt existed in the world. "Just at present," he wrote, "I have come to the conclusion that one must have a means governed by a definite rhythmic sense beyond geometric repetition. The play or spread or swing of space can only be felt with this kind of consciousness — to build a head and put on it hair and eyes and lips and ears like the handles on a jug is not enough.

To make it breathe as does the rest of nature it must have a basic rhythm."[65]

For Dove this rhythm was symbolized by a circular shape expanding from a central core in concentric bands of modulated color. Similar to the effect of a pebble dropped in water, this imagery set up a dynamic reverberation throughout the composition. The sense of vitality was further enhanced by the use of clearly visible brushstrokes which resembled pulsations of energy. Earlier in the century, Robert Henri had also attempted to transmit a sense of vibrancy to the surface of his canvas by the use of what he termed "slashing brushstrokes."

All of Dove's work, even the geometric paintings from the

forties, are characterized by a compositionally dominant center. Structurally this resembles the grid of analytic Cubism in which pictorial incident is concentrated in the center and fades out at the edges.

Color continued to be the important vehicle for communicating feeling. In the paintings from this period colors were usually warm, earth tones rather than brilliant or unnatural. Within a given composition, the number of colors was small. These paintings simulated the after-effects experienced when one looks directly into intense light. Generally, the center core was dark and the next band was light, with the following bands of color diminishing in intensity as they radiated out from the center. These abrupt contrasts of dark and light colors increased the intensity of the light at the center.

Dove's forms entirely filled the shallow landscape background of the canvas. This vocabulary of expanding images that push to the very edge of the composition — in addition to suggesting exploding energy — was a visual equivalent of the dense landscape around Geneva. As Georgia O'Keeffe said, "Dove comes from the Finger Lakes region. He was up there painting, doing abstractions that looked just like that country, which could not have been done anywhere else."[66]

This close-up technique was employed in the photography of Alfred Stieglitz, Paul Strand and Paul Haviland, where it served to make objects more abstract. Painters such as Georgia O'Keeffe and Charles Sheeler appear to reflect these photographic precedents in their single image, cropped paintings, and perhaps Dove too benefited from these examples. It is ironic, given the taste for the factual and the concrete which the camera could provide, that what the artists borrowed from photography was not its precise realism, but its close-up compositions and its ability to abstract from a variety of objects and textures.

Dove's working procedure was to sketch an idea out-of-doors with watercolors. Following his annual spring exhibition at Stieglitz's, Dove would work on ideas in watercolors, later deciding which ones should expand into paintings.[67] To enlarge the basic formal design of the watercolors, Dove used a pantograph or magic lantern. As one arm of the pantograph traced over the watercolor, a marker on the other arm transcribed the composition on a larger scale. Even so, Dove's paintings are small in size and their intimacy demands a proximity of the viewer.

Because Dove did not paint people, it has often been suggested that he was anti-social or that his dislike of illustrating had made him reject human subject matter. This analysis does not consider the fact that almost none of the early modernists painted people. Barbara Rose has pointed out that "the only truly 'heroic' subject for an American artist had been and would continue to be the epic grandeur of the American landscape."[68] To Americans, landscape has always been a metaphor for personal freedom and individual fulfillment.

The womb and phallic images in Dove's work of this period evoke strong sexual overtones, as was later true of Robert Motherwell's and Arshile Gorky's sexually-charged imagery. Dove's sexual images are not so much specific biological representations as they are metaphors for an ecstatic vision of life. In an attitude similar to Dove's, Claes Oldenburg has said, "Any art that is successful in projecting positive feelings about life has got to be heavily erotic."[69]

Fog Horns. 1929.
Oil on canvas, 18″ x 26″
Colorado Springs Fine Arts Center, Gift of Oliver B. James

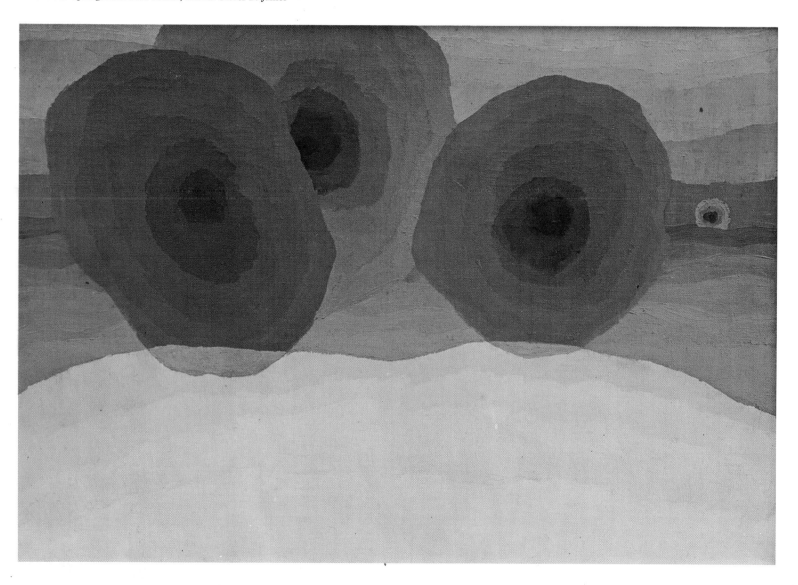

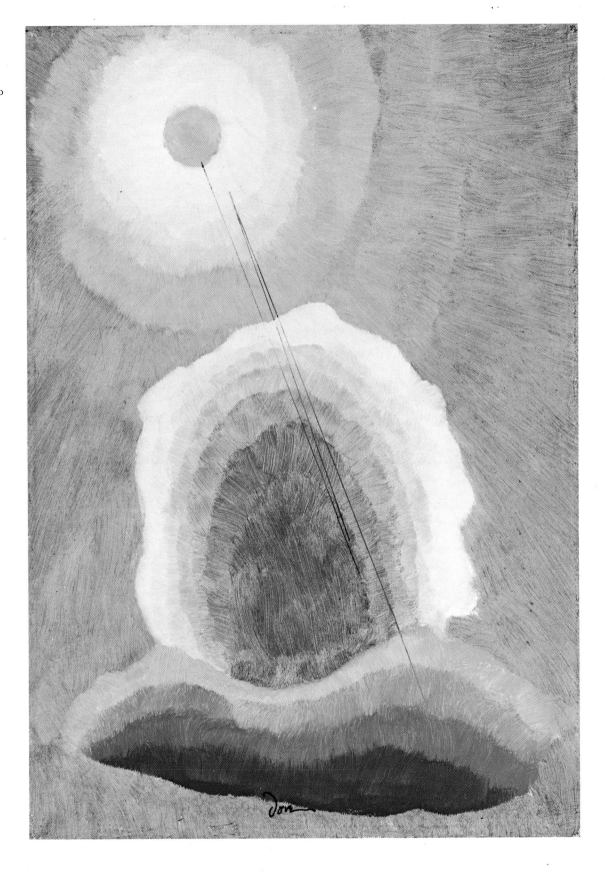

Golden Sunlight. 1937.
Oil on canvas, 13¾″ x 9¾″
Georgia O'Keeffe, Abiquiu, New Mexico

79

Dancing. 1934.
Oil on canvas, 25″ x 35″
The Brooklyn Museum, New York, extended loan of Charles Brooks

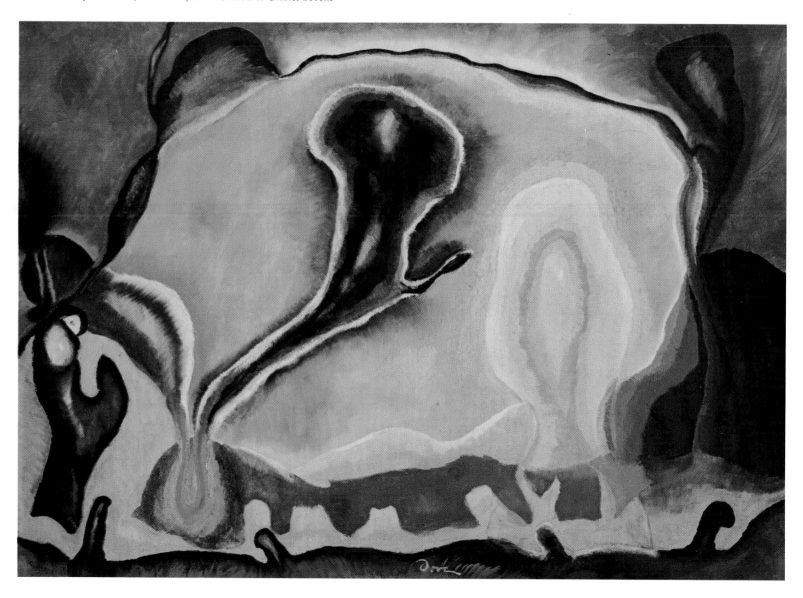

Hardware Store. 1938.
Oil and silver leaf on canvas, 25″ x 35″
Loretta and Robert K. Lifton, New York

81

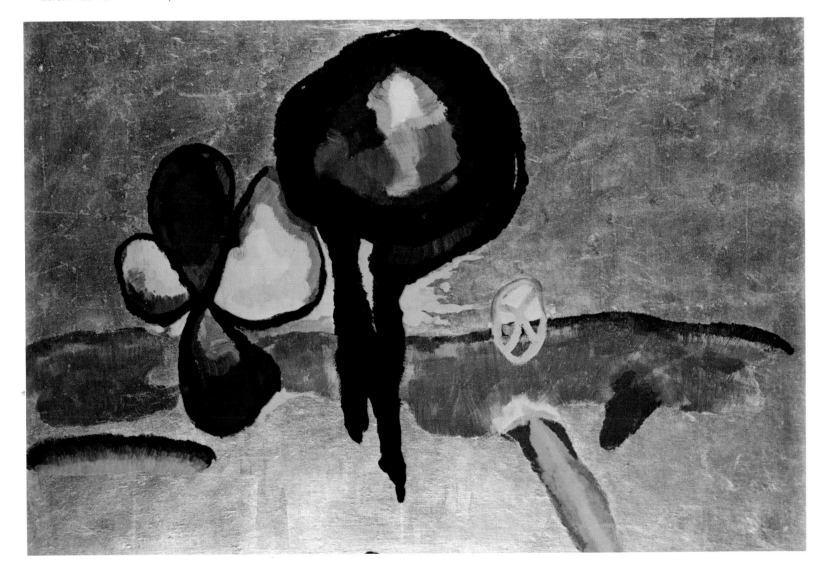

Ferry Boat Wreck. 1931.
Oil on canvas, 18" x 30"
Whitney Museum of American Art, New York
Gift of Mr. and Mrs. Roy R. Neuberger

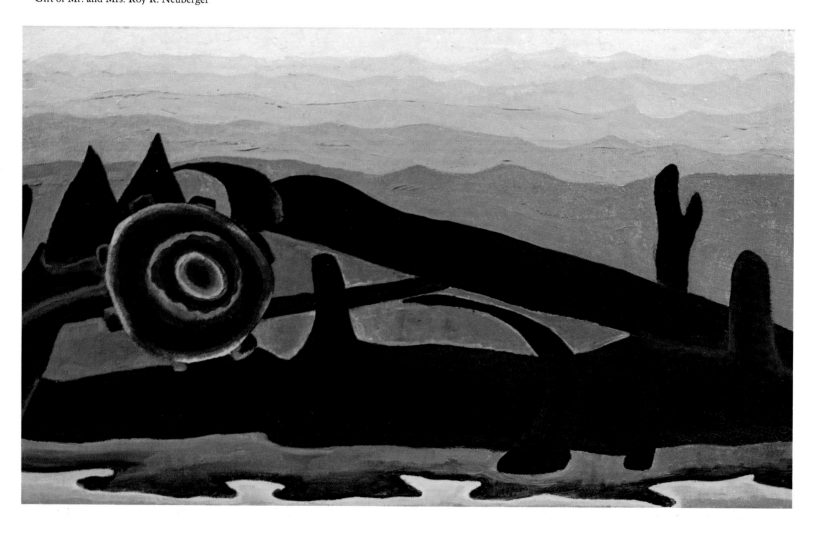

Fields of Grain as Seen From Train. 1931.
Oil on canvas, 24" x 34"
Albright-Knox Art Gallery, Buffalo, New York
Gift of Seymour H. Knox

83

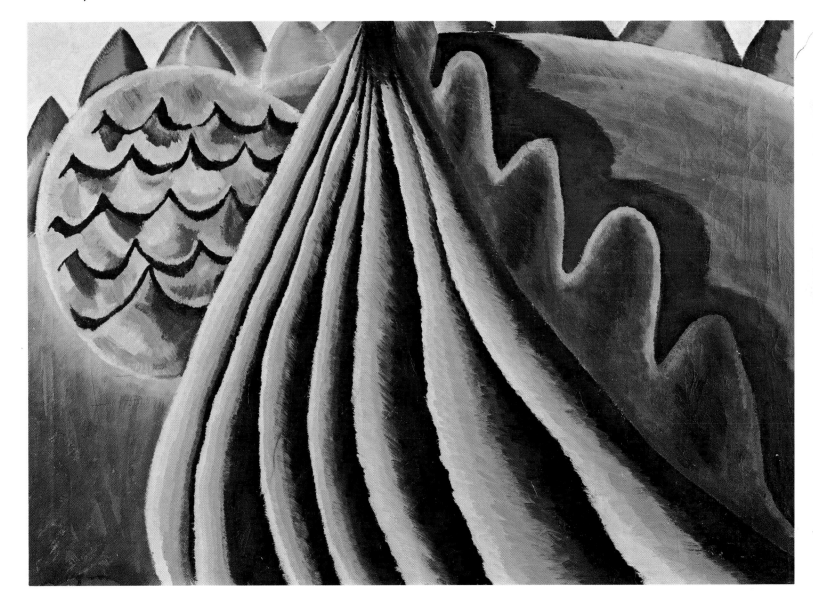

Trees and Covered Boat. 1932.
Oil on canvas, 20″ x 28″
Mr. and Mrs. Robert Kogod, Washington, D.C.

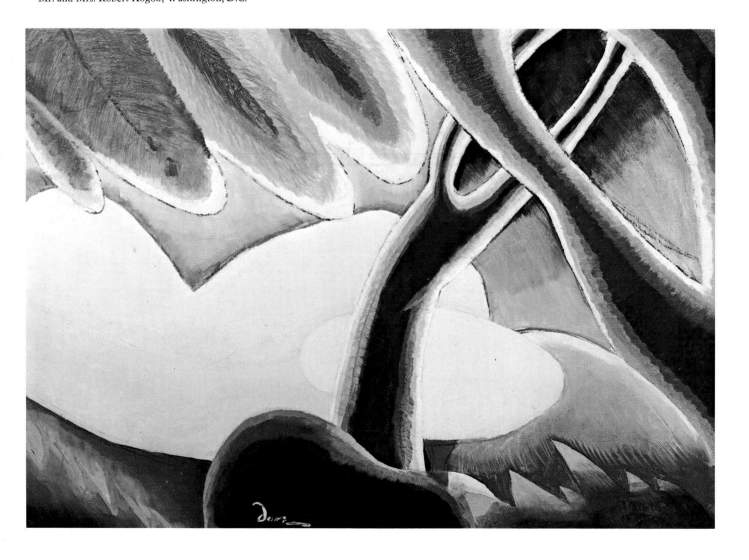

Moon. 1935.
Oil on canvas, 35″ x 25″
Mr. and Mrs. Max Zurier, Los Angeles

85

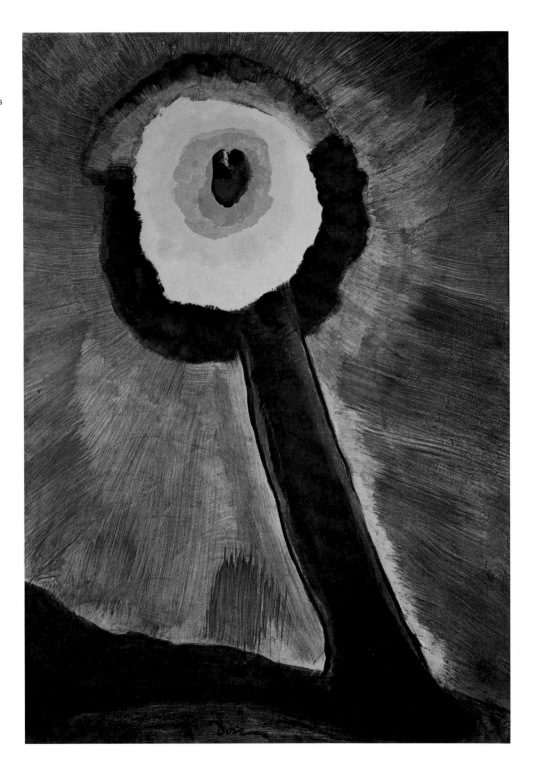

Summer Orchard. 1937.
Wax emulsion on canvas, 15″ x 20¹⁵⁄₁₆″
Munson-Williams-Proctor Institute, Utica, New York
Edward W. Root Bequest

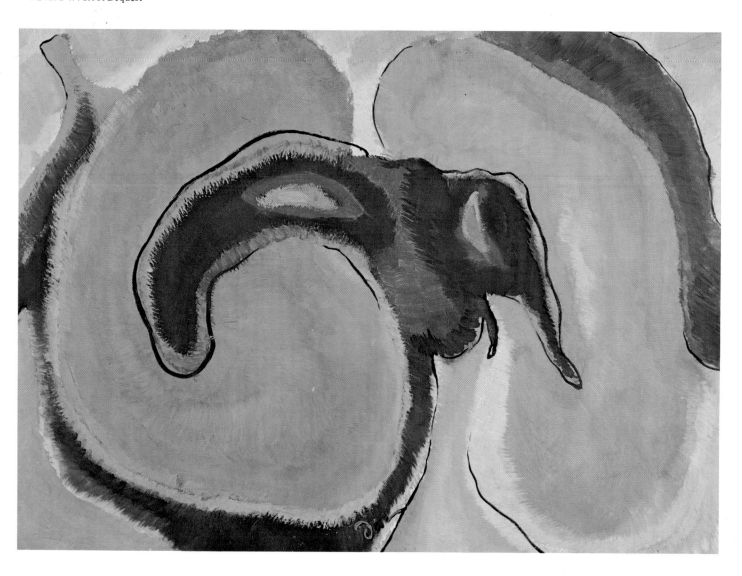

Cow #1. 1935.
Tempera and wax emulsion on canvas, 15″ x 21″
Randolph-Macon Woman's College, Lynchburg, Virginia

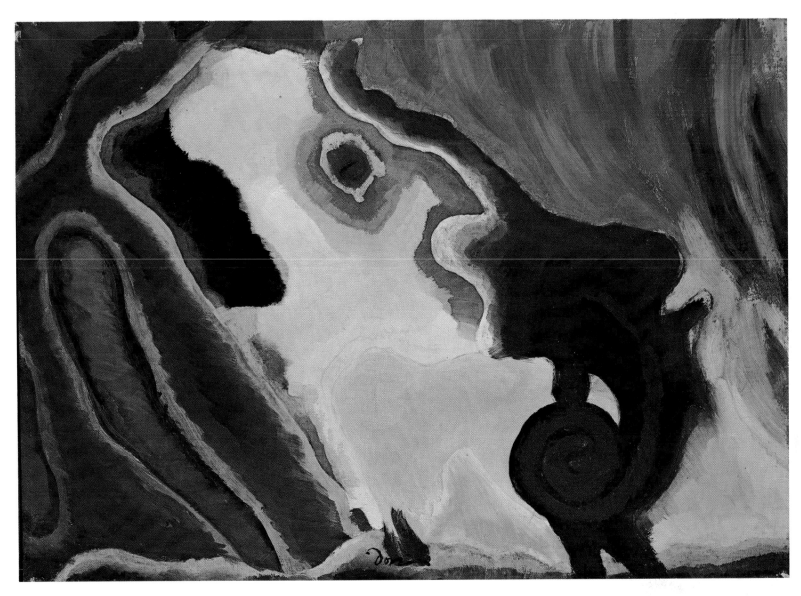

Sunrise I. 1937.
Wax emulsion on canvas, 25″ x 35″
William H. Lane Foundation

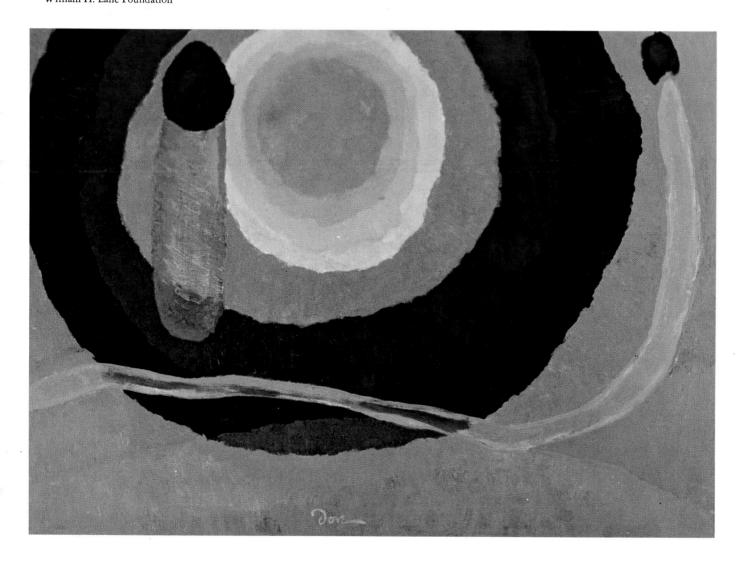

89　　*Snowstorm.* 1935.
Oil on canvas, 14″ x 20⅛″
Private collection

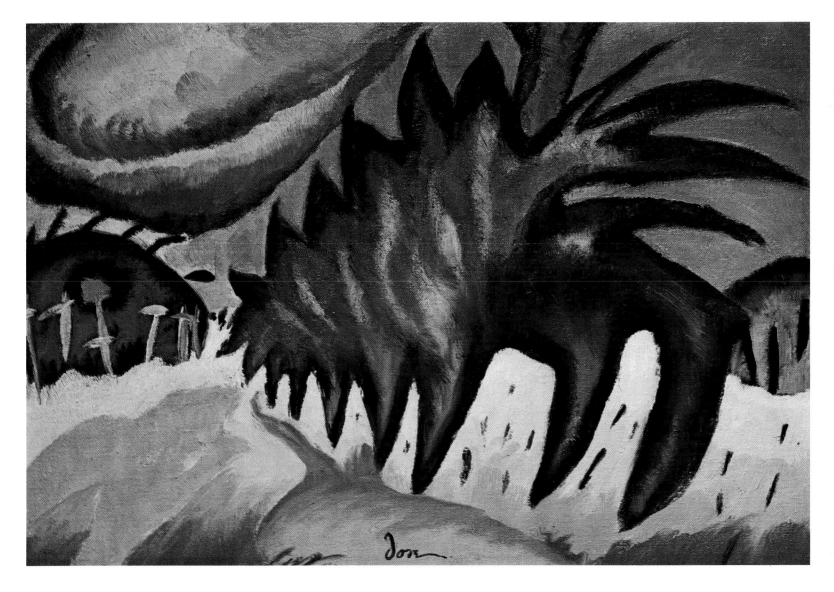

Sand Barge. 1930.
Oil on composition board, 30″ x 40″
The Phillips Collection, Washington, D.C.

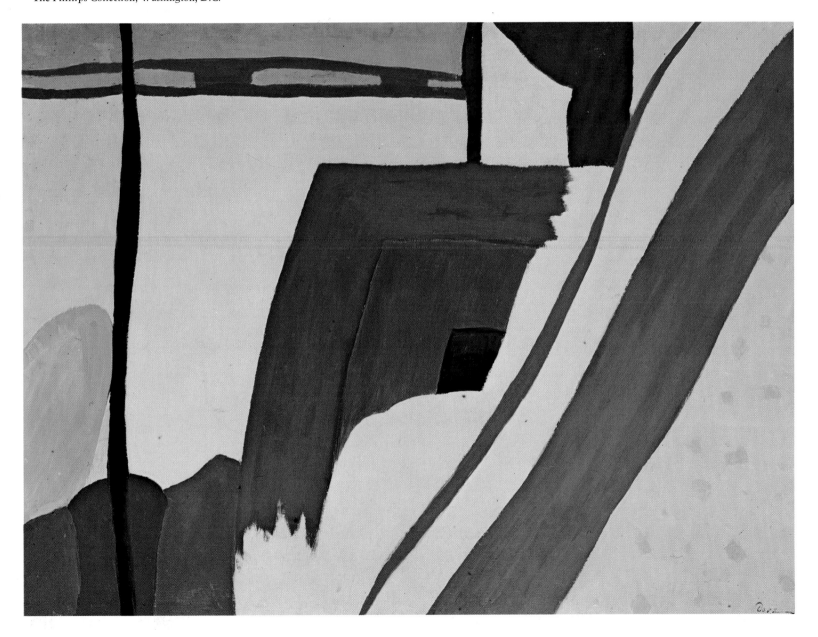

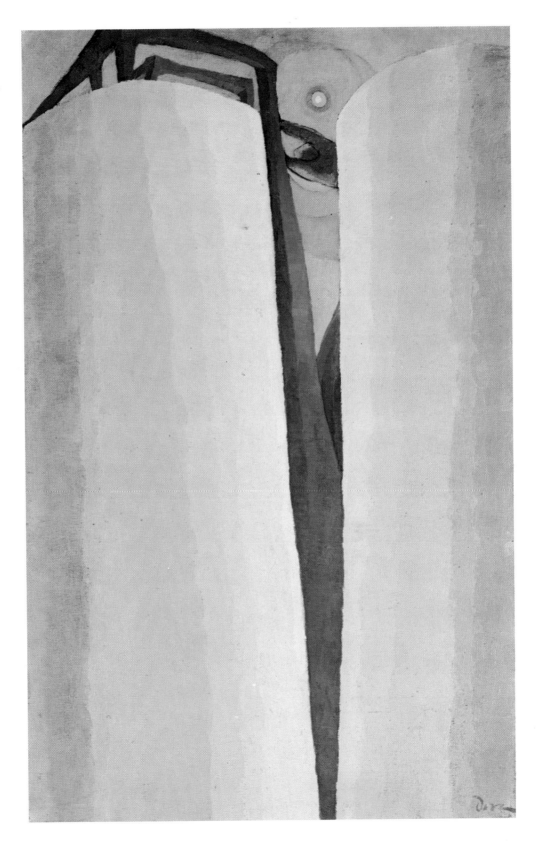

Silver Tanks and Moon. 1930.
Oil on canvas, 28⅛″ x 18″
Philadelphia Museum of Art,
Alfred Stieglitz Collection

91

Sunrise II. 1937.
Wax emulsion on canvas, 25″ x 35″
Richard J. Gonzalez, Houston, Texas

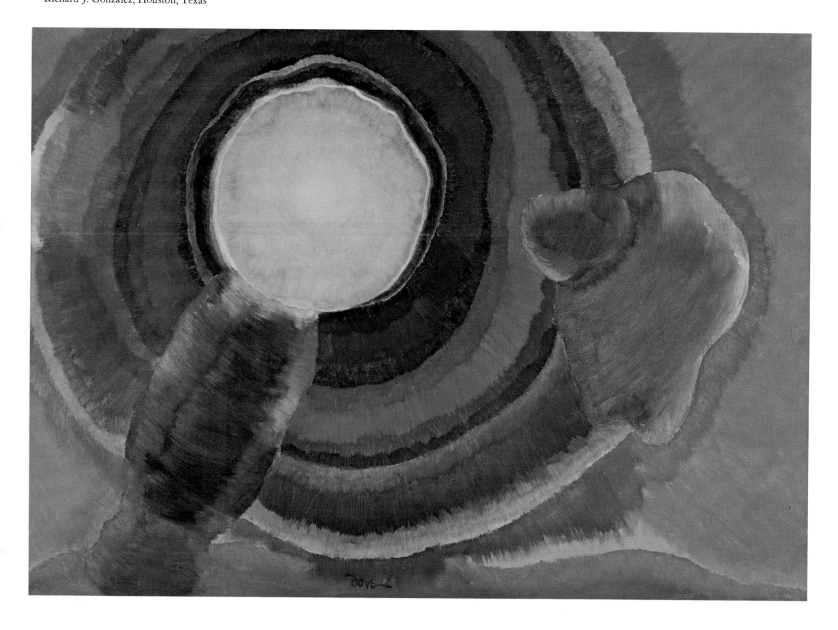

93 *Sunrise III.* 1937.
Wax emulsion on canvas, 24⅞″ x 35⅛″
Yale University Art Gallery, Gift of Collection Société Anonyme

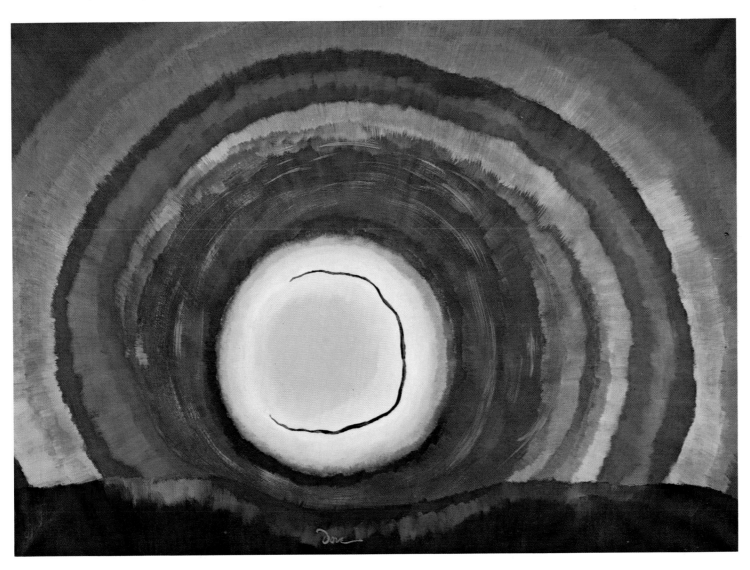

Graphite and Blue. 1936.
Oil on canvas, 25″ x 35″
Warren and Jane Shapleigh, St. Louis, Missouri

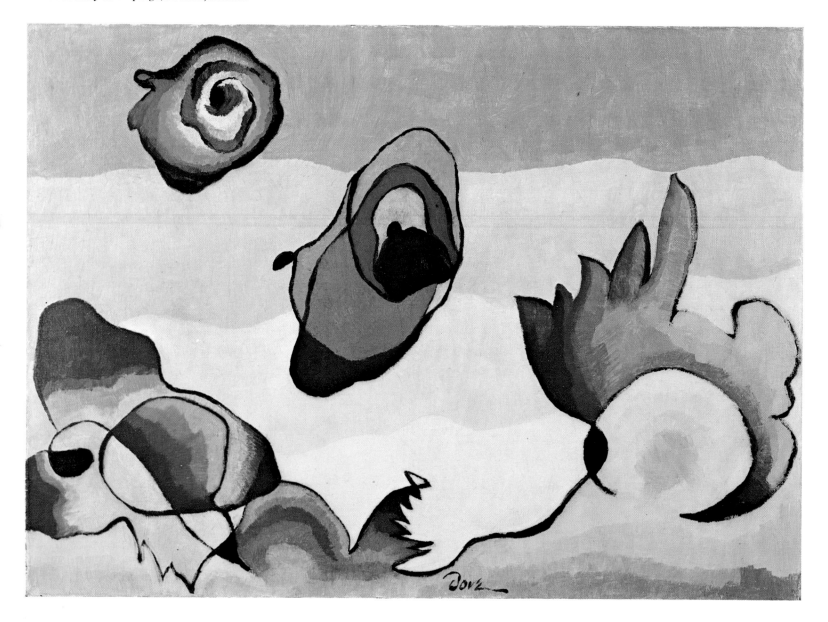

The Park. 1937.
Oil on cardboard, 16″ x 21″
Elmira Bier, Arlington, Virginia

95

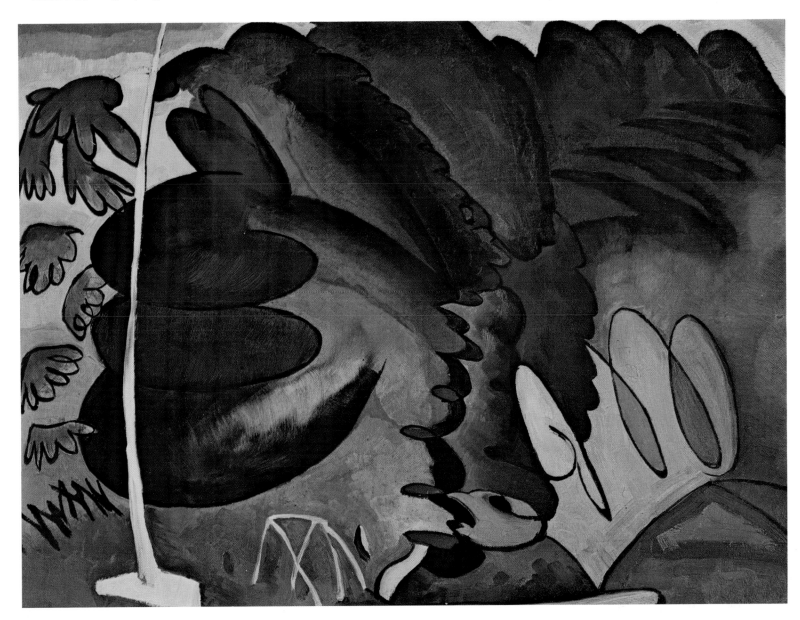

Goat. 1935.
Oil on canvas, 23″ x 31″
The Metropolitan Museum of Art, Alfred Stieglitz Collection

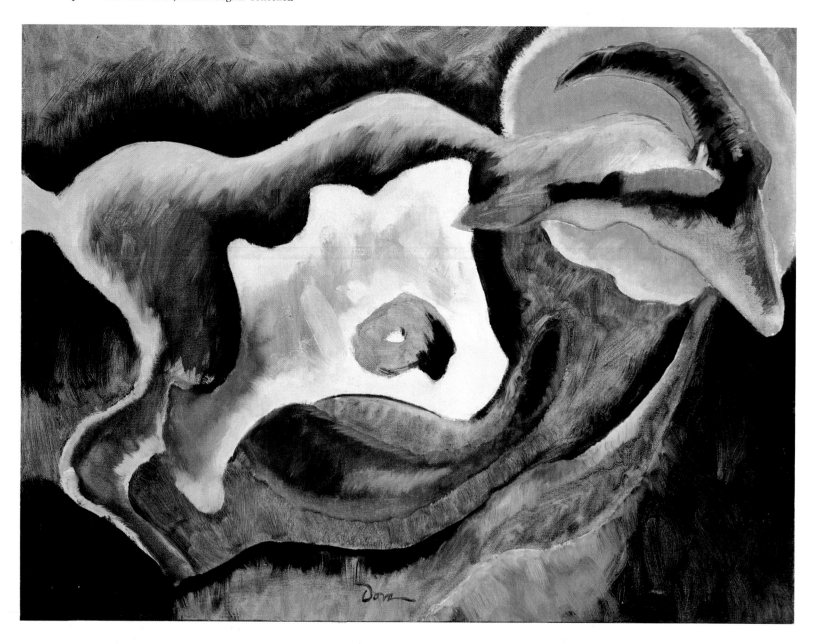

Alfie's Delight. 1929.
Oil on canvas, 22″ x 30″
The Herbert F. Johnson Museum of Art, Cornell University
Extended loan of Dr. and Mrs. Milton Lurie Kramer

97

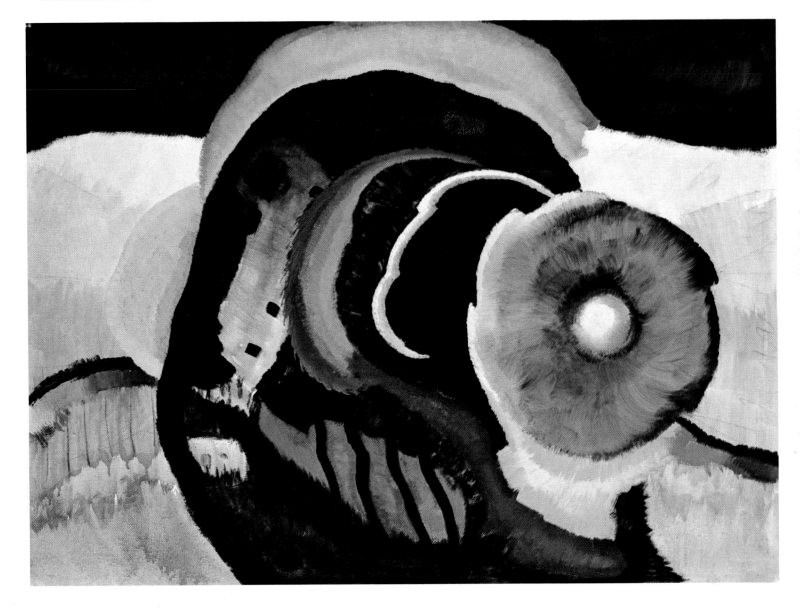

Tree Forms II. 1934–35.
Wax emulsion on canvas, 20″ x 28″
The Phillips Collection, Washington, D.C.

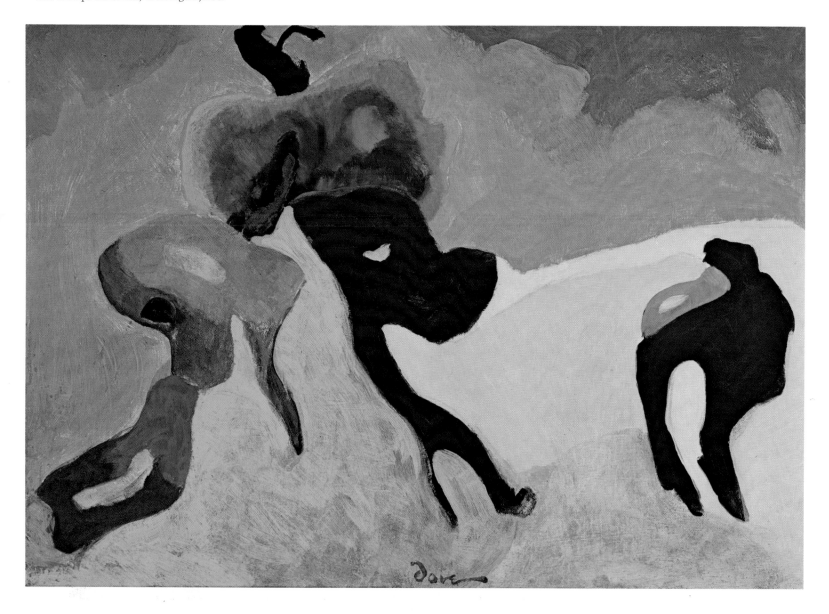

99

No Feather Pillow. 1940.
Wax emulsion on canvas, 16″ x 22″
Munson-Williams-Proctor Institute, Utica, New York
Edward W. Root Bequest

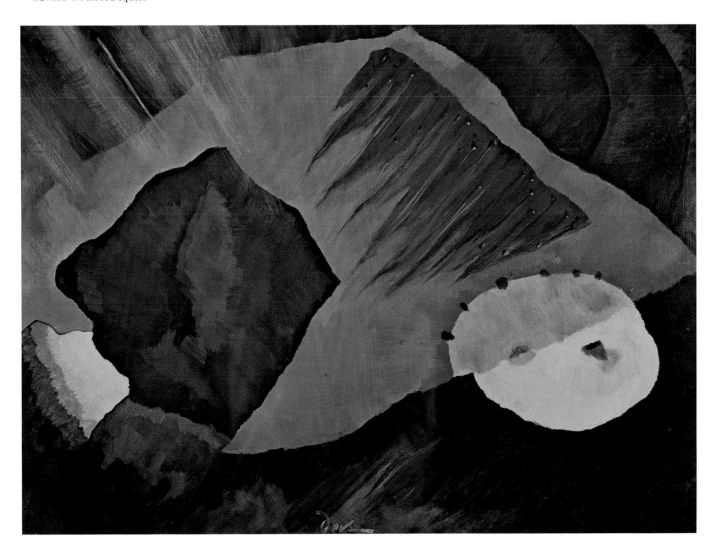

That Red One. 1944.
Wax emulsion on canvas, 27″ x 36″
William H. Lane Foundation

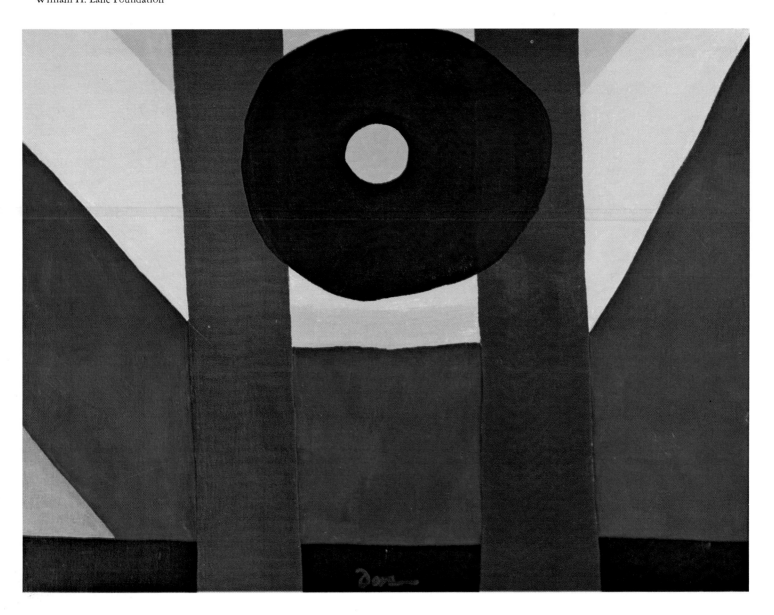

Rooftops. 1941.
Wax emulsion on canvas, 24″ x 32″
William H. Lane Foundation

101

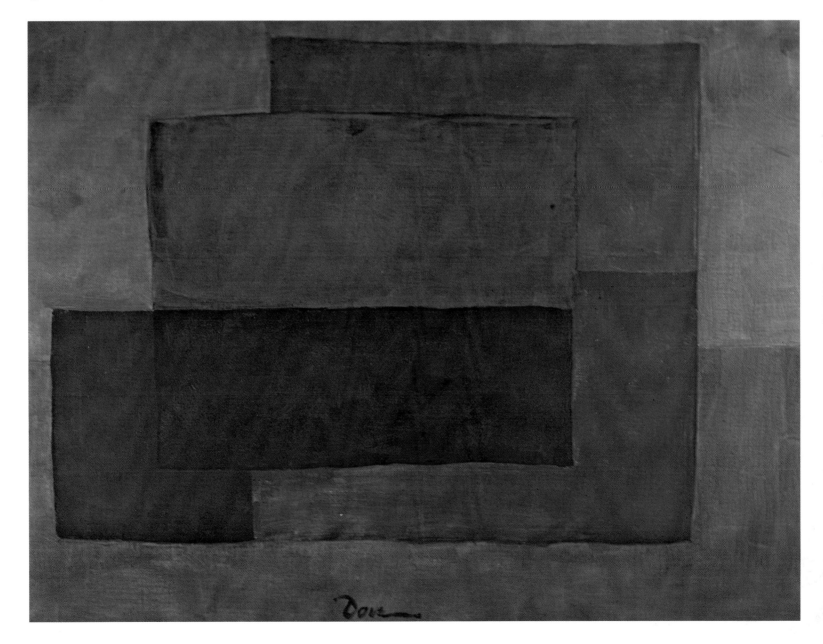

Long Island. 1940.
Wax emulsion on canvas, 20″ x 32″
Galen Brewster, Concord, Massachusetts

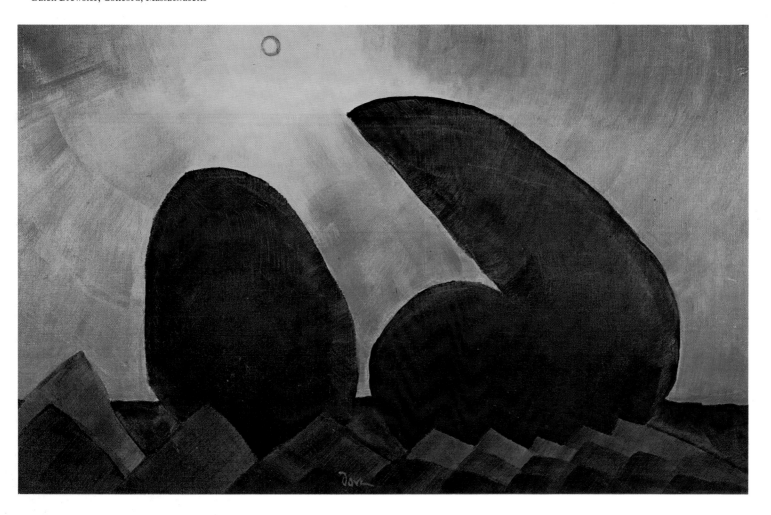

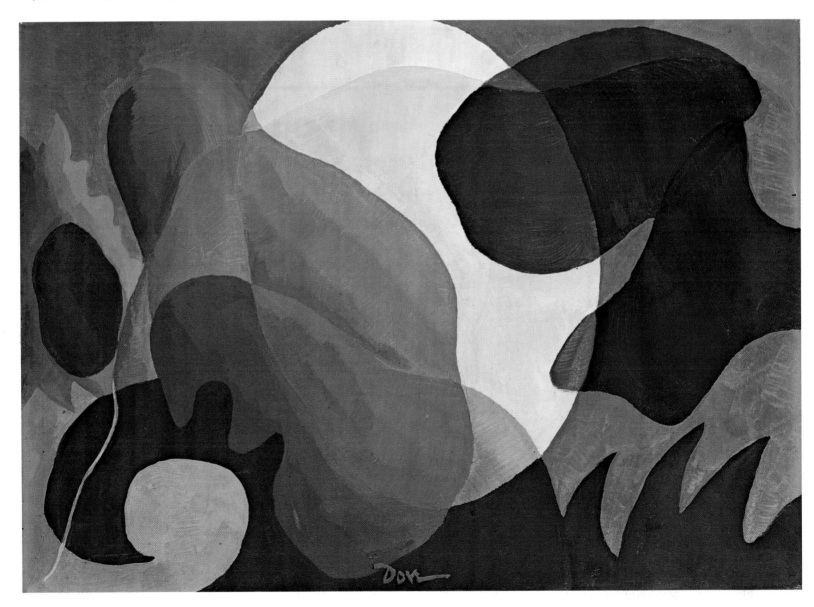

Through a Frosty Moon. 1946.
Wax emulsion on canvas, 14¾″ x 20⅞″
James M. McLaughlin, Washington, D.C.

103

Formation I. 1943.
Wax emulsion on canvas, 25″ x 35″
Fine Arts Gallery of San Diego, California

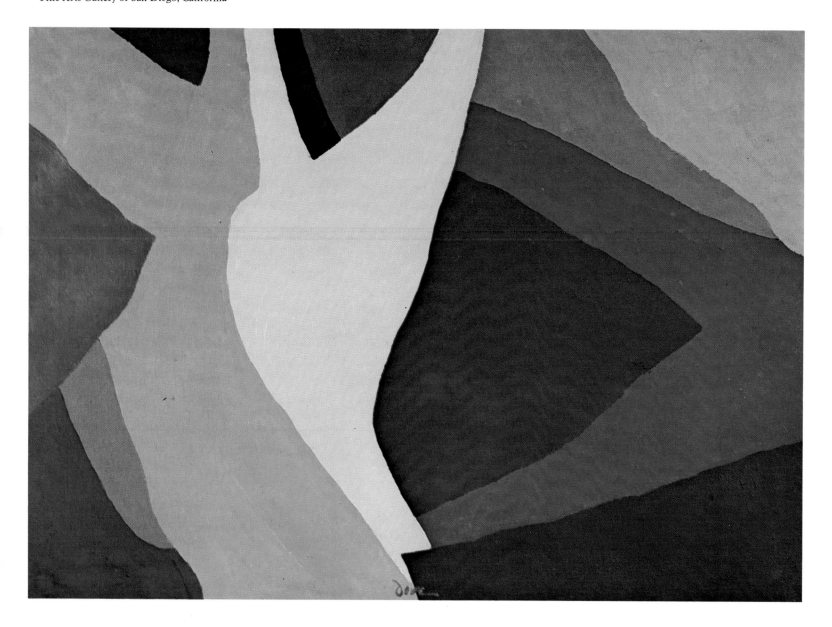

Flight. 1943.
Wax emulsion on canvas, 12″ x 20″
Elmira Bier, Arlington, Virginia

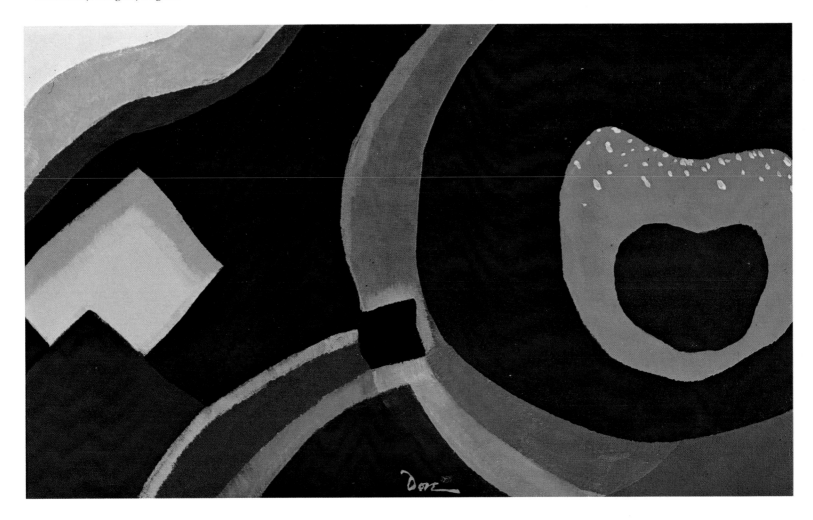

Centerport 1938-1946

By 1938 Dove was obsessed with the need to leave Geneva. "Everyone in Geneva," he wrote in February, "is dead or dying or just walking around ... guess we'd better get out."[70] Visiting his son on Long Island after a trip to New York City, he discovered an abandoned post office in Centerport. This twenty-foot square, one-room building which jutted out into an inlet in Long Island Sound was to be his home for the next eight years. Saying that he never wanted to return to Geneva, Dove bought the house with money from a sale to Duncan Phillips.

Dove had come down with pneumonia while he and Reds were in New York. Although he eventually recovered, the years of strenuous physical work had caught up with him and the deterioration of his health had begun. Pneumonia was followed by a severe heart attack in January of 1939. A letter from the family to Stieglitz reads, "Many complications have set in and the final one is a serious kidney condition. Chances at 50/50. He [Dove] doesn't know what or how serious the condition is and we are all very gay on the surface."[71]

By the end of the year he seemed to be recovering and was eager to resume painting, but even partial recovery was slow, and relapses were frequent. Dove's primary task was trying to take it easy. In May he wrote, "They push me around in one of those Sears Roebuck roller chairs so have been in the sun for two or three days and it helps. Walk very little. Work is a lift if I don't overdo it." The following month: "Was put in bed again for having a temperature or walking too far or something. Pretty lucky to have this swell outlook however. Walked across yard yesterday. Guess I am getting better as all this delay (from painting) irritates me more and more."

On July 4 he wrote: "Am allowed to bathe myself, be in the sun a bit and do quite a bit of work, that is once a day. If I drop my tools, the whistle blows for the day and no more work or thinking either. If I am caught at it — that is looking serious — immediately have to change expression to one of complete bliss. Of course they may be perfectly right. How do I know? They were at first. Why not now? Am getting better at it anyhow and improving rapidly, even in work and ideas I hope. This convalescence is quite a game I find — much more subtle than getting one's foot in the grave. It is nice to be out of the dog house anyway if only on a leash."

In April of 1941 he wrote: "I never know when I go to bed whether I am going to wake up sitting on the right hand of God or just sitting. It is fine to be up here anyway." Recovery seemed to be steady — in March of 1942 he wrote, "Was told a year ago I would never walk like other people. Now I am on my feet about one-half the day, stretching canvas, coating it, etc."

Although Dove had lived through his heart attack, he remained a semi-invalid for the rest of his life. Painting was his only activity. Not only was he kept from much physical exertion, but Reds was very protective about not allowing many visitors to see him. As he recovered, he was allowed to take

Dove,
Centerport, Long Island

Dove residence in
Centerport, Long Island

short excursions around the area and to accompany his doctor on his rounds.

His heart condition had been complicated by Bright's disease (a kidney disorder) which apparently was far more serious for Dove than the difficulty with his heart. In order to keep spirits up, the doctor focused everyone's attention on Dove's heart, which continued to register improvement, and kept the knowledge of Dove's deteriorating kidneys from them.

Despite the uncertainty of his health, Dove was enthusiastic about life and continued to look forward to the future with humor and high spirits. "Life after all," he said, "is pretty damn swell."[72] In a letter that expressed his humor and his admiration for what Stieglitz was doing, Dove wrote: "I am out here in the sun beside the water while you are walking on it again with the rest of the miracles."

Considering the state of his health he was incredibly productive and was enthusiastic about new developments in his paintings. A typical note to Stieglitz reads, "the new ones so far are very clear cut and there's something new that I think worth fighting for." Although the gap between Dove and the public was as great as before, financial recognition seemed to be coming. In 1939, ironically during the precarious stage of his heart attack, Dove had written, "So life goes beautifully on and now the only time we have had any finances to think about, I am not allowed to think about them." He received a $1,000 check from Stieglitz in October and jokingly asked him to verify it with the bank, commenting that "they [the bank] are used to '100' and might imagine I had added an '0'."

The seclusion and calmness that this period required provided Dove with time to delve deeper into himself and discover a more permanent reality than that which the flux of appearance suggested. Illness created an introspection reminiscent of T. E. Lawrence's statement that the desert spawns religion, as cities are replete with subject matter to the point of distraction. "For all these efforts in painting," Dove wrote, "we must have leisure. It is so important. Leisure to work, leisure to search for our next truth. Leisure seems so confused with money and material things these days." It was natural that, from this period, came paintings of dynamic immobility that expressed a more impersonal and timeless absolute.

Colored Planes (Formation II). 1942.
Wax emulsion on canvas, 24″ x 32″
Gordon F. Hampton Collection, San Marino, California

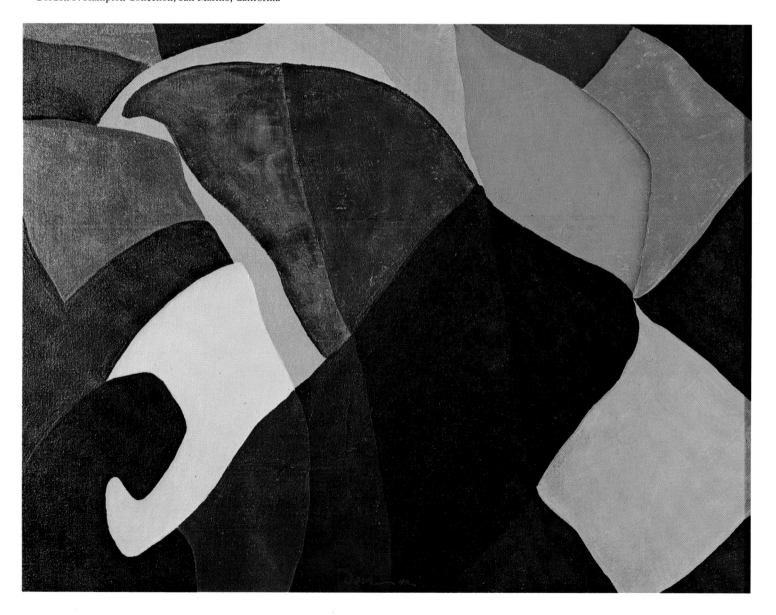

Traveling. 1942–43.
Wax emulsion on canvas, 16″ x 26″
William H. Lane Foundation

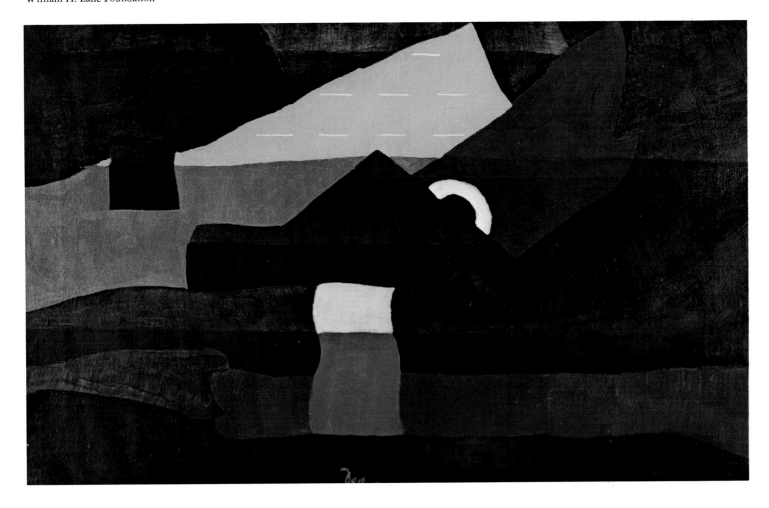

Paintings 1938-1946

*We cannot express the light in nature because we
have not the sun — we can only express the light we
have in ourselves.*
Arthur Dove

*We are moving toward serenity by simplification
of ideas and means. Our only object is wholeness.*
Henri Matisse

Dove's paintings changed around 1938 toward a greater
harmony and quiet. The new work was tranquil and detached;
it had the "calme" of Matisse in a way that his more ener-
gized, explosive work could never have had. His tendency
toward extracting essences increased to the exclusion of all
that was momentary or partially transitory. It was as if his
primary objective was the attainment of an undisturbed
timelessness.

Like Matisse, Dove achieved serenity through simplifi-
cation. His shapes were drastically minimalized and more
distinctly defined; color became co-extensive with shape and
the active brushstrokes of his earlier periods were replaced by
flat, evenly applied areas of color. In place of a dynamic image
evocative of movement and flux, Dove introduced a static icon
inducive of contemplation. Instead of an ecstatic emotionalism,
these elemental forms illustrated essential relationships and
tensions between things.

The more generalized relationships in these paintings relate
to concepts of Gestalt psychology. According to Gestalt theory,
we cannot perceive forms in any visual situation without or-
ganizing them into "wholes" or patterns. Ideas of squareness,
roundness, etc., previously thought to be generalized or ab-
stract concepts are considered the foundation of perception.
As Rudolf Arnheim described in *Art and Visual Perception*,
"It seemed no longer possible to think of vision as proceeding
from the particular to the general. On the contrary, it became
evident that overall structural features are the primary data of
perception, so that triangularity is not a late product of intel-
lectual abstraction but a direct and more elementary experience
than the recording of individual detail."

Although Dove continued to evolve his imagery by looking
at the world, traditional landscape space was virtually elimi-
nated in these paintings. Dove uniformly activated the entire
surface of the painting by applying colors of equal intensity
over all of the picture plane. When he changed colors, he did
not model them subtly as in earlier paintings, but indicated
them boldly. No color, therefore, appeared to recede or ad-
vance in front of another one. Instead, each color clung to the

111

surface of the picture with equal intensity. Depth was thus denied in these works and the flatness of the picture plane was asserted.

This technique has been one of the significant steps away from representation towards abstraction among modern artists. In order to make an art object that was experienced, not as an imitation of anything, but as something real in itself, it was necessary to eliminate any reference to the spatial, real world. By ceasing to create a fictive three-dimensional world, Dove and the other modern artists insured the autonomous reality of art. "Pure painting," Dove said, "has the tendency to make one feel the two-dimensionality of the canvas, a certain flatness which is so important in the balance of things and often so difficult to attain."

This aspect of flatness, combined with Dove's use of more minimal shapes, gave these paintings a less referential feeling. However, the visual experience, even in these works, always took precedence over the conceptual. Shapes and their relationship to one another were still extracted from visual sources. The tilted square that dominates *Square on the Pond,* for instance, was derived from a Catholic monastery across the pond that had two peaked roofs.

Although they are more formal than his previous work, these paintings have a softness and gentleness that contrasts with the mechanical precision and systematic formalism of geometric abstractionists like Fritz Glarner and Burgoyne Diller who were working in the thirties. The circular forms, irregularly shaped rectangles and softly rendered boundary edges are outside the strict formalism that these painters maintained.

Structure. 1942.
Wax emulsion on canvas, 25″ x 32″
Mr. and Mrs. M.A. Gribin, Los Angeles

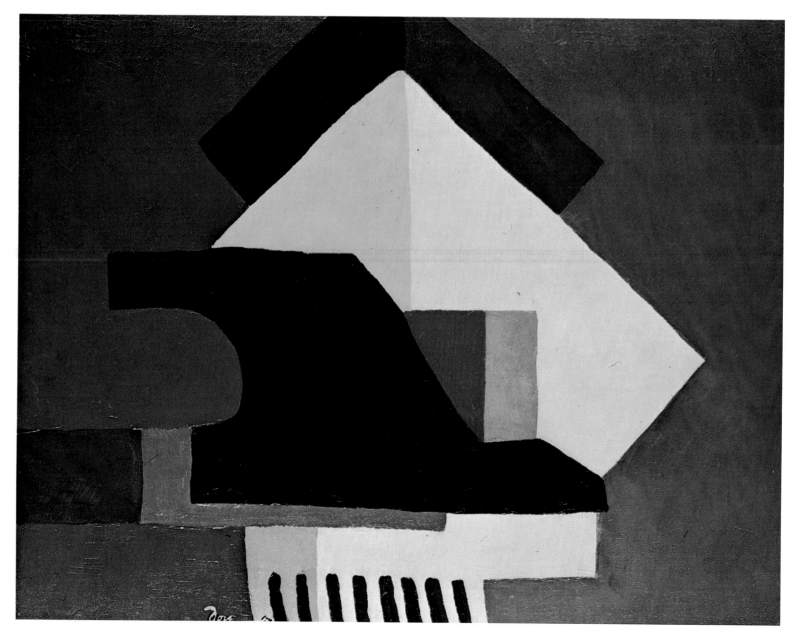

Square on the Pond. 1942.
Wax emulsion on canvas, 20″ x 28″
113 William H. Lane Foundation

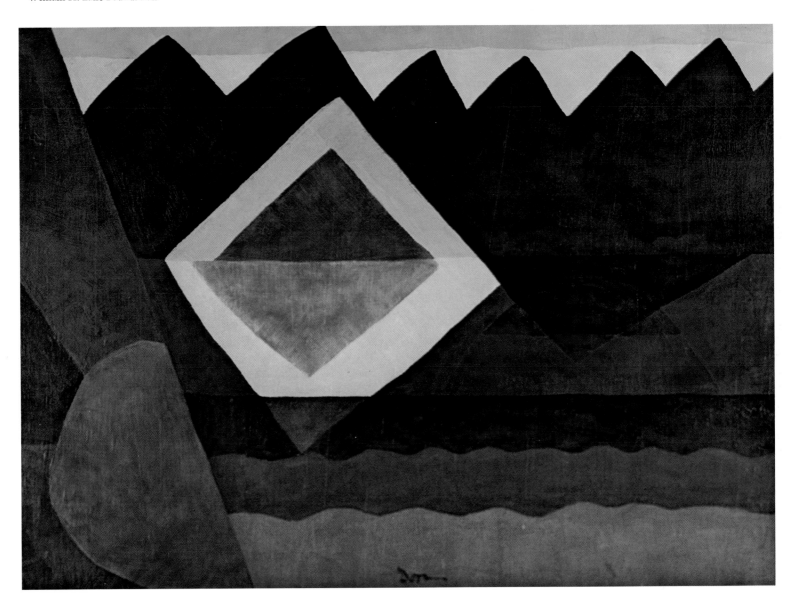

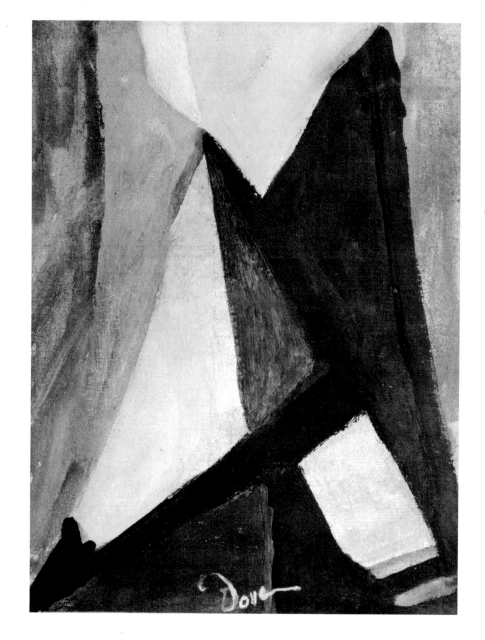

Beyond Abstraction. 1946.
Wax emulsion on canvas, 12″ x 9″
Dr. and Mrs. Leo Chalfen, New York

Dove's almost obsessive concern with continuity and whole-ness were again expressed by the repetition of similar shapes in a composition and, in general, by consistent color intensities. His preference for compositions with a dominant center lingers but forms are distributed more evenly over the entire surface.

In July of 1946 Alfred Stieglitz died. The death of Paul Rosenfeld, who had aligned himself with the Stieglitz group and had supported them in his writings, occurred soon after, and both John Marin and Arthur Dove had heart attacks. Whether this was a coincidence or reflected the loss of morale each of them felt is conjecture. John Marin recovered from his attack. Dove did not. One side of Dove's body, including his face, was left paralyzed and self-initiated movement was im-possible.

Although he was unable to paint without help, he continued to speak of new advances in painting. During the last months of his life, he would paint by having Reds steady his paint brush-held hand and move it to where he told her he wanted it on the canvas. This less decisive means of working is reflected in the loose, wash quality of these paintings.

The forms in these paintings, which Dove titled *Beyond Abstraction*, seem to have severed their connection with the external world. Possibly as a result of the separation from the world that was required during this period, these paintings reflect a state of mind that has turned inward. It is as if the stimulation of the external world was no longer necessary as subject matter and these paintings are instead "mind land-scapes." It may have been Dove's awareness and acceptance that death would at any moment end his work that created the serenity of these paintings. Once death was no longer feared, it was as though Dove existed in a spirit of absolute calmness. Dove died in a Huntington hospital on November 22, 1946.

Dove the Man

I should like to enjoy life by choosing all its high-est instances, to give back in my means of expression all that it gives to me: to give in form and color the reaction that plastic objects and sensations of light from within and without have reflected from my inner consciousness. Theories have been outgrown, the means is disappearing, the reality of the sensation alone remains. It is that in its essence which I wish to set down. It should be a delightful adventure. My wish is to work so unassailably that one could let one's worst instincts go unanalyzed, not to revolu-tionize nor to reform, but to enjoy life out loud. That is what I need and indicates my direction.
Forum Exhibition catalogue, 1916.

Dove was a warm, earthy man with a good sense of humor who enjoyed people. Even during the time he lived aboard the *Mona,* he was not isolated. Reds described, for example, that when he went for mail in the morning to Halesite he would wait on customers when the postman was busy. If he associ-ated less with the New York art crowd than others did, it was partially due to his distance from the city. Also, he enjoyed the realness and absence of theatrics and pseudo-intellectualism of the neighborhood people, preferring to make art more than to talk about it.

The diaries that Reds kept from 1924 on described the fre-quent flow of friends who stopped by for visits and dinner. On these occasions, Dove was often the cook. Since both Reds and he enjoyed drinking, they made their own wine and beer; in Westport, during Prohibition, Dove supplied the drinking population with his homemade bathtub gin.

He was an extremely generous person and whenever money was available he would celebrate with his friends. In New York when he had an allowance he would spend it all in the first few weeks and end up the month with twenty-five cents.

Being adventurous in his life as well as in his art, Dove was willing to experiment with new ideas and was frequently the first to try out a new activity. He was intensely concerned with improving his technical craftsmanship and read voraciously on the subject. He was meticulous about keeping records on file cards of which colors and varnishes he had used in each painting, in case he needed to retouch or repair works. A great deal of his painting time was spent on the mechanical aspects of his art — stretching canvas, applying gesso, making frames and making packing crates.

One of his primary interests was the texture of materials. He freely experimented with new media and often incorpo-rated non-art materials into his compositions. In the twenties, while he was working with assemblages, he began experiment-ing with metallic paint and a variety of unusual supports such as tin, aluminum sheeting, copper and glass.

The *Mona* was too confining for grinding pastels so in the early twenties Dove began searching for a medium that would provide the same texture as pastels but would be more perma-nent. At first he used egg or casein tempera as an under-painting for oil. Around 1936 he turned to a wax emulsion medium which produced a velvety matte finish.

Across the Road. 1941.
Wax emulsion on canvas, 25″ x 35″
Mr. and Mrs. James S. Schramm, Burlington, Iowa

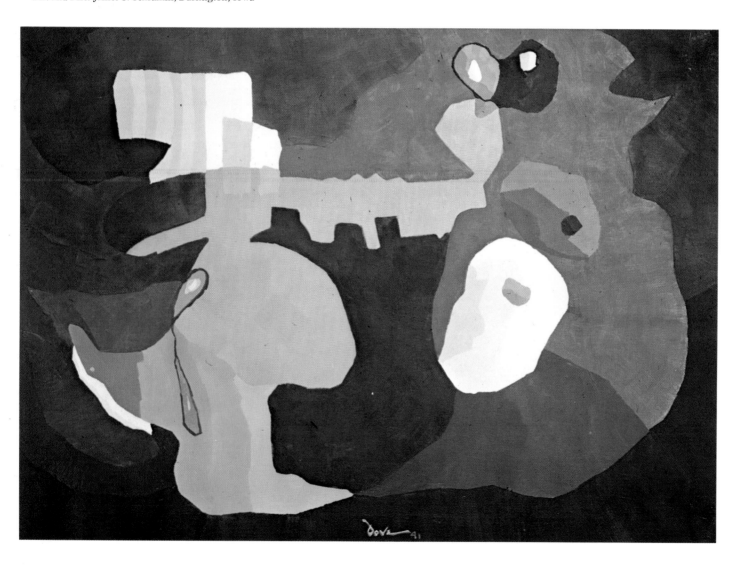

Rain or Snow. 1943–44.
Wax emulsion and silver leaf on canvas,
35″ x 25″
The Phillips Collection, Washington, D.C.

117

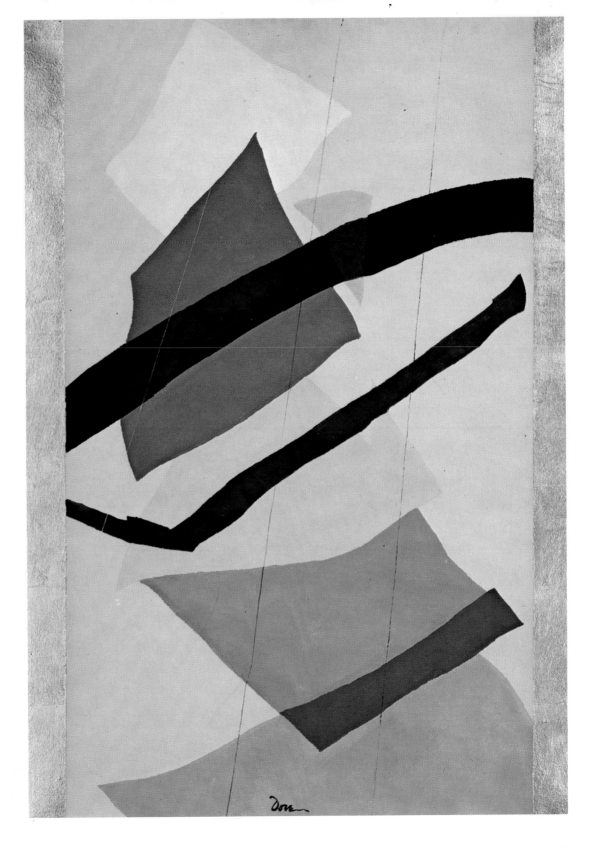

He ground all his own pigments and was constantly searching for new and more permanent colors. In a letter to Duncan Phillips, Dove wrote, "have read Cennino, Blockx, Toch and many others at least ten times each. Writers on permanency are prone to disagree." As Stieglitz's gallery assistant, William Einstein said, "Dove has done things with color that haven't been done for centuries and centuries."

Dove considered every component of the painting important. This held true for frames. Typically his frames were simple wooden mouldings with beveled edges that subtly led the eye into the painting. The matte surfaces of the frames were often painted silver or made out of copper and tin to correspond with the color harmonies in the painting. Dove's concern with the esthetics of the frame is illustrated in a note to Stieglitz: "Something in frames that did not blaze the way it should. After two years of using Japanese gold size from store, I have found out how to do it better with varnish ground so that the same frames have twice the speed — now same feeling as the paintings — makes an amazing difference."[73]

Dove's commitment to every aspect of his art was reflected in his attitude toward life. He believed that everything in the world was a living, vital presence, and once said that "we cannot let a person control our thoughts who does not let the lower orders in. Animals, fish and birds have as much right to any spiritual royalty as any intellectual."

Dove lived with a faith in the continuity of life. When Charles Demuth died, Dove wrote to Stieglitz: "When people die I feel that they grow younger until they are born again. It must be something like that or nature could not breathe as it does. It is not a sad thing to me as much as it is part of a natural continuance. Of course I get lumps in my throat, but when I do, it is at the point of the realization of a fine truth.

Alfy's [Maurer] case seemed to me to make the spiritual coming of age a trifle longer, but what has time to do with eternity?"[74] Dove did not put his faith in an omnipotent, "other" power, but in the perfection and continuity of nature itself. He once told his son that God was the perfection we had in ourselves.

Georgia O'Keeffe said in comparing John Marin and Dove: "Dove is the only American painter who is of the earth. You don't know what the earth is, I guess. Where I come from the earth means everything. Life depends on it. You pick it up and feel it in your hands. . . . No, Marin is not of the earth. He walks over the earth, but Dove is of it."[75] Dove did not impose his will on nature or people, but was receptive to the quality that each thing projected. He treated everyone, including children, with respect. Charles Brooks, a friend of the family, relates a local Halesite fisherman's description of why he preferred to go sailing with Dove: "For with Dove people came into more connection with the reality of the water beneath and of the wind around and of the little rowboat in the midst of it. Not through anything he said, simply through his presence. . . ."[76]

Dove's sense of oneness with the universe was not a product of study as much as a result of having lived with nature and having experienced the quiet states of being part of it. The peace and harmony that Dove drew from nature were reflected in his character. He had the serenity and calmness that comes from knowing and accepting oneself. Charles Brooks said he never met anyone who was more like a Zen roshi than Dove.[77]

Just as Dove brought to his paintings the spirit of the whole man, so too did he bring that wholeness to his life. He projected a sense of interdependence between the intellectual and the emotional and a harmony between himself and the earth.

Holbrook's Bridge to the Northwest. 1938.
Wax emulsion on canvas, 25″ x 35″
Mr. and Mrs. Roy R. Neuberger, New York

119

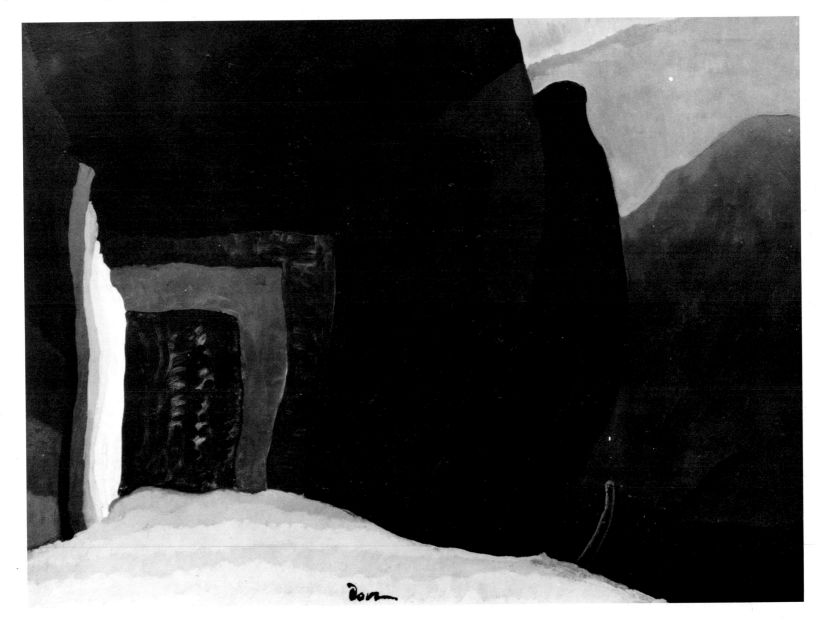

On the Banks. 1941.
Watercolor on paper, 5″ x 7″
Robert Halff and Carl W. Johnson, Los Angeles

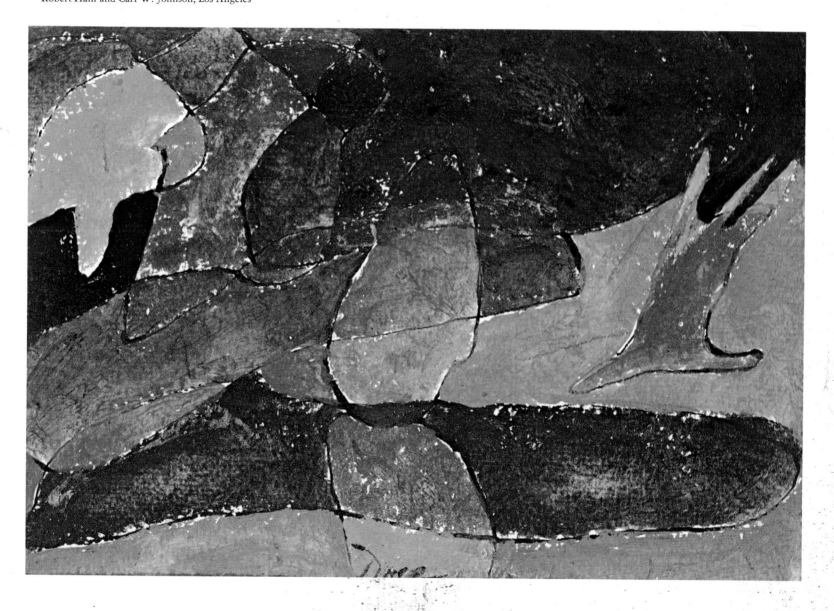

Pieces of Red, Green and Blue. 1944.
Wax emulsion on canvas, 24" x 18"
William H. Lane Foundation

121

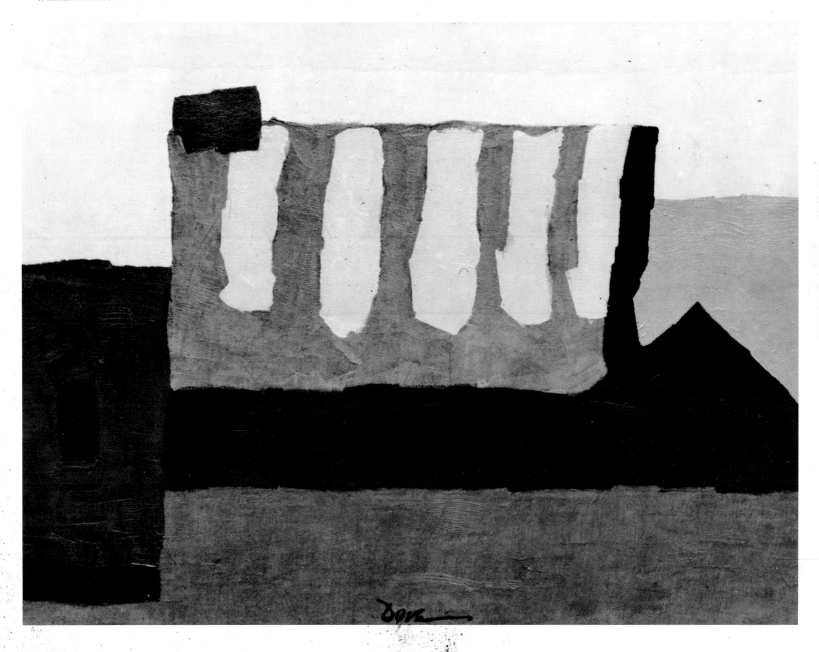

Footnotes

1. H. Effa Webster.
 Chicago Examiner, March 15, 1912.

2. In recent years there has been considerable interest in the Lüscher Color Test which reports to provide psychological and physiological information on individuals from their color preferences. Although more similar to Wassily Kandinsky's approach to color than to Dove's, it is another manifestation of the attitude that color can reveal qualities which cannot be seen with normal vision.

3. Samuel M. Kootz. *Modern American Painters.* Brewer & Warren Inc., 1930.

4. Arthur Jerome Eddy. *Cubists and Post-Impressionism.* McClung, 1914.

5. Statement by Dove in exhibition catalogue, The Intimate Gallery, 1927.

6. Eddy, op. cit.

7. Unpublished notes.

8. Letter to Alfred Stieglitz, July 19, 1930.

9. The catalogue of the 1908 exhibition lists an "Arthur E. Door," born in New York, who presumably is Dove.

10. *America and Alfred Stieglitz.* Edited by Waldo Frank, Lewis Mumford, Dorothy Norman, Paul Rosenfeld and Harold Rugg. Doubleday, Doran & Company, Inc., 1934, p. 245.

11. Dore Ashton. *The New York School: A Cultural Reckoning.* The Viking Press, 1972, p. 9.

12. Barbara Rose. *American Painting: The 20th Century.* Skira, 1973.

13. *New York Post,* 1909.

14. Dorothy Norman. *Alfred Stieglitz: An American Seer.* Random House, 1973, p. 119.

15. Herbert J. Seligmann. *Alfred Stieglitz Talking: Notes on Some of His Conversations, 1925-1931.* Yale University Library, 1966.

16. Van Wyck Brooks. *An Autobiography.* E. P. Dutton & Co., Inc., 1965, p. 362.

17. Frederick S. Wight. *Arthur G. Dove.* Exhibition catalogue, University of California, Los Angeles, 1958, p.24.

18. Statement by Dove in exhibition catalogue, The Intimate Gallery, 1929.

19. First quote: Kootz, op. cit. Second and third quotes: unpublished notes.

20. Statement by Dove in exhibition catalogue, The Intimate Gallery, 1929.

21. During this same period not only Kandinsky, but others like Franz Kupka and Robert Delaunay were also beginning to make paintings that did not refer to outward facts, but instead took as their subject the interaction and rhythmic dynamics of color and form. It is highly unlikely that Dove was aware of the painting experiments that any of these artists were undertaking. As with other breakthroughs that are discovered by more than one person, all of these painters were independently coming to similar conclusions about the possibilities of abstraction.

22. Paul Overy. *Kandinsky: The Language of the Eye.* Praeger Publishers, Inc., 1969, p. 93.

23. Hutchins Hapgood. "The Live Line," *The Globe and Commercial Advertiser.* New York, March 8, 1913, p. 7.

24. Wight, op. cit., p. 21.

25. Webster, op. cit.

26. Joshua C. Taylor. *Futurism.* Exhibition catalogue, The Museum of Modern Art, New York, 1961, p. 13.

27. Ibid., p. 12.

28. Henri Bergson. *A Study in Metaphysics: The Creative Mind.* Littlefield, Adams & Co., 1965, pp. 143-144.

29. Unpublished notes, January 15, 1933.

30. Letter to Stieglitz, May 22, 1917.

31. In the past few years, scientists have verified the thesis that there are two kinds of perception. They have discovered that the human brain is split into two hemispheres, each hemisphere controlling a different faculty. On an elementary level, the right hemisphere is identified with intuition, imagination and fantasy, while the left hemisphere is identified with reason, logic and words.

32. Bergson, op. cit., pp. 162-163.

33. Peter Selz. *German Expressionist Painting.* University of California Press, 1957, p. 7.

34. Taylor, op. cit., p. 13.

35. Ibid., p. 13.

36. Thomas W. Leavitt. *German Expressionism.* Exhibition catalogue, Pasadena Art Museum, 1961, not paginated.

37. *America and Alfred Stieglitz,* op. cit., p. 135.

38. Ibid., p. 129.

39. Ibid., p. 135.

40. Letter to Stieglitz, October 8, 1929.

41. Letter to Stieglitz, 1923.

42. Ibid.

43. Letter to Stieglitz, August 26, 1921.

44. Letter to Stieglitz, June, 1929.

45. Letter to Stieglitz, 1930.

46. Letter to Stieglitz, December, 1932.

47. Letter to Stieglitz, December 22, 1932.

48. Alfred Kazin. *On Native Grounds.* Doubleday & Company, Inc., (Anchor), 1956. Originally published in 1942.

49. D. H. Lawrence. *Studies in Classical American Literature.* New York: Thomas Seltzer, 1923.

50. Letter to Stieglitz, August 28, 1925.

51. Excerpt from poem entitled "The 20th Century Limited or The Train Left Without Them."

52. Sam Hunter. *American Art of the Twentieth Century.* Abrams, 1973.

53. Alfred Kazin suggested in *On Native Grounds* that the postwar muckraking journalism was the American version of Dada.

54. Charles Burchfield, *Creative Art.* September, 1928.

55. Dorothy Rylander Johnson. *Arthur Dove: The Years of Collage.* Exhibition catalogue, University of Maryland Art Gallery, 1967, p. 13.

56. Roger Shattuck. *The Banquet Years.* Doubleday & Company, Inc. (Anchor), 1961, p. 332.

57. Ashton, op. cit., p. 19.

58. Ibid., p. 44.

59. Letter to Stieglitz, August, 1933.

60. Letter to Stieglitz, March 30, 1934.

61. Letter to Stieglitz, May 1934.

62. Letter to Stieglitz, March 7, 1934.

63. Letter to Stieglitz, March 6, 1938.

64. Letter to Stieglitz, January 10, 1934.

65. Elizabeth McCausland. "Dove, Man and Painter," *Parnassus,* December 1937.

66. Seligmann, op. cit.

67. Although the watercolors were often worked into larger paintings, they were considered complete in themselves. They possess a degree of spontaneity that was not possible in the paintings. Also, instead of depicting surface colors (the kind of color that we see "on" objects that presents a barrier beyond which the eye cannot pass), watercolors depict volume colors. Being transparent, they are seen as filling a three-dimensional space rather than occupying a flat surface. This gives an atmospheric fluidity to Dove's watercolor compositions.

68. Rose, op. cit., p. 19.

69. Barbara Haskell. *Claes Oldenburg: Object into Monument.* Exhibition catalogue, Pasadena Art Museum, 1971, p. 10.

70. Letter to Stieglitz, February 8, 1938.

71. Letter from Marion Dove to Stieglitz, January 17, 1939.

72. Letter to Stieglitz, May, 1935.

73. Ibid., August 10, 1931.

74. Letter to Stieglitz, November 6, 1935.

75. Seligmann, op. cit.

76. Charles Brooks. *Sensory Awareness: The Rediscovery of Experience.* New York: Viking Press, 1974.

77. Ibid.

	Personal Events	Historical Events	Selected Exhibitions *One-man exhibitions and selected group exhibitions*
1880	August 2. Arthur Garfield Dove born in Canandaigua, New York to William and Anna Chipps Dove. Family living in Canandaigua while father serves terms as County Clerk.	Election of James Garfield and Chester Arthur.	
1881		Garfield assassinated; Arthur becomes president.	
1882	Family returns to Geneva, New York where father owns a successful brick plant and later is a contractor.		
1883		Completion of the Brooklyn Bridge, first major suspension bridge.	
1886		The Haymarket Riot. Trade unions and workers resort to collective action as their only effective weapon against business. Formation of the American Federation of Labor (AFL).	
1887		Dawes Act confirms end of American Indian independence.	
1891		Van Gogh retrospective exhibition at Salon des Independants in Paris.	
1892	Resigns from Presbyterian church. Birth of his brother, Paul.	Populist party enters national politics.	
1895		Marconi invents the wireless telegraph.	
1896	Due to a steady increase in their economic status, family moves from North Main Street to a house at 512 South Main Street, the more fashionable district of Geneva.		
1897		William McKinley elected president. A vote to continue alliance of government and business. Alfred Stieglitz assumes editorship of *Camera Notes*.	
1898		Eugene V. Debs establishes the Social Democratic Party of America. Advocates public ownership of all means of production and distribution. Spanish-American War.	
1899	Attends Hobart College in Geneva for two years, then transfers to Cornell University, Ithaca, N.Y.		
1900		Publication of Sigmund Freud's *The Interpretation of Dreams*. J. P. Morgan and Andrew Carnegie form U.S. Steel Corp. Max Planck formulates the quantum theory of energy.	
1901		William McKinley assassinated. Theodore Roosevelt becomes President. Socialist Labor Party and Social Democratic Party unite to form the Socialist Party of America.	
1902		First attempt at mass circulation of magazines; *The Saturday Evening Post* sells 314,671 copies per issue. Stieglitz resigns as editor of *Camera Notes*. Founds the Photo-Secession.	
1903	Graduates from Cornell University with B.A.	Wright Brothers stay aloft for twelve seconds on a flight at Kitty Hawk, North Carolina.	

Chronology

Personal Events	Historical Events	Selected Exhibitions	
	Stieglitz edits and publishes *Camera Work*. Theodore Roosevelt signs Canal Treaty with Panama.		**1903**
Moves to New York City and begins work as free-lance commercial illustrator. Illustrations appear in *Collier's, McCalls, The Saturday Evening Post, Life*. Marries Florence Dorsey, a neighbor on South Main Street. Lives on Stuyvesant Square.	Theodore Roosevelt elected president. Period of progressivism in politics.		**1904**
	Les Fauves first exhibition at Société du Salon d'Automne in Paris. Die Brücke founded: publications and manifestoes issued during next few years. Industrial Workers of the World (Wobblies) established. Stieglitz and Edward Steichen open The Little Galleries of the Photo-Secession in three-room attic of brownstone at 291 Fifth Avenue. Originally formed to give Secession a headquarters and further its exhibition work.		**1905**
	"Muckraking" first used as a term by Theodore Roosevelt to describe journalists who concentrated on the exposure of corruption in American political and social life.		**1906**
Fall. Travels to Europe; spends majority of time painting in southern France, with one visit to Italy. Meets Alfred Maurer who becomes his best friend. Working in Impressionist style.	Cézanne retrospective exhibition at Société du Salon d'Automne in Paris. Picasso finishes *Les Demoiselles d'Avignon*. Stieglitz mounts exhibition of Pamela Colman-Smith, first non-photographic show at The Little Galleries of the Photo-Secession. Begins exhibitions of European modern art.		**1907**
	Henry Ford installs gasoline engine in "Model T" and begins manufacturing cars on an assembly-line. Automobile brought farm and city into closer relation and was a force in democratization of America. Formation of New Society of American Artists in Paris. Supplants more conservative parent organization. Rent doubles for The Little Galleries of the Photo-Secession and gallery moves across hall. Becomes known as "291." William Taft elected president.	PARIS, GRAND PALAIS DES CHAMPS-ELYSÉES. *Salon d'Automne*. October 1-November 8. Catalogue.	**1908**
Spring. Returns to Geneva, camps in woods to assess his experiences in France. Fall. Back in New York. Realizes he "cannot live by art alone;" takes a three-week newspaper job, then resumes illustrating.	Publication of first Futurist Manifesto. NAACP founded.	PARIS, GRAND PALAIS DES CHAMPS-ELYSÉES. *Salon d'Automne*. October 1-November 8. Catalogue.	**1909**
July. Birth of his son, William. Purchases farm in Westport, Connecticut and moves family there directly from hospital. Hopes to support his family and his painting by farming and illustrating. Through Maurer, introduces himself to Alfred Stieglitz. Makes first abstract paintings *Abstraction Nos. 1-6*.	*Camera Work* abandons its policy of limiting reproductions to photography.	NEW YORK, THE GALLERY OF THE PHOTO-SECESSION. (Known as "291"). *Younger American Painters*. March 9-21. Also included Brinkley, Carles, Fellows, Hartley, Marin, Maurer, Steichen and Weber.	**1910**

	Personal Events	Historical Events	Selected Exhibitions
1911	Begins pastels.		
1912	Purchases different farm, Beldon Pond, near Westport, where he raises vegetables and chickens, and goes lobster fishing.	Blaue Reiter founded; yearbook published. Publication of Wassily Kandinsky's book, *Concerning The Spiritual in Art.* Woodrow Wilson elected president.	NEW YORK, THE GALLERY OF THE PHOTO-SECESSION. (Known as "291"). *Arthur G. Dove First Exhibition Anywhere.* February 27-March 12. Travelled to: Chicago, W. Scott Thurber Galleries. *Paintings of Arthur Dove.* March 14-30.
1913		International Exhibition of Modern Art (Armory Show), 69th Regiment Armory, New York City. Selection from exhibition travels to The Art Institute of Chicago.	
1914		Outbreak of war in Europe.	
1915		Proto-Dada Magazine, *291,* published under Stieglitz's auspices. This period saw the proliferation of "little" magazines: *Seven Arts, Dial, The New Republic, The Little Review, Smart Set , 391* and *Rongwrong.* Attests to enthusiasm and optimism of 1910s. Arrival in New York of Marcel Duchamp. Establishment of the Friends of the Young Artists, by Mrs. Gertrude Vanderbilt Whitney, from which grew the Whitney Studio Club. Kasimir Malevich launches Suprematism. Revival of the Ku Klux Klan. Organization grew rapidly after 1920, aiming its terrorist attacks at Jews, Blacks, immigrants and Roman Catholics.	
1916		Forum Exhibition organized by Willard Huntington Wright challenges the image of European supremacy established by the Armory Show. Includes nearly 200 works and drawings by American artists. Publication of Albert Einstein's *Relativity; The Special and General Theory.* Publication of Carl Jung's *Psychology of the Unconscious.* Panama Pacific Exhibition in San Francisco — comprehensive survey which brings Futurism to America. Dada established in Zurich at Cabaret Voltaire.	NEW YORK, ANDERSON GALLERIES. *Forum Exhibition of Modern American Painters.* March 13-25. Catalogue by Mitchell Kennerly with statement by Dove.
1917		Founding of the Society of Independent Artists. First exhibition on motto "No Jury — No Prizes." Rejection of *Fountain* signed by R. Mutt. De Stijl movement founded; first issue of magazine *De Stijl* published. United States enters war on allied side. Lenin leads Bolsheviks into power. "291" closes with Georgia O'Keeffe exhibition. Last issue of *Camera Work.*	
1918		Phillips Memorial Gallery founded. First public gallery in the United States devoted to contemporary art. Armistice ends World War I.	
1919		Strikes reflect postwar economic dislocation. Race riots break out.	

Personal Events	Historical Events	Selected Exhibitions	
	Red Scare in the United States as revolutions sweep Eastern Europe. Attorney General Palmer begins persecution of radicals and aliens whose views he regards as dangerous. Raids continue until approximately 1927. Signing of Treaty of Versailles. American Senate rejects treaty which incorporates League of Nations provisions. Bauhaus established in Weimar. Ratification of the 18th amendment, prohibition.		**1919**
Acknowledges failure of his marriage. Goes to live on houseboat on Harlem River with Helen Torr Weed "Reds." Purchases forty-two-foot yawl, the Mona. For next seven years cruises Long Island Sound, Port Washington, Lloyd's Harbor, Huntington Harbor. Ties up for winter by Ketewomoke Yacht Club in Halesite. Continues illustrating during this decade, although by 1930 jobs almost impossible to get.	The decade of the 1920s — frequently called "the jazz age" — was a period marked by an exciting acceleration in the tempo of American life. Disillusioned by the failure of the war to bring genuine peace, people used their increasing leisure time to seek relief from serious problems. Ratification of the 19th amendment, women's suffrage. Formation of the Société Anonyme by Katherine Dreier. The League of Nations opens in Geneva. Warren Harding elected president; the economics of "normalcy" and the diplomacy of isolation follow. Broadcast of election results by first commercial station. Use of radio during the '20s for broadcasting news, music, dramatic sketches, and public events rose appreciably.		**1920**
June 21. William Dove Sr. dies.	Nicola Sacco and Bartolomeo Vanzetti accused of murder despite inconclusive evidence. Appeals drag on for six years until their execution in 1927. Conviction corresponds to fear and persecution of radicals that swept country. Publication of F. Scott Fitzgerald's *This Side of Paradise*. Publication of D. H. Lawrence's *Women in Love*. National Origins Act restricts immigration. Quotas of 1924 further restrict the number of immigrants and drastically reduce quotas from nations of Southern and Eastern Europe. Man Ray and Marcel Duchamp publish *New York Dada*. U.S.S.R. attacks avant-garde art, causing exodus of many artists.		**1921**
	Publication of James Joyce's *Ulysses*.		**1922**
	Harding dies; Calvin Coolidge becomes President.		**1923**
In addition to his paintings, Dove begins to focus his art energy on assemblages.	Lenin dies. George Gershwin composes "Rhapsody in Blue." Reflects cultural acceptance of Ragtime. André Breton publishes first Surrealist Manifesto.	NEW YORK, ANDERSON GALLERIES. *Beginnings and Landmarks of 291.*	**1924**
	Publication of Gertrude Stein's *The Making of Americans*. Publication of F. Scott Fitzgerald's *The Great Gatsby*. John Scopes indicted under a Tennessee law for teaching evolutionary theory in his high-school biology class. Scopes was found guilty but Fundamentalist cause steadily declined thereafter.	NEW YORK, ANDERSON GALLERIES. *Seven Americans.* March 9-28. Gallery pamphlet with list of works and Dove's poem titled "A Way to Look at Things." Exhibition also included Marin, O'Keeffe, Demuth, Hartley, Stieglitz, Strand.	**1925**

	Personal Events	Historical Events	Selected Exhibitions
1925		Stieglitz opens The Intimate Gallery. First experiments in energy radiation from the body — auras. Martha Graham founds her dance company.	
1926	Sells first painting to Duncan Phillips.		NEW YORK, THE INTIMATE GALLERY. *Arthur G. Dove.* January 11-February 7. NEW YORK, THE BROOKLYN MUSEUM. *International Exhibition of Modern Art,* assembled by the Société Anonyme. November 19, 1926-January 1, 1927. Catalogue by Katherine S. Dreier.
1927		Charles Lindbergh makes first nonstop solo flight across Atlantic in "The Spirit of St. Louis." Trotsky banished from U.S.S.R. Chiang Kai-shek breaks with Chinese Communists. Werner Heisenberg forms Principle of Uncertainty. While not signaling a return to metaphysics, theory underscores the inherent limitations of quantitative observation of the visual world. First all-talking motion picture. Movies become most popular form of entertainment, setting the styles in manners and fashions.	NEW YORK, THE INTIMATE GALLERY. *Arthur G. Dove Paintings.* December 12, 1927-January 11, 1928. Gallery pamphlet with list of paintings and a statement by Dove titled "An Idea."
1928	Spends winter of 1928-1929 as resident caretaker on Pratt's Island, Noroton, Connecticut.	The Pact of Paris (Kellogg-Briand Pact) outlawing war is signed in Paris by the United States. Herbert Hoover elected president.	
1929	Spring. Moves to Ketewomoke Yacht Club, Halesite, Long Island. Rent free in exchange for upkeep. October. Florence Dove dies.	Ernest Hemingway publishes *A Farewell to Arms.* Stock market crashes. Opening of The Museum of Modern Art in New York under the leadership of Alfred Barr, Jr., Director, and Lillie P. Bliss, Mrs. Cornelius Sullivan, Mrs. John D. Rockefeller, Jr., and A. Conger Goodyear. The Intimate Gallery closes.	NEW YORK, THE INTIMATE GALLERY. *Dove Exhibition.* April 9-28. Gallery pamphlet with list of paintings and "Notes by Arthur G. Dove."
1930	Phillips begins "patronage" by paying Dove $50 each month in exchange for first choice of paintings from yearly exhibitions. April. Marries Helen Torr Weed.	First Zen Temple in the United States, the Hermitage of Sokei, established in New York City. Stieglitz opens An American Place.	NEW YORK, AN AMERICAN PLACE. *Arthur G. Dove 27 New Paintings.* March 22-April 22. Single-page exhibition list.
1931		Opening of Whitney Museum of American Art, New York.	NEW YORK, AN AMERICAN PLACE. *Arthur G. Dove.* March 9-April 4. Single-page exhibition list.
1932		Franklin D. Roosevelt elected president.	NEW YORK, AN AMERICAN PLACE. *Arthur G. Dove New Paintings (1931-1932).* March 14-April 9. Single-page exhibition list with notes by Dove titled "Addenda." NEW YORK, WHITNEY MUSEUM OF AMERICAN ART. *First Biennial Exhibition of Contemporary American Art Paintings.* November 22, 1932-January 5, 1933.
1933	January 22. Mother dies. April. Travels to Geneva to settle estate.	The "hundred days" of the New Deal.	NEW YORK, AN AMERICAN PLACE. *Arthur G. Dove, Helen Torr, New Paintings and*

Personal Events	Historical Events	Selected Exhibitions	
July. Moves to Geneva in attempt to salvage family fortune; lives in small farmhouse on family property.	Adolf Hitler becomes Chancellor of Germany. Bauhaus closes. Klee returns to Switzerland, Kandinsky to France. Hans Hofmann opens his studio-school.	*Watercolors.* March 20-April 15. SPRINGFIELD, MASSACHUSETTS, SPRINGFIELD MUSEUM OF FINE ARTS. *Selection of Watercolors by Arthur G. Dove.* December.	**1933**
May. Moves into second farmhouse on family property.	Nazi blood purge in Germany. Dionne quintuplets born. Dust storms decimate Great Plains until 1935. Beginning of westward movement of itinerant farmers, mostly to California.	NEW YORK, CONTEMPORARY NEW ART CIRCLE. *Paintings by Arthur Dove, Yasuo Kuniyoshi and Max Weber.* March 6-31. NEW YORK, AN AMERICAN PLACE. *Arthur G. Dove.* April 17-June 1. Catalogue of works with statement by Elizabeth McCausland. CHICAGO, ILLINOIS, THE ART INSTITUTE OF CHICAGO. *A Century of Progress Exhibition of Paintings and Sculpture.* June 1-November 1.	**1934**
June. Begins experiments with tempera.	Works Progress Administration establishes Federal Project I under the general direction of Jacob Baker, with Holger Cahill directing the art project.	NEW YORK, WHITNEY MUSEUM OF AMERICAN ART. *Abstract Painting in America.* February 12-March 22. Catalogue with introduction by Stuart Davis. NEW YORK, AN AMERICAN PLACE. *Arthur G. Dove Exhibition of Paintings (1934-1935).* April 21-May 22. Gallery pamphlet with list of paintings.	**1935**
May. Moves to top floor of Dove Block, a commercial building built by his father, whose top floor had been used as an auditorium and roller skating rink.	Formation of the American Abstract Artists organization. Provides reference point and support for artists beginning to move toward abstraction. King George dies and Edward III abdicates. Spanish Civil War breaks out.	BUFFALO, NEW YORK, ALBRIGHT-KNOX ART GALLERY. *The Art of Today.* January 3-31. NEW YORK, AN AMERICAN PLACE. *New Paintings by Arthur G. Dove.* April 20-May 20. Gallery pamphlet with list of paintings.	**1936**
Begins using wax emulsion with tempera underpainting.	Amelia Earhart lost over Pacific. Picasso paints *Guernica.*	MINNEAPOLIS, MINNESOTA, UNIVERSITY GALLERY, UNIVERSITY OF MINNESOTA. *Five Painters.* January. Catalogue with foreword by Ruth Lawrence. NEW YORK, AN AMERICAN PLACE. *Arthur G. Dove: New Oils and Watercolors.* March 23-April 16. Gallery pamphlet with list of paintings and introduction by William Einstein. WASHINGTON, D.C., PHILLIPS MEMORIAL GALLERY. *Retrospective Exhibition of Works in Various Media by Arthur G. Dove.* March 23-April 18. Gallery pamphlet with list of paintings and introduction by Duncan Phillips. NEW YORK, AN AMERICAN PLACE. *Beginnings and Landmarks: "291" 1905-1917.* October 27-December 27. Gallery pamphlet with list of works and introduction by Dorothy Norman.	**1937**
May. Moves to Centerport, Long Island. Pneumonia.	Hahn and Strassman split the uranium atom. Arrival in New York of Piet Mondrian. Formation of the labor union, Congress of Industrial Organization.	NEW YORK, AN AMERICAN PLACE. *Arthur G. Dove Exhibition of Recent Paintings, 1938.* March 29-May 10. Catalogue with list of paintings and text by Duncan Phillips titled "The Art of Arthur Dove," originally written for the 1937 retrospective at the Phillips Memorial Gallery.	**1938**

	Personal Events	Historical Events	Selected Exhibitions
1938			PARIS, MUSÉE DU JEU DE PAUME. *Trois Siècles d'Art aux État-Unis.* Organized in collaboration with The Museum of Modern Art, New York. May 24-July 31.
1939	January. Heart attack complicated by kidney disorder.	Solomon Guggenheim opens The Museum of Non-Objective Art. World War II begins with German invasion of Poland. Publication of James Agee's and Walker Evans' book, *Let Us Now Praise Famous Men.* Represents documentary genre that characterizes 1930s. First television broadcast.	NEW YORK, AN AMERICAN PLACE. *Arthur G. Dove Exhibition of Oils and Temperas.* April 10-May 17. Gallery pamphlet with list of paintings. BOSTON, MASSACHUSETTS, MUSEUM OF FINE ARTS. *Ten American Watercolor Painters.* April 15-May 7. Museum pamphlet with list of paintings. Exhibition also included Burchfield, Dehn, Ganzo, Hopper, Keller, Marin, Marsh, Sample.
1940			NEW YORK, AN AMERICAN PLACE. *Arthur G. Dove Exhibition of New Oils and Watercolors.* March 30-May 14. Gallery pamphlet with list of paintings and notes by Dove.
1941		Japan attacks Pearl Harbor and the United States enters World War II.	NEW YORK, AN AMERICAN PLACE. *Exhibition of New Arthur G. Dove Paintings.* March 27-May 17. Single-page exhibition list.
1942		Opening of Peggy Guggenheim's gallery-museum "Art of This Century." Operated as transmission point between paintings of Surrealists and younger New York painters. First nuclear chain reaction. New York International Surrealist exhibition.	NEW YORK, AN AMERICAN PLACE. *Arthur G. Dove Exhibition of Recent Paintings (1941-1942).* April 14-May 27. Gallery pamphlet with list of paintings and three brief critical comments.
1943			NEW YORK, AN AMERICAN PLACE. *Arthur G. Dove Paintings — 1942-1943.* February 11-March 17. Gallery pamphlet with list of paintings and statement by Dove. NEW YORK, ART OF THIS CENTURY. *Collages.* April 16-May 15.
1944		Allied forces invade occupied Europe at Normandy.	NEW YORK, AN AMERICAN PLACE. *Arthur G. Dove Paintings — 1944.* March 21-May 21. Gallery pamphlet with list of paintings. PHILADELPHIA, PENNSYLVANIA, PHILADELPHIA MUSEUM OF ART. *History of an American: Alfred Stieglitz, "291" and After.* Selections from the Stieglitz Collection. September-October. Catalogue with introduction by Henry Clifford and Carl Zigrosser. NEW YORK, THE MUSEUM OF MODERN ART. *Seven American Painters.* (Circulating exhibition.) December 1944-May 1945.
1945		Roosevelt dies; Harry Truman becomes president. Germany surrenders, May. American airmen drop first atomic bomb on Hiroshima, August 6. Three days later a second bomb is dropped on Nagasaki.	NEW YORK, AN AMERICAN PLACE. *Arthur G. Dove Paintings — 1922-1944.* May 3-June 15. Single-page exhibition list.

Personal Events	Historical Events	Selected Exhibitions	
	Japan surrenders, August.		**1945**
Another attack which leaves half his body paralyzed. November 22. Dies in hospital in Huntington, Long Island.	Leaders of Nazi Germany tried at Nuremburg. Civil war begins in China. Establishment of the United Nations Organization. Stieglitz dies, July.	NEW YORK, AN AMERICAN PLACE. *Recent Paintings (1946) Arthur G. Dove.* May 4-June 4. NEW YORK, WHITNEY MUSEUM OF AMERICAN ART. *Pioneers of Modern Art in America.* April 2-May 12. Catalogue by Lloyd Goodrich.	**1946**

Selected Exhibitions After 1946

1947
NEW YORK, THE DOWNTOWN GALLERY.
Retrospective Exhibition. January 7-25.
Travelled to: Los Angeles, California, Vanbark
Studios, February 7-March 15; Santa Barbara,
California, Santa Barbara Museum of Art, March;
San Francisco, California, San Francisco Museum of
Art, April 22-May 18.
Gallery pamphlet with list of paintings.

WASHINGTON, D.C., PHILLIPS MEMORIAL GALLERY.
Arthur Dove Retrospective Exhibition.
April 18-September 22.
Gallery pamphlet with list of works.

UTICA, NEW YORK, MUNSON-WILLIAMS-PROCTOR
INSTITUTE.
Paintings by Arthur G. Dove.
Retrospective Exhibition. December 7-29.

1949
NEW YORK, THE DOWNTOWN GALLERY.
Dove Watercolors. May 3-21.

1951
HOUSTON, TEXAS, CONTEMPORARY ARTS MUSEUM.
Arthur G. Dove, Charles Sheeler. January 7-23.
Exhibition pamphlet with list of paintings and notes
by Edith G. Halpert and Alfred H. Barr, Jr.

NEW YORK, THE MUSEUM OF MODERN ART.
Abstract Painting and Sculpture in America.
January 23-March 5.

NEW YORK, THE BROOKLYN MUSEUM.
Revolution and Tradition in Modern American Art.
November 19, 1951-June 6, 1952.
Catalogue by John I. H. Baur.

1952
NEW YORK, THE DOWNTOWN GALLERY.
Arthur G. Dove. Retrospective exhibition.
April 22-May 10.
Gallery pamphlet with texts by Paul Rosenfeld,
(reprinted from *Creative Art*, 1932) and Alfred H.
Barr, Jr., (reprinted from *Arthur G. Dove, Charles
Sheeler*, Contemporary Arts Museum, Houston, 1951).

1953
WASHINGTON, D.C., INSTITUTE OF
CONTEMPORARY ART.
Retrospective Exhibition. May 2-July 14.

1954
MINNEAPOLIS, MINNESOTA, WALKER ART CENTER.

Paintings and Watercolors by Arthur G. Dove.
January 10-February 20.
Pamphlet with list of paintings.

NEW YORK, THE DOWNTOWN GALLERY.
Dove and Demuth Watercolor Retrospective.
April 6-May 1.
Gallery pamphlet with list of works and
notes by Alfred H. Barr Jr., reprinted from
1951 exhibition pamphlet, Houston.

ITHACA, NEW YORK, ANDREW DICKSON WHITE
MUSEUM OF ART, CORNELL UNIVERSITY.
*Arthur G. Dove 1880-1946: A Retrospective
Exhibition.* November.
Catalogue with text by Alan Solomon and
foreword by Duncan Phillips.

1955
NEW YORK, THE DOWNTOWN GALLERY.
Collages: Dove. November 1-26.
Gallery pamphlet with list of paintings.

1956
NEW YORK, THE DOWNTOWN GALLERY.
Special Exhibition of Paintings by Dove.
February 28-March 24.
Gallery pamphlet with list of paintings.

LOS ANGELES, CALIFORNIA, PAUL KANTOR GALLERY.
Arthur Dove. May 7-June 1.
Gallery pamphlet with list of paintings and
notes by Alfred H. Barr, Jr., Robert Goldwater
and Frederick S. Wight.

1957
LYNCHBURG, VIRGINIA, RANDOLPH-MACON
WOMAN'S COLLEGE.
Retrospective Exhibition.

1958
NEW YORK, THE DOWNTOWN GALLERY.
*Dove: First Public Presentation, Group of Watercolors
1929-1946.* September 30-October 11.

LOS ANGELES, ART GALLERIES OF THE
UNIVERSITY OF CALIFORNIA.
Arthur G. Dove. Retrospective Exhibition.
Travelled to: New York, Whitney Museum of
American Art, October 1-November 16; Washington,
D.C., Phillips Memorial Gallery, December 1, 1958-
January 5, 1959; Boston, Massachusetts, Museum of
Fine Arts, January 25-February 28; San Antonio,
Texas, Marion Koogler McNay Art Institute, March

18-April 18; Los Angeles, California, Art Galleries
of the University of California, Los Angeles, May 9-
June 15; La Jolla, California, La Jolla Art Center,
June 20-July 30; San Francisco, California, San
Francisco Museum of Art, August 15-September 30.
Catalogue with text by Frederick S. Wight and
introduction by Duncan Phillips.

CLAREMONT, CALIFORNIA, POMONA COLLEGE
GALLERIES.
Stieglitz Circle. October 11-November 15.

1961
WILMINGTON, DELAWARE, DELAWARE ART MUSEUM.
The Stieglitz Circle. March 30-April 23.

WORCESTER, MASSACHUSETTS, WORCESTER ART
MUSEUM.
Paintings and Watercolors by Arthur G. Dove.
Lent by the William H. Lane Foundation.
July 27- September 17.
Catalogue with text by Daniel Catton Rich.

MILWAUKEE, WISCONSIN, MILWAUKEE ART CENTER.
Ten Americans. September 21-November 5.
Catalogue with introduction by Edward H. Dwight.

NEW YORK, THE MUSEUM OF MODERN ART.
The Art of Assemblage. October 4-November 12.
Catalogue by William C. Seitz.

1962
NEW YORK, THE DOWNTOWN GALLERY.
Abstract Painting in America, 1903-1923.
March 27-April 21.
Gallery pamphlet with list of paintings.

IOWA CITY, STATE UNIVERSITY OF IOWA.
*Vintage Moderns; American Pioneer Artists,
1903-1932.* May 24-August 2.
Catalogue by Frank Seiberling.

1963
NEW YORK, WHITNEY MUSEUM OF AMERICAN ART.
The Decade of the Armory Show. April 9-May 19.
Travelled to: St. Louis, Missouri, City Art Museum;
Cleveland, Ohio, Cleveland Museum of Art;
Philadelphia, Pennsylvania, Pennsylvania Academy
of Fine Arts; Chicago, Illinois, The Art Institute
of Chicago; Buffalo, New York, Albright-Knox
Art Gallery.
Catalogue by Lloyd Goodrich.

Selected Exhibitions After 1946

1963
SAN FRANCISCO, CALIFORNIA, GUMP'S GALLERY.
Paintings by Arthur G. Dove. July 2-31.
Gallery pamphlet.

WALTHAM, MASSACHUSETTS, THE ROSE ART
MUSEUM, BRANDEIS UNIVERSITY.
American Modernism: The First Wave.
October 4-November 10.
Catalogue with introduction by Sam Hunter and
statement by Edith Gregor Halpert.

1964
NEW YORK, WHITNEY MUSEUM OF AMERICAN ART.
*Between the Fairs; 25 Years of American Art,
1939-1964.*
Catalogue by John I. H. Baur.

DETROIT, MICHIGAN, DONALD MORRIS GALLERY.
*Arthur G. Dove: Oils — Watercolors —
Drawings — Collage.* May 3-23.
Gallery pamphlet with list of paintings.

1965
NEW YORK, METROPOLITAN MUSEUM OF ART.
American Painting in the 20th Century.
Catalogue by Henry Geldzahler.

LONDON, ENGLAND, LEICESTER GALLERIES.
Six Decades of American Art. July 14-August 18.

WASHINGTON, D.C., NATIONAL COLLECTION OF
FINE ARTS.
Roots of Abstract Art in America 1910-1930.
December 1, 1965-January 9, 1966.
Catalogue with text by Adelyn Breeskin.

1966
NEW YORK, WHITNEY MUSEUM OF AMERICAN ART.
Art of the United States: 1670-1966.
September 28-November 27.
Catalogue by Lloyd Goodrich.

NEW YORK, METROPOLITAN MUSEUM OF ART.
*Two Hundred Years of Watercolor Painting in
America: An Exhibition Commemorating the
Centennial of the American Watercolor Society.*
December 8, 1966-January 29, 1967.

1967
PHILADELPHIA, PENNSYLVANIA, PEALE GALLERIES,
PENNSYLVANIA ACADEMY OF FINE ARTS.
*An Exhibition of Paintings, Drawings and Sculpture
by Charles Demuth, Arthur Dove, John Marin and
Elie Nadelman.* February 2-March 12.

COLLEGE PARK, MARYLAND, J. MILLARD TAWES FINE
ARTS CENTER, UNIVERSITY OF MARYLAND
ART GALLERY.
Arthur Dove: The Years of Collage.
March 13-April 19.
Catalogue by Dorothy Rylander Johnson.

NEW YORK, THE DOWNTOWN GALLERY.
Arthur G. Dove Paintings 1911-1946.
March 15-April 8.
Gallery pamphlet with list of paintings.

HUNTINGTON, NEW YORK, HECKSCHER MUSEUM.
Arthur G. Dove of Long Island Sound.
August 20-September 17.
Catalogue with foreword by Eva Gatling.

GENEVA, NEW YORK, HISTORICAL SOCIETY MUSEUM.
Arthur G. Dove — Paintings, Drawings, Memorabilia.
October 15-30.
Organized under the auspices of the Geneva
Historical Society and the Hobart and William
Smith Colleges.
Museum pamphlet with introduction by John Loftus.

1968
NEW YORK, THE MUSEUM OF MODERN ART.
Arthur Dove. Circulating exhibition.
Travelled to: Fort Worth, Texas, Fort Worth Art
Center, March 3-24; Austin, Texas, University Art
Museum, April 7-May 1; Macon, Georgia, Mercer
University, June 11-July 8; Brunswick, Maine,
Bowdoin College Museum of Art, September 9-
October 6; South Hadley, Massachusetts,
Mt. Holyoke College, October 20-November 10;
Jacksonville, Florida, Cummer Gallery of Art,
January 7-28, 1969; Athens, Georgia, University of
Georgia Museum of Art, February 17-March 10;
Mason City, Iowa, Charles H. MacNider Museum,
March 28-April 27.
Museum pamphlet with list of works and text
by Margaret Potter.

LOS ANGELES, LOS ANGELES COUNTY MUSEUM
OF ART.
Eight American Masters of Watercolor.
April 23-June 16.
Travelled to: San Francisco, M. H. de Young Memorial
Museum, June 28-August 18; Seattle, Washington,
Seattle Art Museum, September 5-October 13.
Museum catalogue with text by Larry Curry.

EAST LANSING, MICHIGAN, MICHIGAN STATE
UNIVERSITY.
Retrospective exhibition. November 3-24.

1970
NEW YORK, TERRY DINTENFASS INC.
*Arthur G. Dove: Exhibition of Watercolors and
Drawings.* March 31-April 25.
Gallery pamphlet with list of works.

SANTA BARBARA, CALIFORNIA, ESTHER BEAR
GALLERY.
Arthur G. Dove: Watercolor and Drawings.
May 31-June 26.

NEW YORK, TERRY DINTENFASS INC.
Arthur G. Dove: Collages. December 22, 1970-
January 23, 1971.
Gallery pamphlet with list of works and introduction
by Dorothy Rylander Johnson (excerpted from
Arthur Dove: The Years of Collage).

1971
HOUSTON, TEXAS, GALERIE ANN.
Retrospective exhibition. January 7-February 4.

1971
PITTSBURGH, PENNSYLVANIA, CARNEGIE INSTITUTE,
MUSEUM OF ART.
Forerunners of American Abstraction.
November 18, 1971-January 9, 1972.

1972
NEW YORK, TERRY DINTENFASS INC.
Arthur G. Dove: Exhibition of Paintings, 1917-1946.
February 1-26.
Gallery pamphlet with list of paintings, introduction
by Thomas M. Messer, and excerpt from a letter
written by Dove in 1929.

BOSTON, MASSACHUSETTS, THE ALPHA GALLERY.
Watercolors by Arthur G. Dove. March 4-28.

NEW YORK, LUBIN HOUSE.
Arthur G. Dove Watercolors,
December 19, 1972- January 19, 1973.

1973
NEW YORK, WASHBURN GALLERY.
"291." February 7- March 3.
Gallery pamphlet.

NEW YORK, TERRY DINTENFASS INC.
Country Life: Arthur G. Dove.
September 18-October 13.
Gallery pamphlet with list of paintings.

NEW YORK, ANDREW CRISPO GALLERY.
Pioneers of American Abstraction.
October 17-November 17.
Catalogue with introduction by Andrew J. Crispo.

1974
NEW YORK, WASHBURN GALLERY.
Seven Americans. February 6-March 2.
Gallery pamphlet.

NEW YORK, ANDREW CRISPO GALLERY.
Ten Americans: Masters of Watercolor.
May 16-June 30.
Catalogue with foreword by Andrew J. Crispo and
text on Dove by Larry Curry.
Exhibition also included Avery, Burchfield, Demuth,
Homer, Hopper, Marin, Prendergast, Sargent, Wyeth.

LOS ANGELES, ESTHER-ROBLES GALLERY.
Arthur Dove Watercolors. October 3-26.
Gallery brochure.

Selected Bibliography

GENERAL WORKS ON PERIOD AND ON ALFRED STIEGLITZ

Baur, John I. H. *Revolution and Tradition in Modern American Art.* Cambridge, Massachusetts: Harvard University Press, 1951.

Brown, Milton W. *American Painting from the Armory Show to the Depression.* Princeton, New Jersey: Princeton University Press, 1955.

Doty, Robert. "Articulation of American Abstraction," *Arts,* XLVIII, November 1973, pp. 47-49.

Frank, Waldo, Lewis Mumford, Dorothy Norman, Paul Rosenfeld and Harold Rugg, eds. *America and Alfred Stieglitz: A Collective Portrait,* Garden City, New York: Doubleday, Doran & Company, Inc. (Literary Guild Selection), 1934.

Geldzahler, Henry. *American Painting in the Twentieth Century.* New York: The Metropolitan Museum of Art, 1965. Distributed by New York Graphic Society, Greenwich, Connecticut.

Green, Jonathan, ed. *Camera Work: A Critical Anthology.* New York: Aperture, Inc., 1973.

Green, Samuel M. *American Art: A Historical Survey.* New York: The Ronald Press Co., 1966.

Homer, William. "Stieglitz and 291," *Art in America,* LXI, July 1973, pp. 50-57.

Hunter, Sam. *American Art of the 20th Century.* New York: Harry N. Abrams, Inc., 1973.

Mellquist, Jerome. *The Emergence of an American Art.* New York: Charles Scribner's Sons, 1942.

Norman, Dorothy. *Alfred Stieglitz: An American Seer.* New York: Random House, 1973.

Rose, Barbara. *American Art Since 1900: A Critical History.* New York: Frederick A. Praeger, Inc., 1967.

Rose, Barbara. *American Painting: The 20th Century.* Cleveland: World Publishing Co., (Skira), 1970.

Seligmann, Herbert J. *Alfred Stieglitz Talking: Notes on Some of His Conversations, 1925-1931.* New Haven: Yale University Library, 1966.

SPECIFIC WORKS ON DOVE *(Includes articles, books, exhibition catalogues)*

Frank, Waldo. "The Art of Arthur Dove," *The New Republic,* XLV, January 27, 1926, pp. 269-270.

Goldwater, Robert. "Arthur Dove," *Perspectives USA,* No. 2, Winter 1953, pp. 78-88.

Johnson, Dorothy Rylander. *Arthur Dove: The Years of Collage.* College Park, Maryland: University of Maryland, 1967. Exhibition catalogue.
Reprinted in modified form as "The Collages of Arthur Dove,"*Artforum,* V, May 1967, pp. 40-41.

Kramer, Hilton. "The World of Arthur Dove," *New York Times,* Sec. II, March 19, 1967.
Reprinted in *The Age of the Avant-Garde.* Farrar, Straus and Giroux, Inc., 1973, pp. 278-281.

McCausland, Elizabeth. "Dove's Oils, Watercolors Now at An American Place," *Springfield (Mass.) Sunday Union and Republican,* April 22, 1934. Reprinted as gallery pamphlet for exhibition at An American Place.

McCausland, Elizabeth. "Dove: Man and Painter," *Parnassus,* IX, December 1937, pp. 3-6.

Morgan, Ann Lee. "Toward the Definition of Early Modernism in America: A Study of Arthur Dove." Unpublished doctoral thesis, The University of Iowa, 1973.

Phillips, Duncan. "Arthur Dove, 1880-1946," *Magazine of Art,* XL, May 1947, pp. 192-197.

Rosenfeld, Paul. "Arthur G. Dove," *Port of New York: Essays on Fourteen American Moderns.* New York: Harcourt, Brace and Company, 1924.

Rosenfeld, Paul. "The World of Arthur G. Dove," *Creative Art,* X, June 1932, pp. 426-430.

Solomon, Alan. *Arthur G. Dove.* Ithaca, New York: Andrew Dickson White Museum of Art, Cornell University Press, 1954. Exhibition catalogue.

Wight, Frederick S. *Arthur G. Dove.* Berkeley: University of California Press, 1958. Exhibition catalogue.

STATEMENTS BY ARTHUR DOVE *(Includes Writings and Quotations)*

Eddy, Arthur J. *Cubists and Post-Impressionism.* Chicago: A. C. McClung. 1914; 2nd ed., 1919.

Statement in *Camera Work,* entitled "291," Number XLVII, January 1915, p. 37.

Statement in exhibition catalogue, *Forum Exhibition of Modern American Painters,* Anderson Galleries, New York, 1916.

Kootz, Samuel M. *Modern American Painters.* New York: Brewer & Warren, Inc., 1930.

Statement in *MMS,* "Can a Photograph Have the Significance of Art?," No. 4, December 1922.

Statement in exhibition catalogue entitled "An Idea," The Intimate Gallery, New York, 1927.

Statement in exhibition catalogue entitled "Notes by Arthur G. Dove," The Intimate Gallery, New York, 1929.

Statement in *America and Alfred Stieglitz* entitled "A Different One," op. cit., pp. 243-245.

Statement in exhibition catalogue, An American Place, New York, 1940.

Statement in *Seven Americans* exhibition catalogue entitled, "A Way to Look at Things," Anderson Galleries, New York, 1925.

UNPUBLISHED SOURCE MATERIAL

Diaries of Helen Torr Dove, 1924-1939.

Dove letters to Stieglitz, Collection of American Literature, The Beinecke Rare Book and Manuscript Library, Yale University, New Haven, Connecticut.

Dove files, The Downtown Gallery, New York (microfilm copy in Archives of American Art).

Stieglitz letters to Dove, estate of Arthur Dove.

Appendix

DOVE LETTER TO ARTHUR JEROME EDDY,
Cubists and Post-Impressionism, 1914.

My dear Mr. Eddy:

You have asked me to "explain as I would talk to any intelligent friend, the idea behind the picture," or in other words, "what I am driving at."

First of all this is not propaganda, there has been too much of that written on Modern Art already. It is simply an explanation of *my own means* in answer to the above question.

Inasmuch as the means continually change as one learns, perhaps the best way to make it understood would be to state the different steps which have been taken up to the present time. After having come to the conclusion that there were a few principles existent in all good art from the earliest examples we have, through the masters to the present, I set about it to analyze these principles as they occurred in works of art and in nature.

One of these principles which seemed most evident was the choice of the simple motif. This same law held in nature, a few forms and a few colors sufficed for the creation of an object. Consequently I gave up my more disorderly methods (impressionism). In other words I gave up trying to express an idea by stating innumerable little facts, the statement of facts having no more to do with the art of painting than statistics with literature.

The first step was to choose from nature a motif in color and with that motif to paint from nature, the forms still being objective.

The second step was to apply this same principle to form, the actual dependence upon the object (representation) disappearing, and the means of expression becoming purely subjective. After working for some time in this way, I no longer observed in the old way, and, not only began to think subjectively but also to remember certain sensations purely through their form and color, that is, by certain shapes, planes of light, or character lines determined by the meeting of such planes.

With the introduction of the line motif the expression grew more plastic and the struggle with the means became less evident. . .

DOVE LETTER TO SAMUEL KOOTZ, written in 1910's
Modern American Painters, 1930.

. . .To understand painting one must live with it. The speed of today leaves very few time to really live with anything, even ourselves. That too painting has to meet.

Then there was the search for a means of expression which did not depend upon representation. It should have order, size, intensity, spirit, nearer to the music of the eye.

If one could paint the part that goes to make the spirit of painting and leave out all that just makes tons and tons of art.

There was a long period of searching for a something in color which I then called "a condition of light." It applied to all objects in nature, flowers, trees, people, apples, cows. These all have their certain condition of light, which establishes them to the eye, to each other, and to the understanding.

To understand that clearly go to nature, or to the Museum of Natural History and see the butterflies. Each has its own orange, blue, black; white, yellow, brown, green, and black, all carefully chosen to fit the character of the life going on in that individual entity.

After painting objects with those color motives for some time, I began to feel the same idea existing in form. This had evidently been known by the Greeks, as in going over conic sections again, with this in mind, I found that they were called 'Maenechmian Triads.' Maenechmus was an early Greek sculptor, and invented these triads.

This choice of form motives of course took the paintings away from representation in the ordinary sense.

Then one day I made a drawing of a hillside. The wind was blowing. I chose three forms from the planes on the sides of the trees, and three colors, and black and white. From these was made a rhythmic painting which expressed the spirit of the whole thing. The colors were chosen to express the substances of those objects and the sky. There was the earth color, the green of the trees, and the cyan blue of the sky. These

colors were made into pastels carefully weighed out and graded with black and white into an instrument to be used in making that certain painting. . .

Later the choice of form motive was reduced from the plane to the line. That happened one day in trying to draw a waterfall. The line was the only thing that had speed enough.

"The Cow" 1911 is an example of the line motive freed still further.

The line at first followed the edges of planes, or was drawn over the surface, and was used to express actual size, as that gave a sense of dimension; later it was used in and through objects and ideas as force lines, growth lines, with its accompanying color condition.

Feeling that the "first flash" of an idea gives its most vivid sensation, I am at present in some of the paintings trying to put down the spirit of the idea as it comes out. To sense the "pitch" of an idea as one would a bell.

It is the form that the idea takes in the imagination rather than the form as it exists outside.

This is no rule, nor method, but leaves the imagination free to work in all directions with all dimensions that are or may have been realized.

291
Camera Work, January 1914.

The question, "What is "291"?" leaves one in the same position in explaining it as the modern painter is in explaining his painting. The modern painting does not present any definite object. Neither does "291" represent any definite movement in one direction, such as Socialism, Suffrage, etc. Perhaps it is these movements having but one direction that makes life at present so stuffy and full of discontent.

There could be no "291ism." "291" takes a step further and stands for orderly movement in all directions; in other words it is what the observer sees in it—an idea to the *n*th power.

One means used at "291" has been a process of elimination of the non-essential. This happens to be one of the important principles in modern art; therefore "291" is interested in modern art.

It was not created to promote modern art,

photography, nor modern literature. That would be a business and "291" is not a shop.

It is not an organization that one may join. One either belongs or does not.

It has grown and outgrown in order to grow. It grew because there was a need for such a place, yet it is not a place.

Not being a movement, it moves, so do "race horses," and some people, and "there are all sorts of sports," but no betting. It is finer to find than to win.

This seems to be "291" or is it Stieglitz?

WHAT PHOTOGRAPHY MEANS TO ME
MMS June 19, 1922.

I'd rather have truth than beauty
I'd rather have a soul than a shape . . .
I'd rather have today than yesterday
I'd rather have tomorrow than today
I'd rather have the impossible than the possible
I'd rather have the abstract than the real

AN IDEA
Statement in exhibition catalogue,
The Intimate Gallery, 1927.

Why not make things look like nature? Because I do not consider that important and it is my nature to make them this way. To me it is perfectly natural. They exist in themselves, as an object does in nature.

The music things were done to speed the line up to the pace at which we live to-day. The line is the result of reducing dimension from the solid to the plane then to the point. A moving point could follow a waterfall and dance. We have the scientific proof that the eye sees everything best at one point.

I should like to take wind and water and sand as a motif and work with them, but it has to be simplified in most cases to color and force lines and substances, just as music has done with sound.

The choice of motif has been departed from in some of the paintings to express sentimental humor and a strained condition.

The force lines of a tree seem to me to be more important than its monumental bulk. When mariners say "the wind has weight," a line seems to express that better than bulk.

The colors in the painting "Running River" were chosen looking down into a stream. The red and yellow from the wet stones and the green from moss with black and white. The line was a moving point reducing the moving volume to one dimension. From then on it is expressed in terms of color as music is in terms of sound.

As the point moves it becomes a line, as the line moves, it becomes a plane, as the plane moves, it becomes a solid, as the solid moves, it becomes life and as life moves, it becomes the present.

NOTES BY ARTHUR G. DOVE
Statement in exhibition catalogue,
The Intimate Gallery, 1929.

Dec. 19 — Anybody should be able to feel a certain state and express it in terms of paint or music. I do not mean feeling a certain way about something, that is taking an object or subject and liking certain things about it and setting down those things.

But, for instance, to feel the power of the ground or sea, and to play or paint it with that in mind letting spirit hold what you do together rather than continuous objective form, gaining in tangibility and actuality as the plane leaves the ground, to fly in a medium more rare and working with the imagination that has been built up from reality rather than building back to it.

To create a feeling for the idea rather than to go back to the "nest" each time to find whether or not the wings were sufficient.

The offspring of the idea to be in mind rather than its parentage.

Dec. 14 — The line still holds and the contrasting sizes. Actual size all the time, and as much as you need of any size, so that all the things you feel are quite real, and actual, and all the feelings can be contrasted much the same as waves roll on shore and wash back against each other. It certainly can be drawn through as fine as that. And as I said before things can be of the same size and of different sizes at the same time. That is certainly true and covers both vision and feelings.

There is no right or wrong in aesthetics, there is only that thing of finding something that seems more true than the last something that you or some one else found that seemed quite true. There being no possibility of an absolute true, we approach it by dividing the distance.

Dec. 27 — Perhaps one might take two or three motifs, we will say in a blunt way for example to express ruggedness.

One Motif: Prussian blue black; raw sienna with a touch of light gray, and transparent brown mixed with burnt sienna and a bit of white.

The line motif to be the lines in a lump of coal.

Two Motif: Raw sienna with a touch of white; silver, burnt brown wood color dark.

The line motif to be the line in the grain of wood.

Three Motif: Silver and ultramarine ash.

Pure straight line.

This would seem to be enough to work with and let these forms as organized motifs go through each other, take care of themselves rather than to represent a stump or tree or some rock about the title of which everyone would be certain that "Ruggedness" was correct.

Jan. 12 — Just now I am trying to put a line around, in, and through an idea. After that, or at the same time, to thoroughly grasp or sense the light condition in which that idea exists. The rest is just trying to make everything you put down say the same thing in different ways as hard as possible, and with order, or disorder, if necessary, to make the sensation completely realized.

March 5th — Perhaps art is just taking out what you don't like and putting in what you do .

There is no such thing as abstraction. It is extraction, gravitation toward a certain direction, and minding your own business.

If the extract be clear enough its value will exist.

It is nearer to music, not the music of the ears, just the music of the eyes. It should necessitate no effort to understand.

Just to look, and, if looking gives vision, enjoyment should occur as the eyes look.

THE 20TH CENTURY LIMITED OR THE TRAIN LEFT WITHOUT THEM

When a few people all over the world have been fighting for an idea for years and bestowing all the care they can imagine on that idea, it would seem that it might by this time be understood, at least that the intention in direction might in the present civilization be known. If they refuse to read the writing on the wall, the part of art that is most alive will move on without them.

There are many things next door that we do not see when we look so near. Light is always present, if we are not blind. Even the blind feel it, whether they know it or not.

The reaction is just different in different cases. For those who try to weave the idea of comfort, by that I mean not endlessly trying to go beyond the last thing they have done for something further on; For those who have no further wish than the expression of the thing at the roadside; For those who feel they must go back to the classic to realize themselves; For those who have given up hope of anything beyond; For those there is no hope. It must be your own sieve through which you sift all these things and the residue is what is left of you —

They accept Bach, understand his idea, and refuse Marin and Klee — I sometimes wonder whether these three are not grounded on the same love — One in his own realm of sound, one in his own sensation of space, and one in a colored measurement of life trying to combine the other two. They seem to be held just at the point where all the arts become identical. It is the love of the sort of beauty that is above being so real that the fingers may be stuck in its side...

If these "modern" things are as bad as they think, there should be no real worry for them. If that were the case the moderns would be the troubled ones. When people find things "baffling," "defeating," "putting obstacles in their way" (and that is putting it mildly), they will usually find that they themselves are the obstacles, and their vocabulary becomes merely a stronger portrait of themselves, and I for one am amazed at some of these portraits.

I know an old weather prophet who intensely dislikes the word barometer. It should be time after all these years that the value of the new findings should be recognized. People have more to do who are of today than those who are of the past. Very few welcome ideas that are destructive to their own. If they are destroyed they naturally want to do the destroying themselves. Enjoyment is easily distinguished from enthusiasm. Enthusiasm is flat, and enjoyment is round, one is a projection of the other. And the heightening of all those feelings gives a hunger that is beyond the moment...

A WAY TO LOOK AT THINGS

Statement in exhibition catalogue, *Seven Americans,* Anderson Galleries, 1925.

We have not yet made shoes that fit like sand
Nor clothes that fit like water
Nor thoughts that fit like air,
There is much to be done —
Works of nature are abstract,
They do not lean on other things for meaning
The sea-gull is not like the sea
Nor the sun like the moon.
The sun draws water from the sea
The clouds are not like either one —
They do not keep one form forever.
That the mountainside looks like a face is accidental.

Statement from exhibition catalogue,
An American Place, 1940.

As I see from one point in space to another, from the top of the tree to the top of the sun, from right or left, or up, or down, these are drawn as any line around a thing to give the colored stuff of it, to weave the whole into a sequence of formations rather than to form an arrangement of facts.

To search and find, that is God as we call it. In other words *work*. It is the only thing that gives happiness. Mere contemplation does not give happiness. Finding through work, the rest will take care of itself.

To actually see is the only thing in life.

Freedom doesn't mean freedom from anything, it means freedom toward something.

Actuality! At that point where mind and matter meet. That is at present where I should like to paint. The spirit is always there. And it will take care of itself. We can tear our imaginations apart, but there is always that same old truth waiting.

Maybe the world is a dream and everything in it is your self.

So what we know about objects is not so important as what we feel about them. So there we are being ourselves, and we might as well do it. And point and say what we feel in our own way.

Time makes a march on us while we are marking time. I have the dread of losing any moments.

There is nothing like the color of a mouse.

The color of the bark of each tree is different, but how many know them by that difference.

All colors are made of light and are a part of the universe.

Lines, if perceptible, are forms and have to go through the same being born as a form.

It is all right to make a good shot, but how about the rest of the game? I still cannot believe that life is an entire accident.